The Art of Painting
Landscapes, Seascapes, and Skyscapes
in Oil & Acrylic

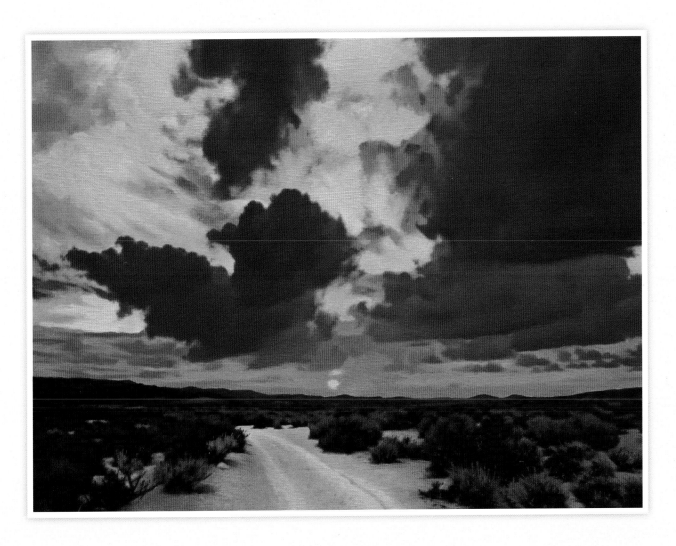

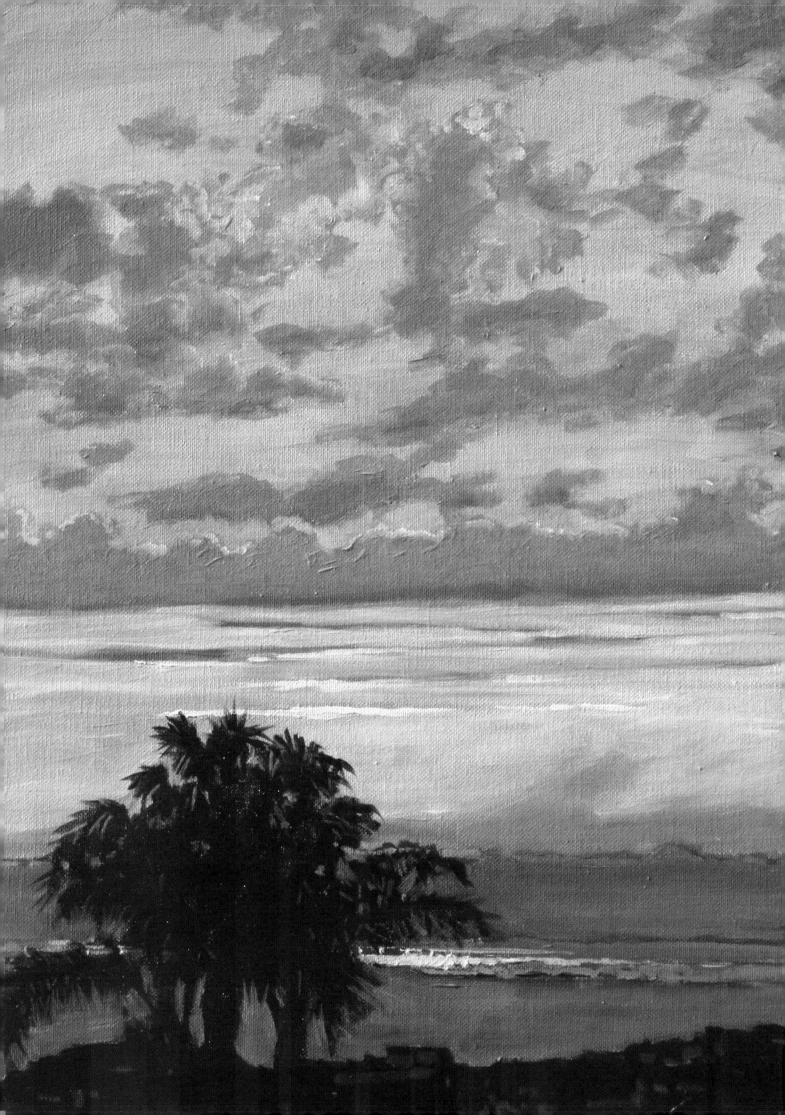

Contents

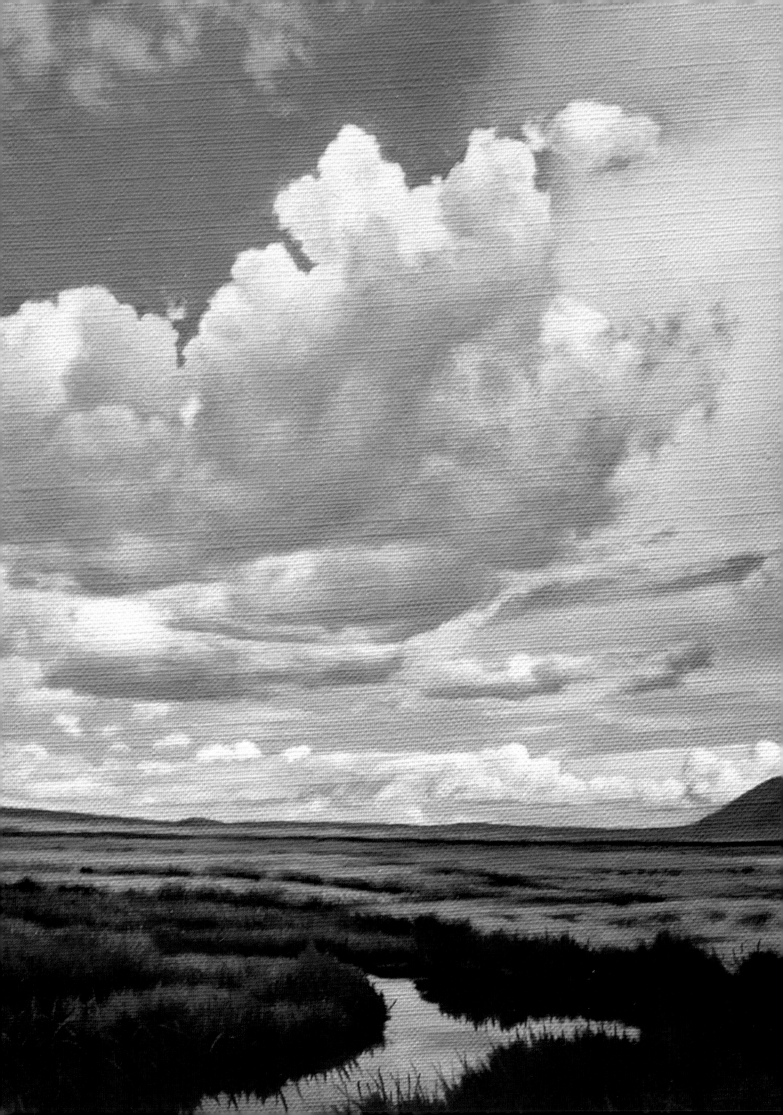

CHAPTER 1

Introduction

An internationally known Australian surf break. Dark, thunderous clouds rolling across a Midwestern plain. A quaint hay field in the Italian countryside. Learn to paint these and other delightful outdoor scenes with the step-by-step lessons featured in *The Art of Painting Landscapes, Seascapes, and Skyscapes in Oil & Acrylic*. Six experienced artists share their secrets for creating textures, capturing time of day and mood, planning a composition, understanding perspective, and much more in this easy-to-follow guide. Additionally, beginning artists will learn how to use the tools of the trade, sketch a scene, and master a variety of oil and acrylic techniques to create their own polished, eye-catching works of art. Let's get started!

Tools & Materials

You will see a vast array of items to choose from as you scan the shelves of your local art supply store. But there is no need to become overwhelmed; you will only need a few materials to begin painting. A good rule of thumb is to always buy the best products you can afford.

Buying Paints

You can use either oil or acrylic paint to complete the projects in this book. The main difference between the two mediums—aside from one being oil-based and the other water-based—is that acrylic dries much faster than oil, making it easier to paint over mistakes. Oil, however, has more pigment and renders richer colors. Both types of paint are available in two grades. "Artist grade" is the highest quality and contains the most pigment, whereas "student grade" is less expensive and contains more filler.

Choosing a Color Palette

The nine colors shown below make a good basic palette. Each project in this book has its own palette, which you should review before purchasing paints.

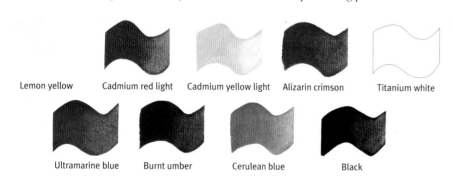

Lemon yellow	Cadmium red light	Cadmium yellow light	Alizarin crimson	Titanium white
Ultramarine blue	Burnt umber	Cerulean blue	Black	

▲ **Selecting Supports** The surface on which you paint is called the support. Ready-made canvases are available in dozens of sizes and come pre-primed and either stretched on a frame or glued over a board. Watercolor illustration boards work well with acrylic paint, providing a smoother surface. When working with oil paint, artists generally use canvas or wood. When using wood or any other porous material, you may need to add primer first to keep the paint from soaking through. Experiment with several different kinds of supports to see which best suits your own painting style.

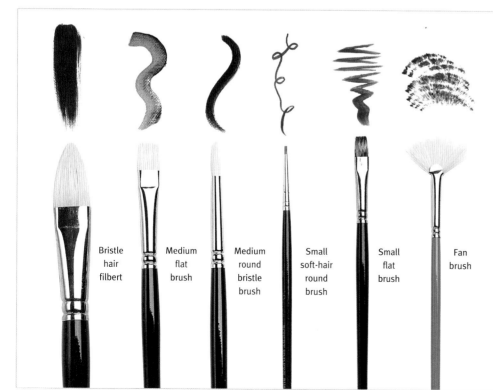

Bristle hair filbert	Medium flat brush	Medium round bristle brush	Small soft-hair round brush	Small flat brush	Fan brush

Buying and Caring for Brushes

There is no universal standard for brush sizes, so they vary slightly among manufacturers. Just get the brushes that are appropriate for the size of your paintings and that are comfortable for you to work with. The six brushes pictured here are a good starting set; you can always add to your collection later. Brushes are also categorized by the material of their bristles; keep in mind that natural-hair brushes are generally not recommended for use with acrylic paint.

Oil and Acrylic Mediums

You will want to purchase some mediums and thinners to accompany your paint—they are used to modify its consistency. Many different types of oil painting mediums are available—some act as thinners (linseed oil) and others speed up drying time (copal). Acrylic paint dries quickly, so you will want to keep a spray bottle filled with water handy. Another way to keep the paint moist is to add acrylic retarder. Don't use more than a 15-percent solution; too much retarder can cause uneven drying. There are a variety of oil and acrylic mediums available that achieve a wide range of effects. Visit your local art supply store and get acquainted with the possibilities.

Use a glass jar or metal cup to hold the medium.

Picking a Palette
Whatever type of mixing palette you choose—glass, wood, plastic, or paper—make sure it's easy to clean and large enough for mixing your colors. You can purchase an airtight plastic box to keep your leftover paint fresh between sessions.

Finishing Up Varnishes are used to protect your painting—spray-on varnish temporarily sets the paint, and brush-on varnish permanently protects your work.

Using Painting and Palette Knives
Palette knives can be used either to mix paint on your palette or as a tool for applying paint to your support. Painting knives usually have a smaller, diamond-shaped head, and are well suited for applying paint directly to the canvas.

Cleaning Brushes A jar that contains a coil will save time and mess because it will loosen the paint from the brush. For removing oil paint, you need to use turpentine. Once the paint has been removed, you can use brush soap and warm water—never hot—to remove any residual paint. When painting with acrylic, use soap and water to remove paint from the brush. Reshape the bristles and lay flat to dry. Never store brushes bristle-side down.

Selecting an Easel The easel you choose will depend on where you plan to paint; for painting landscapes, you may want a portable easel.

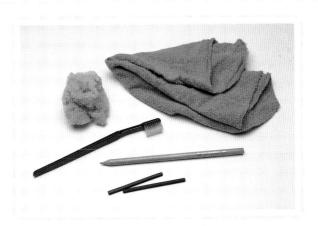

Including the Extras

Paper towels or lint-free rags are invaluable for cleaning your tools and brushes. They can also be used as painting tools to scrub in washes or soften edges. In addition, you may want charcoal or a pencil for sketching and a mahl stick to help you steady your hand when working on a large support. A silk sea sponge and an old toothbrush can be used to render special effects.

Oil & Acrylic Techniques

There are many different ways to approach a blank support. Some artists begin by toning (or covering) it with a thin wash of color. This "underpainting" provides a base for building colors, and sometimes it peeks through in the final painting. This process prevents your final artwork from ending up with unpainted areas. The underpainting is generally a neutral color; warm colors work well for earth-toned subjects, and cool hues suit most other subjects.

Working with Painting Tools

The way you hold your tool, how much paint you load on it, the direction you turn it, and the way you manipulate it will all determine the effect of your stroke. The type of brush you use also has an effect; bristle brushes are stiff and hold a generous amount of paint. They are also excellent for covering large areas or for scrubbing in underpaintings. Soft-hair brushes (such as sables) are well suited for soft blends, glazes, and intricate details.

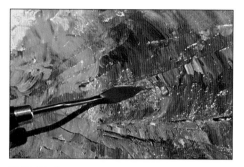

Knife Work For thick texture, load a painting knife with paint and place the side of the blade on the support. Draw it down, letting the paint "pull" off the knife. You can also use this effect to blend colors directly on your support.

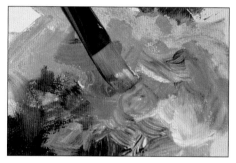

Impasto Use a paintbrush or a painting knife to apply thick, varied strokes, creating ridges of paint. This technique can be used to punctuate highlights in a painting.

Scumble With a dry brush, lightly scrub semi-opaque color over dry paint, allowing the underlying colors to show through. This is excellent for conveying depth.

Smear For realistic rocks or mountains, use a paint or palette knife to lightly smear on layers of color, blending slightly. Overworking the area will ruin the texture.

Scratch To effectively render rough textures such as bark, use the side of a paint or palette knife to apply quick, vertical strokes to scratch off color.

Dab To achieve a soft blend, dab color onto the support using light vertical tapping strokes with a brush or your finger. Some pigments, however, are toxic and should not come in contact with your skin.

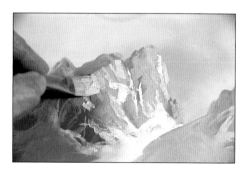

Slash Use a bristle brush or knife to make angular strokes following the direction of a mountain or rock's jagged, jutting planes.

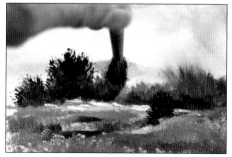

Stamp and Lift For background foliage, take a loaded round bristle brush and push onto the canvas then pull away. Stroke up with the brush as you lift to create tall grasses.

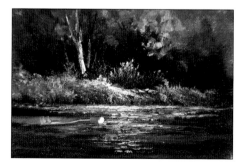

Drag Dragging is perfect for rendering sunlight glistening on the water; pull the brush lightly across the canvas to leave patterns of broken color over another color.

Artist's Tip

Use an old, dull pizza cutter to make straight lines; just roll it
through the paint and then onto the support.

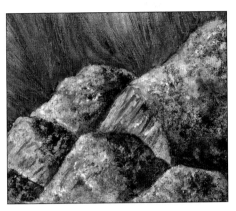

Sponge Here different colors are sponged on in layers, creating the appearance and texture of stone.

Stipple For reflections or highlights, use a stiff bristle brush and hold it straight, bristle side down. Then dab on the color quickly, creating a series of small dots.

Scrape Use the tip of a palette knife to scrape color away. This can create an interesting texture or represent grasses.

Spatter To spatter, load a brush—or toothbrush—with paint and tap your finger against the handle. The splattered paint creates the appearance of rocks or sand.

Lifting Out For subtle highlights, wipe paint off with a paper towel or blot it with a tissue. To lighten the color or fix mistakes, use a moistened rag (use thinner with oil paint).

Soft Blend Lay in the base colors and lightly stroke the brush back and forth to pull the colors together. Make sure that you don't overwork the area.

Blending Large Areas

A hake brush is handy for blending large areas. While
the area is still wet, use a clean, dry hake to lightly stroke
back and forth over the color. Be sure to remove any stray
hairs before the paint dries and never clean your hake in
thinner until you're done painting, as it will take a long
time to dry.

Color Theory

A color wheel can be a handy visual reference for mixing colors. All the colors on the color wheel are derived from the three primary colors—yellow, red, and blue. The secondary colors—purple, green, and orange—are each a combination of two primaries, whereas tertiary colors are mixtures of a primary and a secondary (red-orange and blue-green). Complementary colors are any two colors directly across from each other on the color wheel, and analogous colors are any three adjacent colors on the color wheel.

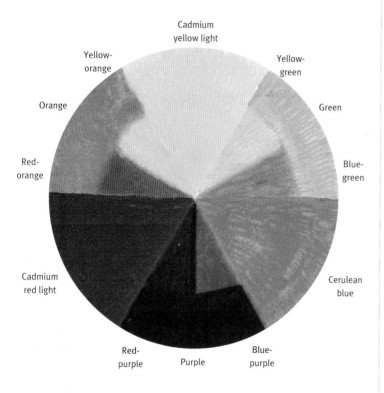

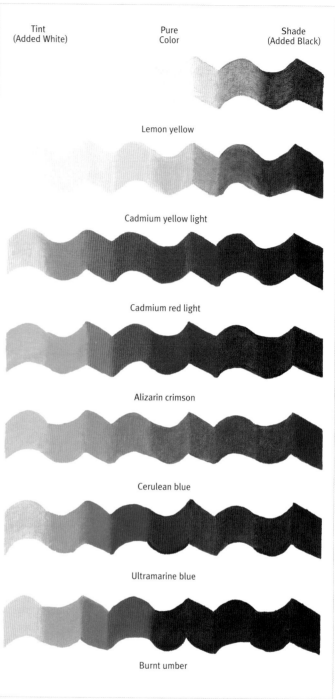

Tint (Added White)	Pure Color	Shade (Added Black)

Lemon yellow

Cadmium yellow light

Cadmium red light

Alizarin crimson

Cerulean blue

Ultramarine blue

Burnt umber

Complementary Colors

As noted above, complements are any two colors directly opposite each other on the color wheel, such as blue and orange. When placed next to each other, complementary colors create visual interest, but when mixed, they neutralize (or gray) one another. For example, to neutralize a bright red, mix in a touch of its complement: green. By mixing varying amounts of each color, you can create a wide range of neutral grays and browns. Mixing neutrals is preferable to using them straight from a tube because the colors will be closer to those found in nature.

Value

The variations in value throughout a painting are the key to creating the illusion of depth and form. On the color wheel, yellow has the lightest value and purple has the darkest value. You can change the value of any color by adding white or black. Adding white to a pure color results in a lighter value tint of that color, adding black results in a darker value shade, and adding gray results in a tone.

Color Temperature

Colors on the red side of the color wheel are considered "warm," while colors on the blue side are "cool." Warm colors convey energy and excitement, whereas cool colors evoke a calm, peaceful mood. Within all families of colors, there are both warm and cool hues. For example, a cool red contains more blue, and a warm red contains more yellow. Keep in mind that cool colors tend to recede, while warmer colors appear to "pop" forward. In a landscape, you can use this contrast to portray distance.

Mixing Color

Successfully mixing colors is a learned skill—the more you practice, the better you will become. One of the most important things is to train your eye to see the shapes of color in an object—the varying hues, values, tints, tones, and shades. Once you can see them, you can practice mixing them. If you're a beginner, you might want to go outside and mix some of the colors you see in nature at different times of day. Your ability to discern the variations in color under different lighting conditions is one of the keys to successful color mixing.

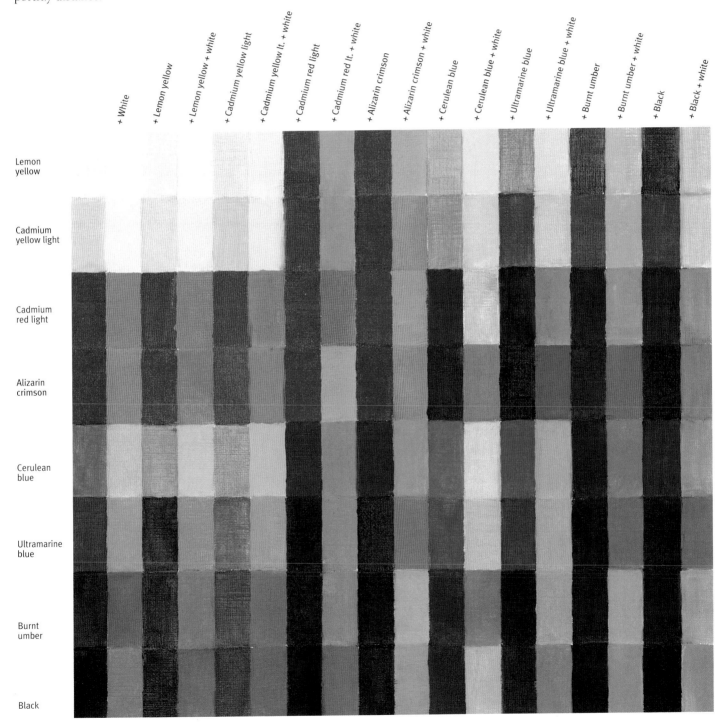

Using a limited palette This chart shows only a portion of the colors that can be made using the basic palette listed on page 8. To practice your mixing skills, create your own chart using the colors from your palette.

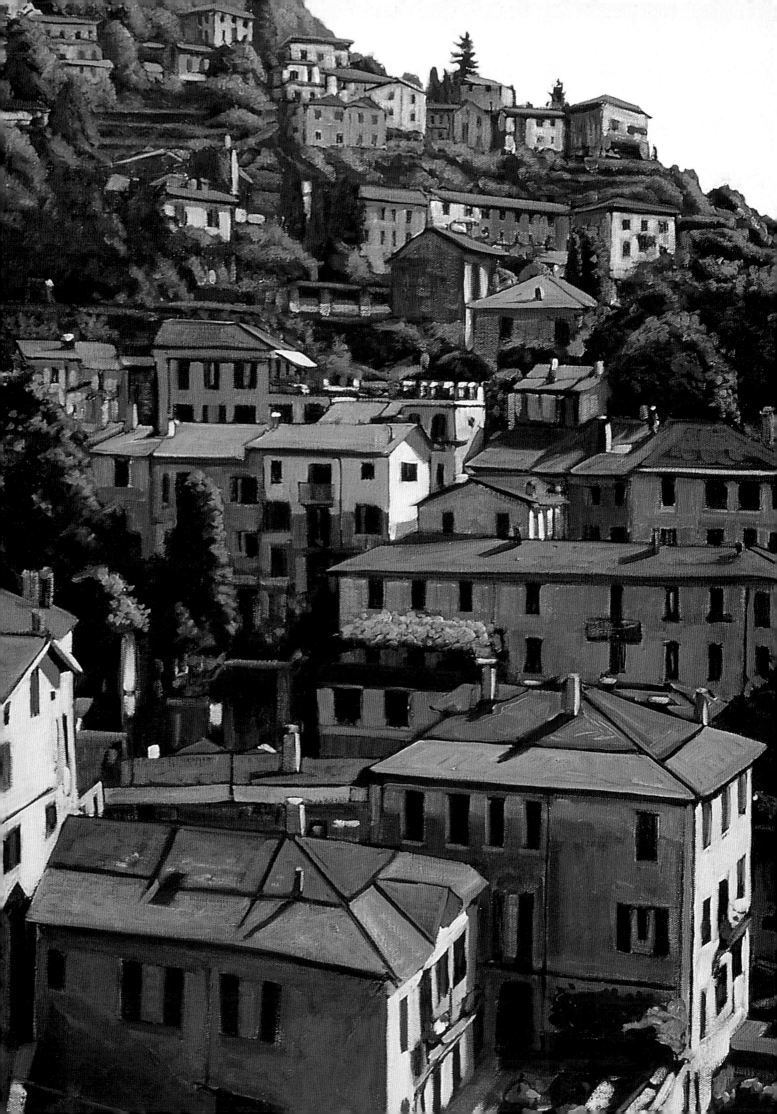

Landscapes

WITH ANITA HAMPTON, MICHAEL OBERMEYER, KEVIN SHORT, AND TOM SWIMM

Capture the majestic beauty and grandeur of landscapes with the step-by-step lessons featured in this chapter. Each artist introduces his or her unique perspective on techniques, special effects, and approaches to painting an array of beautiful panoramas, including an autumn forest scene and a hillside village. Along the way, you'll find the inspiration and information you need to choose your own subjects, develop your own style, and paint your own unique landscapes in either oil or acrylic.

Painting a Panorama *by Tom Swimm*

Panoramic landscapes are always fun and challenging. This photo, taken in Italy, inspired me with its contrasting color hues. The hay rolls add a nice focal point that accentuates the depth and contrast.

▶ Using my computer, I cropped the image and saturated the color to heighten the tonal values. I also added some clouds in the sky to create more interest.

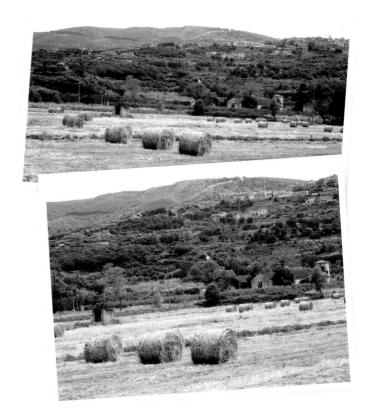

PALETTE

Original painting done in oil

burnt sienna • cadmium yellow light
cerulean blue • dark green • dioxazine purple
flesh • Payne's gray • orange
oxide green • permanent blue
Prussian green • raw sienna • sap green
unbleached titanium (acrylic) • white • yellow ochre

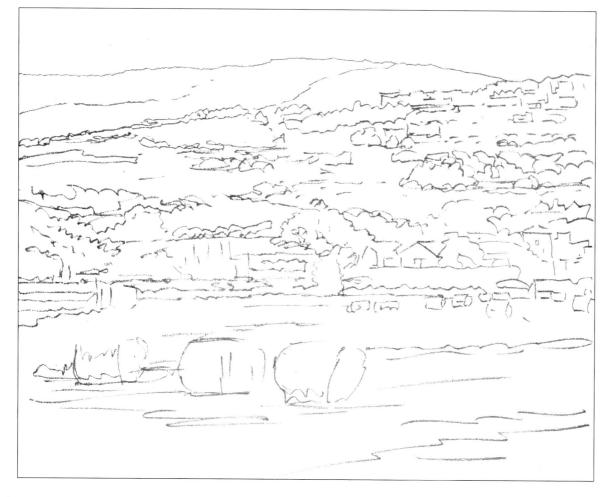

1. Start with a simple sketch to define the major elements. I prefer to use a felt-tip marker because it doesn't smear. Next, cover the canvas with a thin wash of acrylic unbleached titanium. It dries fast, allowing you to start right away.

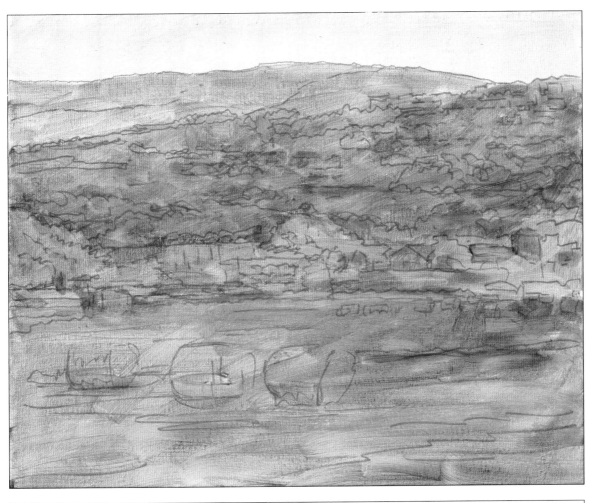

2. This step establishes the basic color range and values. Dilute a palette of cerulean blue, sap green, burnt sienna, and Payne's gray with linseed oil or a comparable medium. Starting at the top, block in large areas of color with a medium-sized flat sable brush. Keep the paint thin, allowing the drawing to show through.

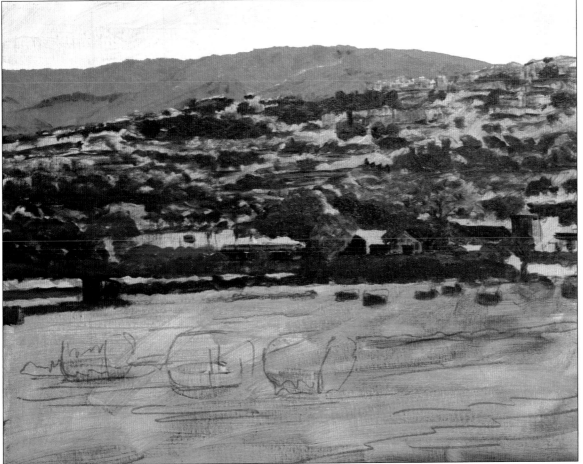

3. Now the painting will come to life with ease! Load the brush with cerulean blue and block in the farthest hills. Use less linseed oil at this stage and vary the pressure and direction of the brushstrokes. Next, define the darker masses of color in the middle section using Prussian green mixed with dioxazine purple and Payne's gray. Continue by defining the trees and building shapes just above the field.

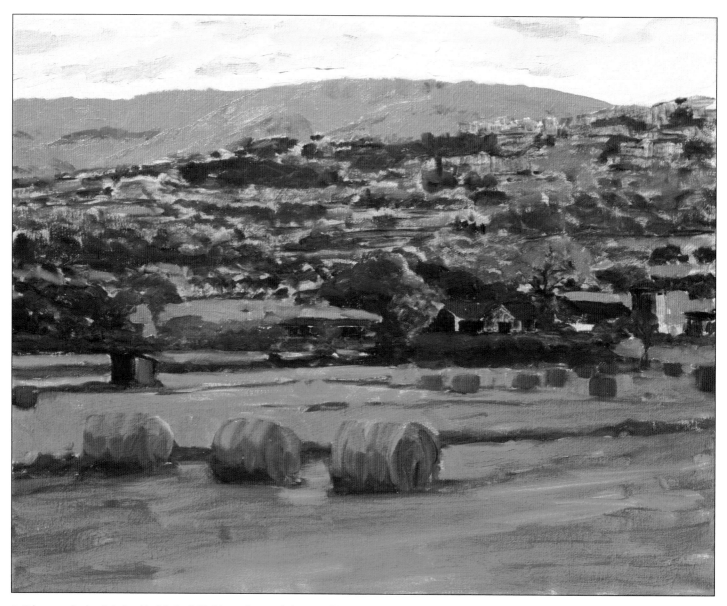

4. Using sweeping brushstrokes, block in the field with raw sienna, painting around the hay rolls. Use dark green to add some crop rows, and then shade the hillside with permanent blue. Next, mix oxide green, flesh, and raw sienna and apply it in the middle section to suggest variations. Moving on to the sky, mix a few colors by adding white to cerulean blue, flesh, and dioxazine purple. Randomly block in large shapes of blue, and then add purple for the undersides of the clouds and flesh for the tops.

You don't have to make a perfect copy of the sky; be spontaneous!

Paint the underside of the hay bails with dioxazine purple and Payne's gray; then hit the tops with flesh highlights.

Note that some of the underpainting shows through.

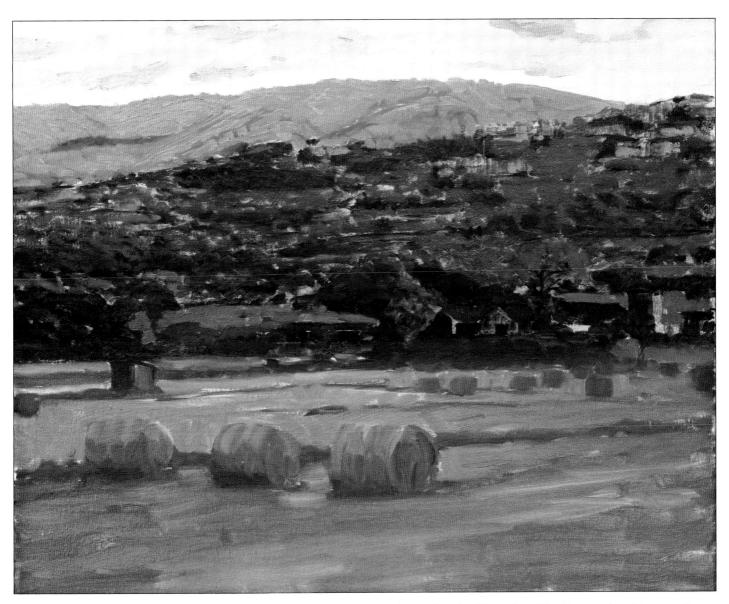

5. Using the blue sky mixture, apply touches of color to the hills in the distance. Vary your brushstrokes to make each a different shape. Using this same color, paint some small shapes in the middle area to suggest buildings. Don't try to paint exact shapes—just add dabs of color. You'll be surprised how realistic it already looks when you take a step back!

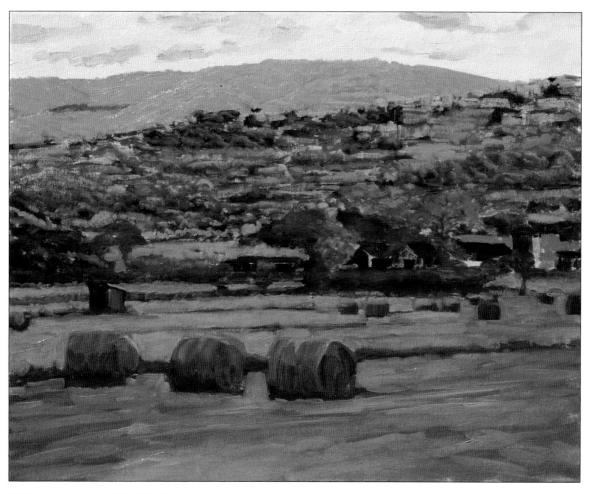

6. Using flesh, work the color into the distant hills to show variations in slope and areas of highlight. You can thin the color and blend it into the background. Don't overwork the blue underpainting—you want some of it to show through. Mix a few greens using Prussian green, oxide green, flesh, and raw sienna and apply them randomly, varying the thickness. Don't get caught up trying to paint individual trees or details— just let the paint flow and have fun.

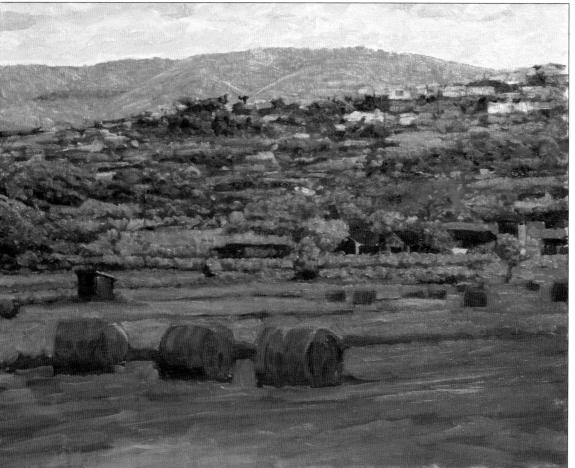

7. Make two mixtures using sap green: one mixed with yellow ochre, and one mixed with cadmium yellow light. Apply these colors to highlight the trees in the foreground. Next, add another layer of color to the field using mixtures of yellow ochre and flesh. Use sweeping, horizontal brushstrokes thick with paint to convey a plowed look. Mix lighter values for the sky using white, cerulean blue, flesh, and cadmium yellow light. Highlight the clouds and distant buildings. Then highlight the trees and hills with the light green mixture

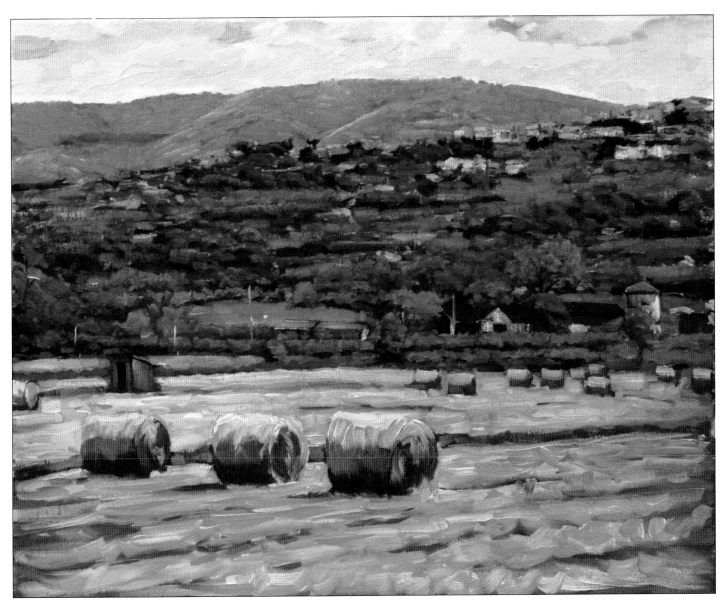

8. Add the brightest values in this last step. Premix some colors using white with orange, yellow ochre, flesh, permanent blue, and cadmium yellow light. Now punch up the areas getting the most light. Notice the dabs of light blue used to harmonize the highlights and suggest accents in the distance. Finally, step back and take a look at your masterpiece, sign it, and be proud of your accomplishment!

Determining a Format *by Tom Swimm*

Format is the shape, size, and orientation of a painting. A horizontal format is a logical choice for a broad seascape or landscape, whereas a vertical format is better suited for tall subjects, such as high-rise buildings, a narrow tree, or a standing figure. You may want to try sketching your subject in several different formats to decide which one you prefer before you begin painting. For this painting of a hillside in Lake Como, Italy, I chose a vertical composition.

PALETTE

Original painting done in acrylic

acrylic medium: gloss • alizarin crimson
burnt sienna • bronze yellow
cerulean blue • chrome orange
chromium oxide green • dioxazine purple
light blue-violet • light portrait pink
magenta • Payne's gray • Prussian blue
phthalo green • red oxide • sap green
unbleached titanium • white • yellow oxide

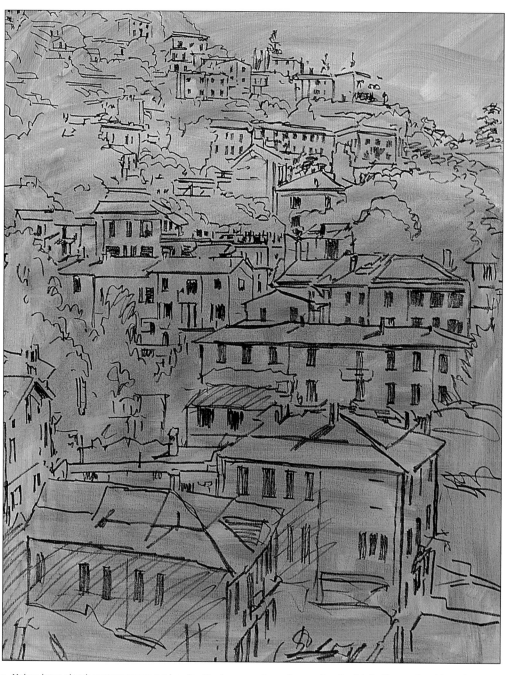

SHADOW VARIATIONS

Dioxazine purple and light blue-violet

Cerulean blue and Payne's gray

Light blue-violet and Payne's gray

Dioxazine purple and unbleached titanium

Payne's gray and bronze yellow

Red oxide and unbleached titanium

1. Make a loose sketch on your canvas, paying attention to perspective and suggesting the details. Next apply a thin wash using burnt sienna in the foreground and cerulean blue in the background. Blend the colors slightly where they meet, giving a visual guideline for where the value transitions will occur.

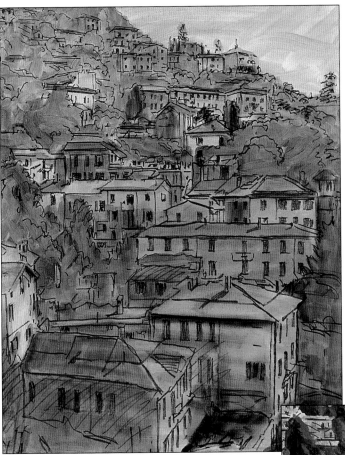

2. Apply a mix of sap green, Payne's gray, and dioxazine purple to the foliage. Then layer burnt sienna on the foreground buildings. Define the shadows with dioxazine purple, and apply it to the buildings and rooftops in the distance.

3. Develop the architecture with a dark mix of Prussian blue, phthalo green, and alizarin crimson, diluting for lighter values. Shape the foliage with variations of green mixed with a little dioxazine purple and Payne's gray. For distant foliage, add dioxazine purple and cerulean blue.

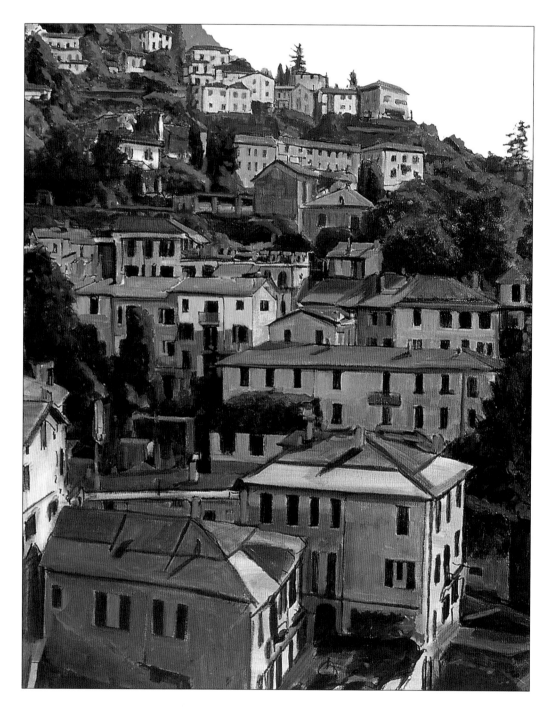

4. Add mixes of burnt sienna, yellow oxide, magenta, dioxazine purple, and gloss to the buildings. Then mix light portrait pink and unbleached titanium for the sky. With light blue-violet, light portrait pink, and yellow oxide, paint around the windows. Add touches of light blue-violet mixed with dioxazine purple.

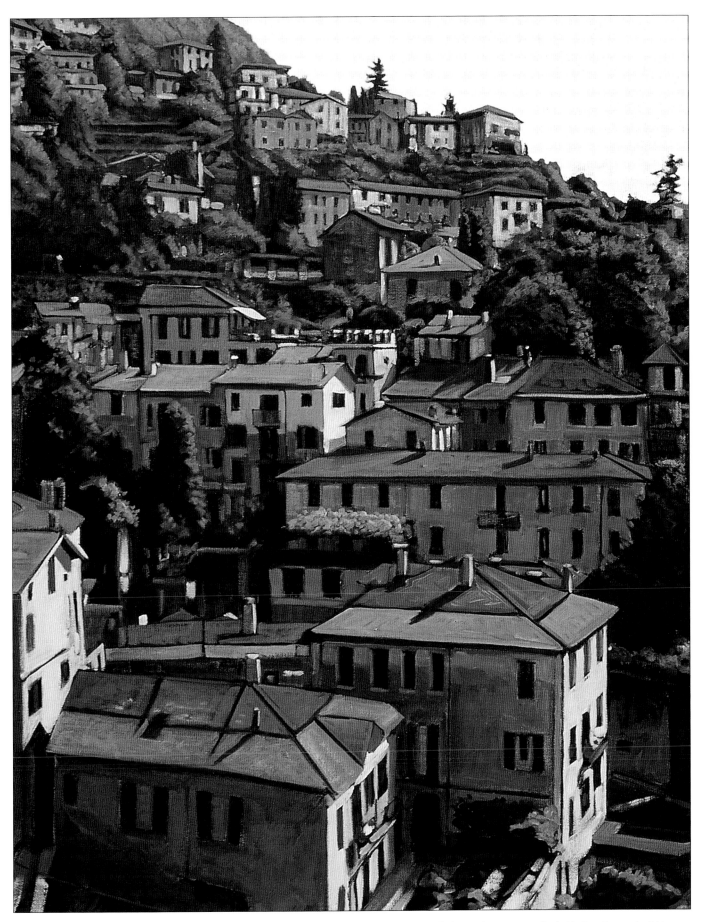

5. Now brighten the foliage highlights. Apply the paint thickly using a dry brush. Next, add color to the foliage shadows using sap green mixed with dioxazine purple. Add a mix of light blue-violet, white, and gloss to the sky. Apply a mix of light portrait pink and yellow oxide for building highlights. Add details to the rooftops by mixing variations of oxide red, light portrait pink, bronze yellow, and orange.

Painting Still Water *by Tom Swimm*

Water can take on many forms—whether calm and still or turbulent and in motion—and the reflections of objects will appear quite different depending on the state of the water. In water at rest, images are reflected more clearly, yet they still aren't exact mirror images. Even in still water, the colors in the reflections will be a little less intense than they are in the objects themselves, as you can see in this scene near the Ponte Vecchio bridge in Florence, Italy.

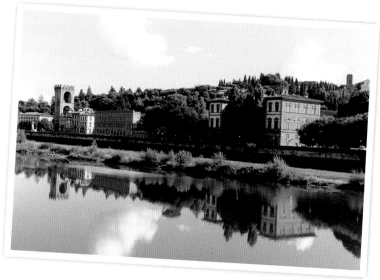

▶ **Painting Reflections** Reflections can add interest and drama to a painting, especially when they're unusually sharp and clear. On this crisp, sunny fall afternoon, there was little wind to disturb the still river, so the colorful, Old-World landscape is clearly mirrored in its neighboring waters.

PALETTE

Original painting done in acrylic

acrylic mediums: gloss and gel

burnt sienna • cerulean blue

chrome orange • chromium oxide green

dioxazine purple • light blue-violet

light portrait pink • oxide green • Payne's gray

red oxide • sap green • white

yellow oxide

1. Start by drawing a loose sketch on the canvas, shading in areas with parallel strokes.

2. Next apply two underpaintings: dioxazine purple and chrome orange. These colors provide a separation of the values and will add harmony to the subsequent layers.

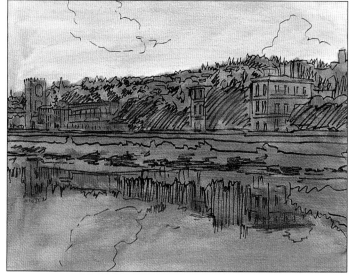

3. Block in transparent washes of dioxazine purple, Payne's gray, sap green, cerulean blue, red oxide, and yellow oxide, mixed with gloss medium. For the dark reflections of the trees and buildings, add Payne's gray to the color. Use stronger color (with less medium) to darken the sky's reflection.

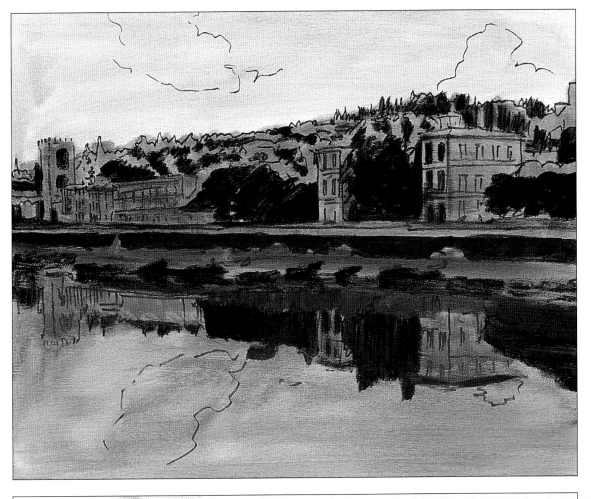

4. Next paint the darker values above water, using mixtures of sap green, burnt sienna, Payne's gray, and dioxazine purple. To make the colors more opaque, use only a touch of gel. Establish the reflections by pulling the color down with vertical strokes. Define the edges of buildings and windows with a small flat brush.

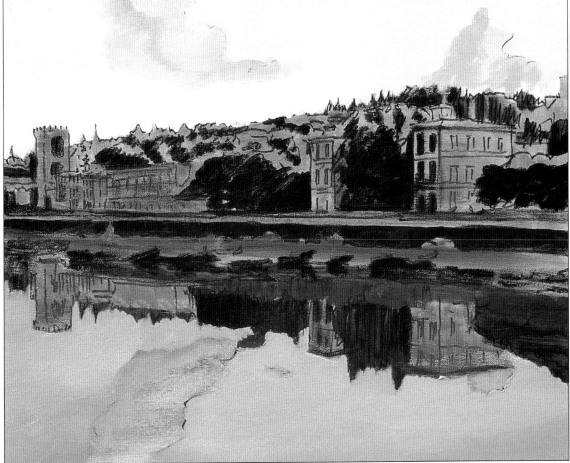

5. Add another layer of color to the sky and water, mixing white, cerulean blue, and gel. Use more cerulean blue in the reflected sky. For the clouds, apply light blue-violet mixed with a little dioxazine purple.

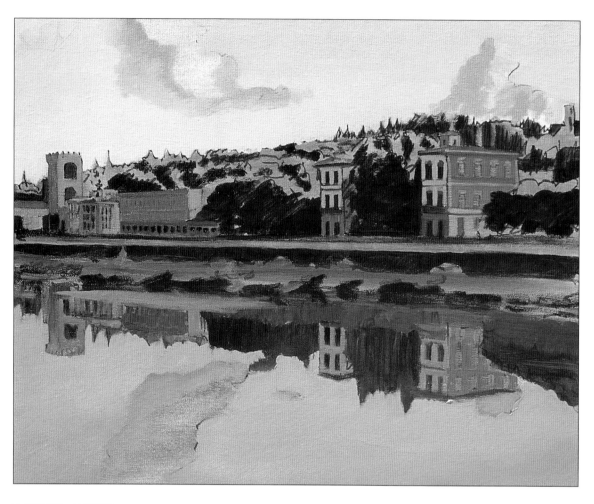

6. With the red oxide, yellow oxide, and light blue-violet already on your palette, mix a few color variations to define the buildings' details. Add a bluish highlight to the water on the left, applying dioxazine purple mixed with light blue-violet horizontally with a dry brush.

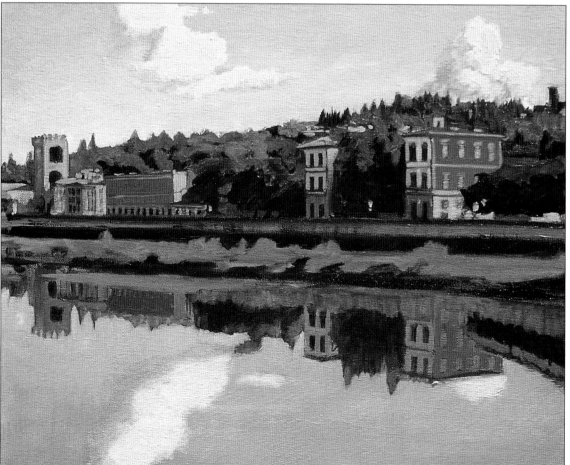

7. Next mix some variations of sap green, oxide green, cerulean blue, Payne's gray, and yellow oxide mixed with gel to develop the foliage. Apply the colors using a large flat brush and varying brushstrokes. Keep the darker colors in the distance, adding gradually lighter colors as you move forward. Add more highlights to the clouds and the brightest area of the buildings with a mix of light portrait pink and white.

PAINTING UPSIDE-DOWN

You may find it helpful to turn your painting upside-down when it comes time to paint the reflections.

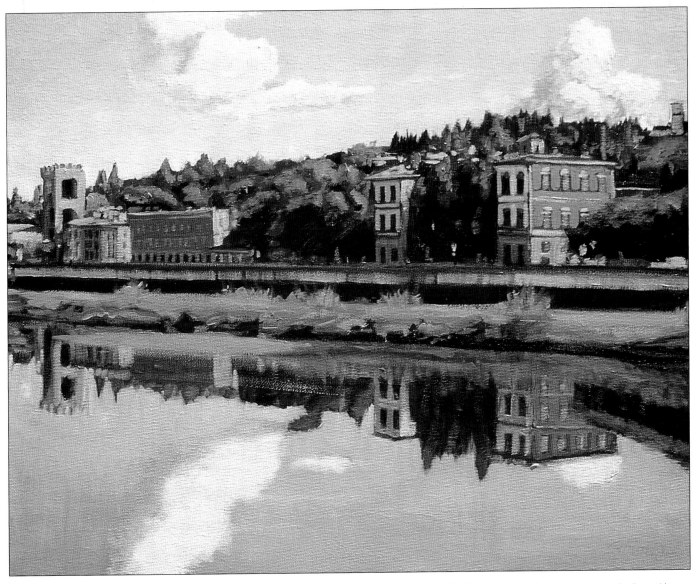

8. Now it's time to make a few final adjustments. First brighten the foliage with mixtures of yellow oxide, white, and oxide green. Apply a few random strokes of yellow oxide mixed with chrome orange along the shoreline. To brighten the buildings, dab on small spots of the color mixes used earlier. There's no need to render every aspect of the painting exactly. Little flecks of color here and there can give the impression of windows, lampposts, or even figures along the walkway.

Adding Final Highlights

Using colors already on your palette, touch up the windows on the right side of the building, leaving dark colors evident to give the appearance of reflected light. Also, clarify the direction of the light source by placing the brightest highlights in the direct path of the sun.

Introducing Perspective *by Kevin Short*

Perspective is the representation of objects in three-dimensional space to give the illusion of distance. You probably already know more about perspective than you think. If you've ever looked at rows of telephone poles that seem to get smaller until they converge at a spot in the distance, you have observed linear perspective. The spot where the receding lines converge is called the "vanishing point." Artist Kevin Short demonstrates a perfect example of perspective in this colorful rendering of Trestles Beach in San Clemente, California.

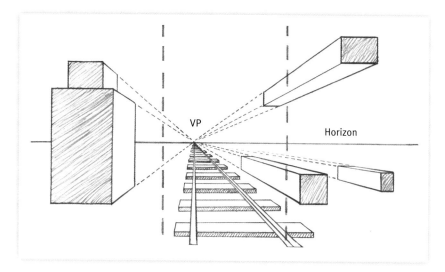

One-Point Perspective To sketch a subject using one-point perspective, make all of the parallel lines in the scene recede to the vanishing point.

PALETTE

Original painting done in oil

cadmium orange • cadmium yellow medium • carbazole violet • phthalo green • quinacridone red • titanium white • ultramarine blue

1. Sketch the horizon line and other basic elements, taking care to get the perspective correct. Paint the shadows of the trestle with a mix of carbazole violet, ultramarine blue, and quinacridone red, mixing in more carbazole violet, ultramarine blue, and titanium white as you recede into the distance. With a small round brush, block in the bushes with thick strokes. As you move into the distance, use less cerulean blue until you're using only phthalo green, cadmium yellow medium, carbazole violet, and titanium white.

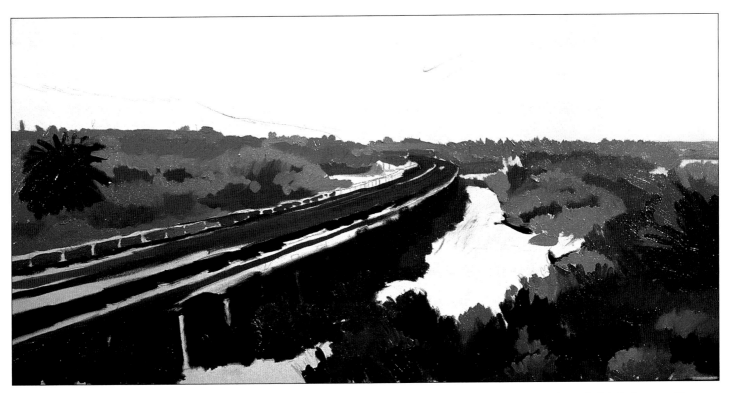

2. Add a little of the trestle shadow color to the darker mix used for the bushes, and place a few strong shadows in the foreground and near the trestle. Paint in the ocean with a small flat brush and a mixture of ultramarine blue, phthalo green, and titanium white. Stroke a mix of ultramarine blue, carbazole violet, quinacridone red, and titanium white onto the track with the same brush. Add more titanium white and ultramarine blue to the tracks as they disappear into the distance.

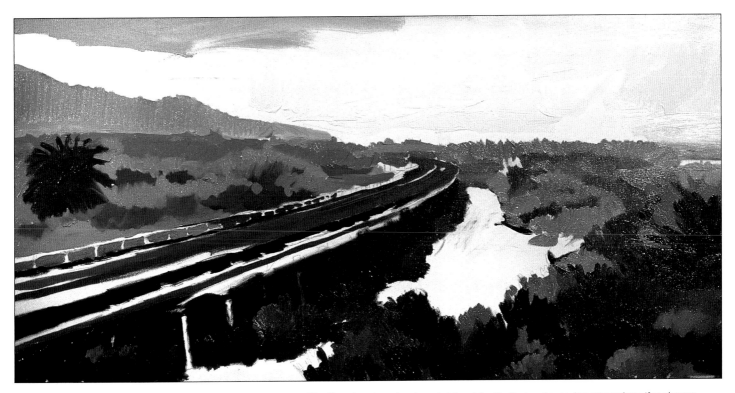

3. Create a large amount of a pale yellow mixture for the sky. Save some to blend into the other color elements later, giving the illusion of a very hazy atmosphere. If an element "pops" forward too much, simply add a little sky color to it. Start by first painting the mountain in the distance and then thickly laying on the sky colors with a medium round brush.

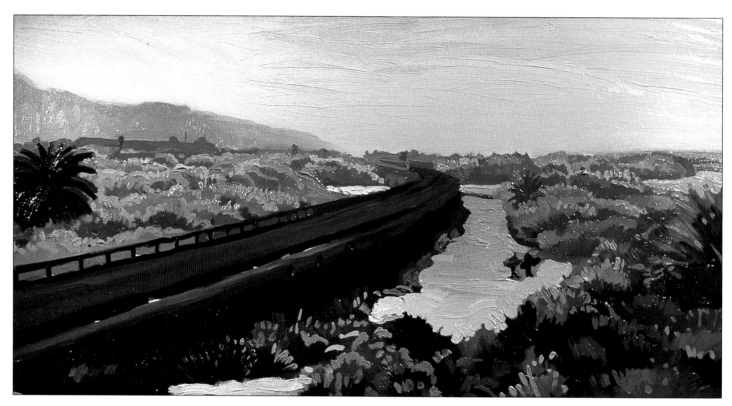

4. Blend the sky color into the mountain until it starts to disappear. Scrub in the sand and add cadmium yellow medium to the edges of the path. Add thick highlights to the bushes with various mixtures of ultramarine blue, cadmium yellow medium, titanium white, and phthalo green. Next, dab in the flowers and highlights. Add the final sand color and then darken the palm tree on the left to bring it forward. Place the two figures and add some of the sky mix to the sand color near the horizon.

Sky Detail

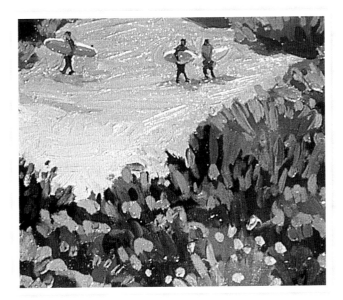

Artist's Tip

Adding figures to your landscape is a great way to capture a viewer's attention and add visual interest to a painting.

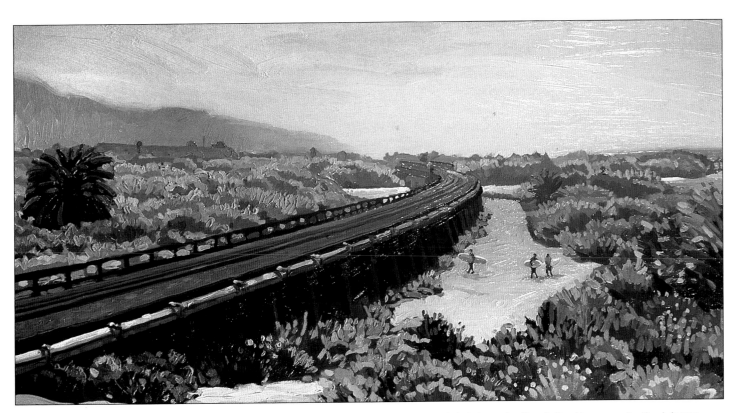

5. Add flowers to the bushes with a mix of quinacridone red and titanium white. Refine the figures by painting their clothes and surfboards. To add one more directional element, add a surfer going the other direction. Finalize the tracks by painting highlights on the gravel, using colors from step 4 with more quinacridone red and titanium white. Highlight the tracks with ultramarine blue and titanium white, and add a few highlights to the foreground bushes.

SAND

Carbazole violet, quinacridone red, cadmium orange, cadmium yellow medium, and white

SAND SHADOWS

Carbazole violet, ultramarine blue, quinacridone red, cadmium orange, cadmium yellow medium, and white

33

Depicting Depth *by Anita Hampton*

Aside from linear perspective, there are several other visual cues artists use to convey depth. Overlapping elements creates an illusion of distance because the objects in front appear to be closer. Varying the size, or scale, of similar elements works because the larger objects will appear closer than the smaller objects. In this portrayal of Hendry Beach, the artist uses overlapping and distinctive color changes to create a sense of depth.

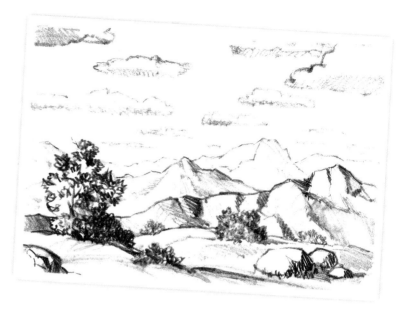

▶ **Combining Methods** When you overlap objects and vary their sizes, you will create the illusion of depth.

PALETTE

Original painting done in oil

burnt sienna • cadmium red light • cadmium yellow deep • cadmium yellow pale
cerulean blue • cobalt blue • phthalo yellow-green • quinacridone rose
titanium white • ultramarine blue • viridian green • yellow ochre

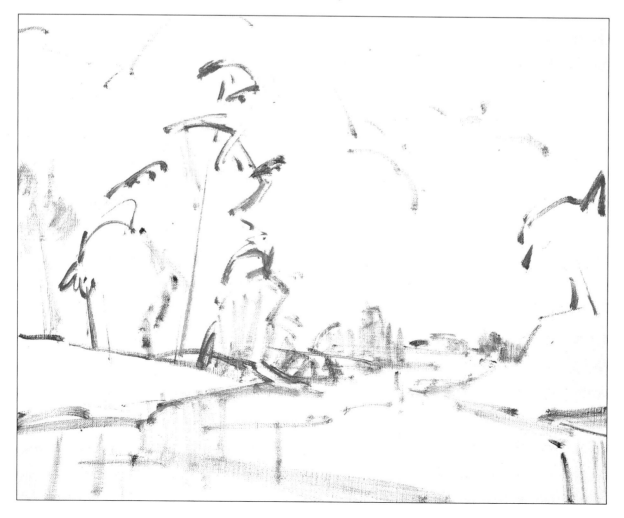

1. Sketch the composition directly on the canvas with a small, flat bristle brush and a diluted mix of cerulean blue and yellow ochre. Place the basic shapes carefully, making sure there are a variety of sizes and lines and a good placement for the center of interest—the trees on the left.

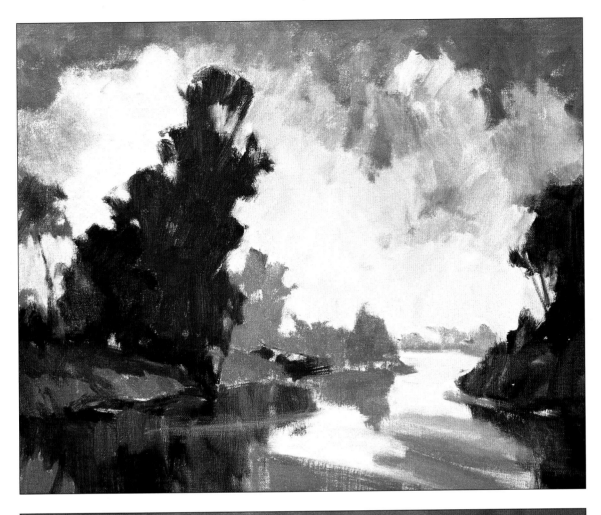

2. Block in the dark trees with a large brush and a diluted mixture of viridian green, ultramarine blue, burnt sienna, and yellow ochre. Occasionally change the dominant hue by adding more of one of the colors to the mixture as you go. Block in the rest of the foliage and the reflections. Mix titanium white, yellow ochre, and a small amount of cadmium red light and cerulean blue for the clouds. For the sky, mix titanium white, ultramarine blue, cerulean blue, and a touch of quinacridone rose. As the sky nears the horizon, apply a mix of titanium white, cerulean blue, and a touch of cadmium yellow pale.

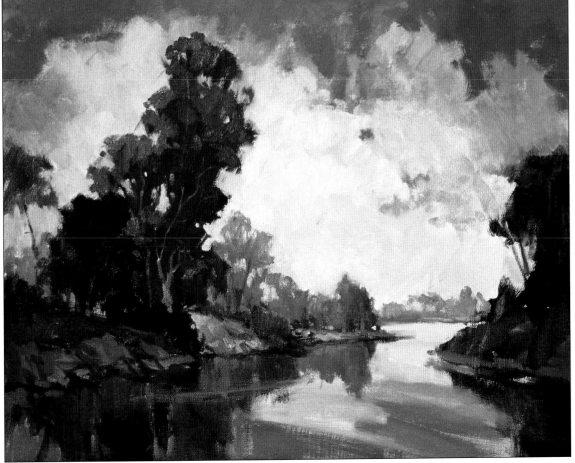

3. Using a small brush, apply color to the foliage shapes on the left with a mix of titanium white, yellow ochre, cadmium red light, and touches of phthalo yellow-green and cadmium yellow deep. Add the darker values in the shadows with a mix of titanium white, viridian green, ultramarine blue, yellow ochre, and a little cadmium red light. Paint the tree trunks with a small brush dipped in a mix of titanium white, cadmium red light, viridian green, and yellow ochre.

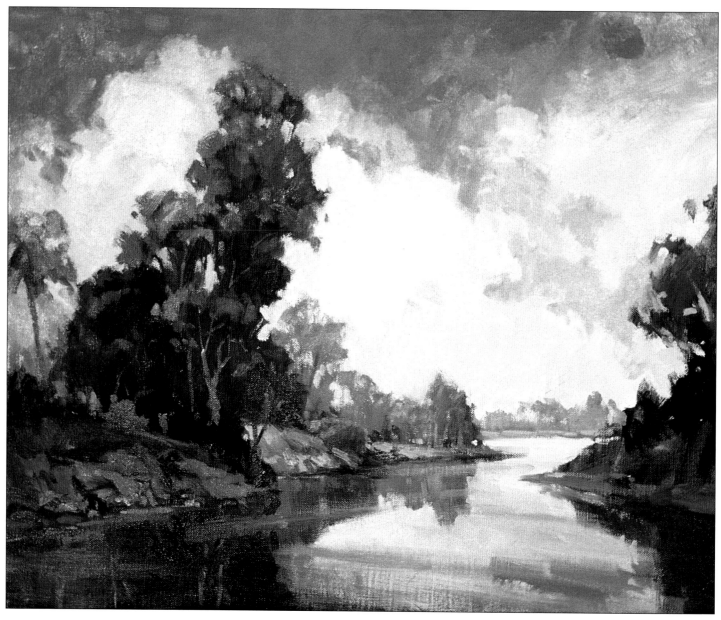

4. Develop the large trees using a small bristle brush and the light and dark mixtures from step 3. Also develop the outlying areas with a large brush. During these final stages, use more color in your mixtures. Save the cleanest, purest colors for the foreground.

ATMOSPHERIC PERSPECTIVE

Impurities in the air block out some of the light, making objects in the distance appear less distinctive. The impurities also filter out the longer, red wavelengths of light, allowing your eye to see only the shorter blue wavelengths.

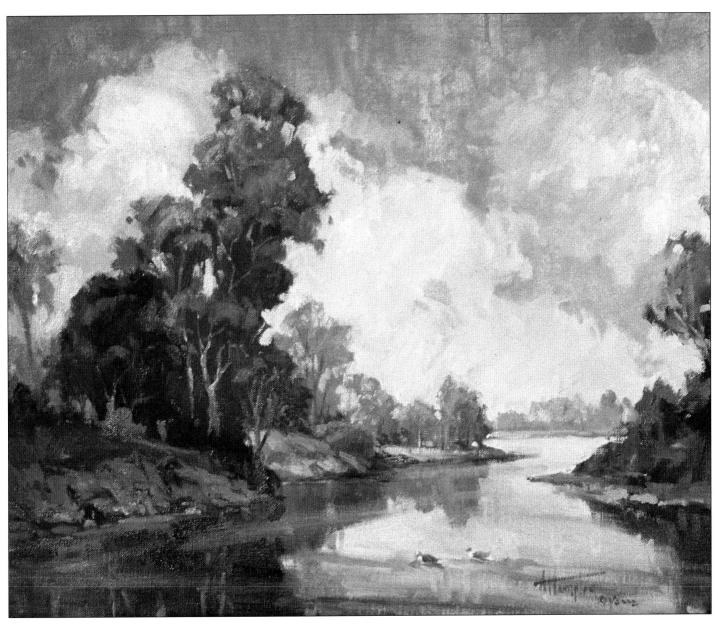

5. Add clean color to various areas of the canvas you want to highlight, and add the ducks in the foreground. These pure colors will "pop," adding interest and excitement. Mix titanium white and cobalt blue with a little ultramarine blue and quinacridone rose for the sky. Apply the mix with a large flat brush—but don't disturb the paint underneath. When you are finished refining the details of your landscape, sign your name!

USING A VIEWFINDER

When photographing the subject of your painting, you can easily move the camera around until you see your desired composition in the camera's viewfinder. An artist who chooses to work without photos can find the frame of his or her painting by using a viewfinder as well. You can buy one, make one, or form "L" shapes with your thumbs and index fingers.

Creating Drama with Light & Shadow

by Michael Obermeyer

Often the most captivating aspect of a scene is the interplay between light and shadow. It can make a location seem quiet and tranquil or dark and sinister. Sometimes the contrast is so striking that the interaction between light and dark becomes the focus of the painting.

COMPARING LIGHT DIRECTION

The direction and intensity of light influences the shadows and colors in a scene. When light is hitting the subject head-on, the shadows are minimal. Light coming from behind the subject tends to create silhouettes with illuminated edges. This depiction of a bridge in Central Park, New York, captures the long, cool shadows created by the three-quarter lighting of the late afternoon.

PALETTE

Original painting done in oil

alizarin crimson • cadmium yellow deep
cadmium yellow light cerulean blue • titanium white
ultramarine blue • viridian green

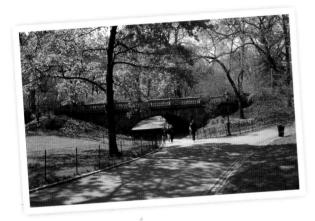

Focusing on Shadows This snapshot captures the natural, delicate balance between light and shadow. For the painting, simplify the shadows but try to retain the delicate laciness that makes them so interesting.

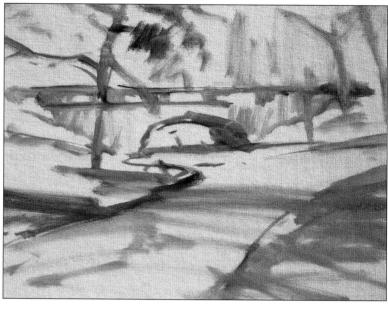

▲ **1.** Quickly sketch in the composition with a thin wash of ultramarine blue. Include the shaded areas, as they will be the focal point of the painting.

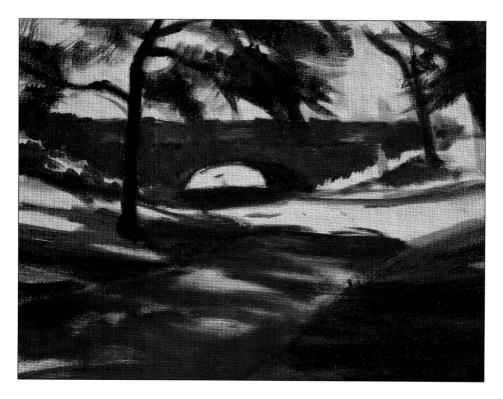

2. With a thin mix of ultramarine blue and cadmium yellow light, block in the shadows on the grass with quick, bold brushstrokes. Paint the tree trunks and bridge with a mix of alizarin crimson and ultramarine blue. Then use a large flat brush to work in the cool shadows.

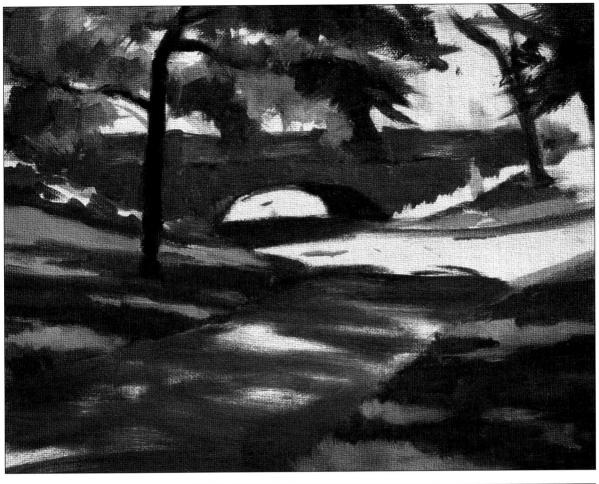

3. Now add the warm tones: the sunlit grass in the foreground and the light areas of the tree in front. Keep the paint thick, using strong, bold brushstrokes. For the grass, use a mix of cadmium yellow light with a touch of viridian green and a hint of cadmium yellow deep.

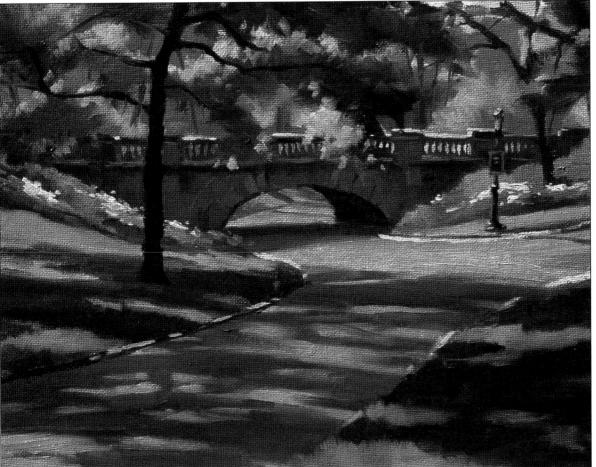

4. Develop the sunlit areas of the street with a light yellowish-red mixture. Add the sky (cerulean blue, titanium white, and cadmium yellow light) and distant trees (alizarin crimson, ultramarine blue, and titanium white). Then block in the buildings with ultramarine blue and titanium white. With small flats, work throughout the entire painting, adjusting values as necessary and adding more detail. When the contrast between the sunlit patches and the cool shadows is well balanced, your painting is done!

Land and Sea *by Anita Hampton*

The energy and intrigue of the ocean has captivated and inspired artists for centuries. Depending on the location, the weather, and the light, the sea can appear playful, dangerous, or peaceful. Its vast scale can remind us of the constant power struggle between humankind and nature.

STUDYING THE WAVES

Waves aren't always blue. At sunset they might be a mix of warm oranges, pinks, and reds. The light patterns are always changing as well, depending on the position of the sun. Also keep in mind that waves have a thick base and a thin crest at the top, where the light has more opportunity to shine through.

▶ **Sketching the Composition** Begin sketching this scene of the Cambria Coast in California with a thin mix of cerulean blue and yellow ochre. Be sure to vary the shapes and sizes of the elements, and never cut the canvas in half vertically or horizontally.

PALETTE

Original painting done in oil

cadmium red light • cadmium yellow light • cadmium yellow pale • cerulean blue • cobalt blue • quinacridone rose • sap green
titanium white • transparent oxide red • ultramarine blue • viridian green • yellow ochre

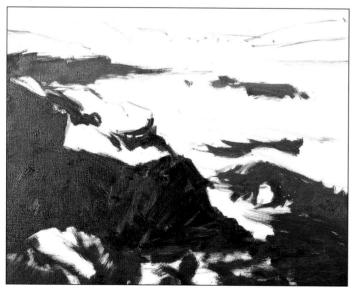

1. Create various mixes of transparent oxide red, sap green, and ultramarine blue for the rocks. Then apply the darks of the water with a mix of ultramarine blue, transparent oxide red, and a little titanium white.

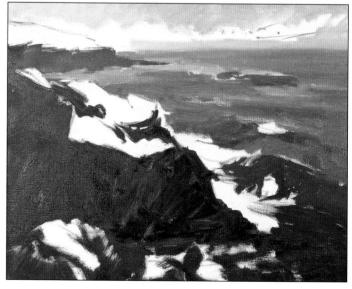

2. Next add the water midtones (see swatches below). For the sky, I use a mix of white, viridian green, and a touch of cadmium red light.

WATER MIDTONES

Ultramarine blue, transparent oxide red, titanium white, viridian green, and quinacridone rose

FOAM HIGHLIGHTS

Titanium white, cadmium yellow light, cadmium red light, cerulean blue, and cadmium yellow pale

HEADLAND

Titanium white, viridian green, cadmium red light, yellow ochre, cadmium yellow light, cadmium red light, ultramarine blue, transparent oxide red, and quinacridone rose

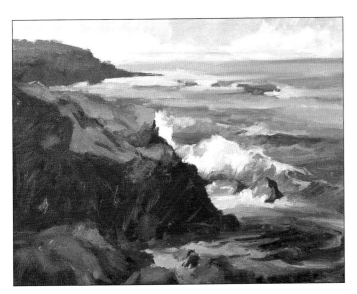

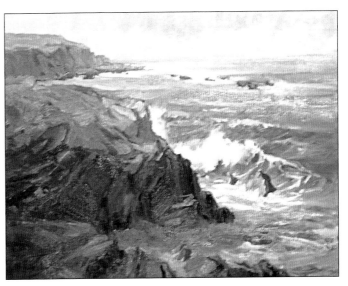

3. Apply light color on the rocks and darken the foam. Then paint the clouds with a mix of white, cadmium yellow pale, and cadmium red light, blending the edges. Add more midtones to the water and darken the foam with a mix of white, cobalt blue, rose, cadmium yellow light, and a touch of cadmium red light.

4. Build up the texture on the main rock with light and dark values, creating highlights with a mix of white, oxide red, viridian green, yellow ochre, and cadmium red light. Then switch to a mix of sap green, yellow ochre, and cadmium red light for the dark areas. Randomly add a range of values with a small brush to the land, but be careful not to draw attention away from the focal point.

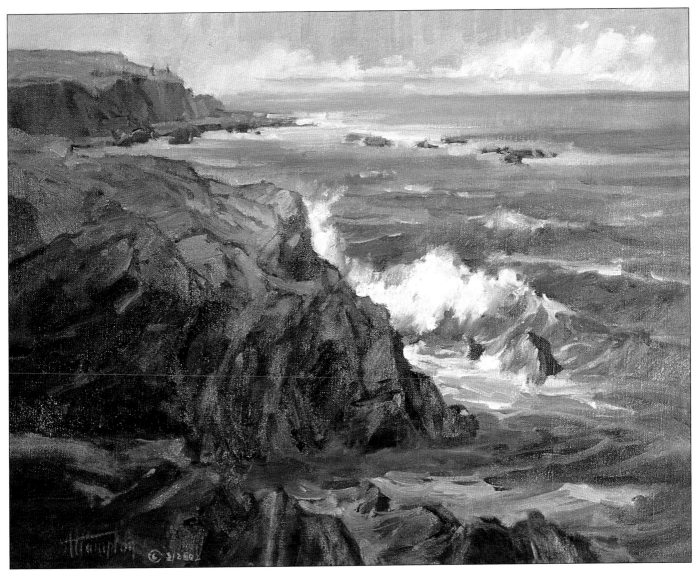

5. At this final stage, make sure that every brushstroke enhances the focal point of the painting. Add more darks to the crevices in the rocks with a small brush, and apply more color and interesting shapes to the foreground foam. Finally, step back and make sure you are satisfied with your work.

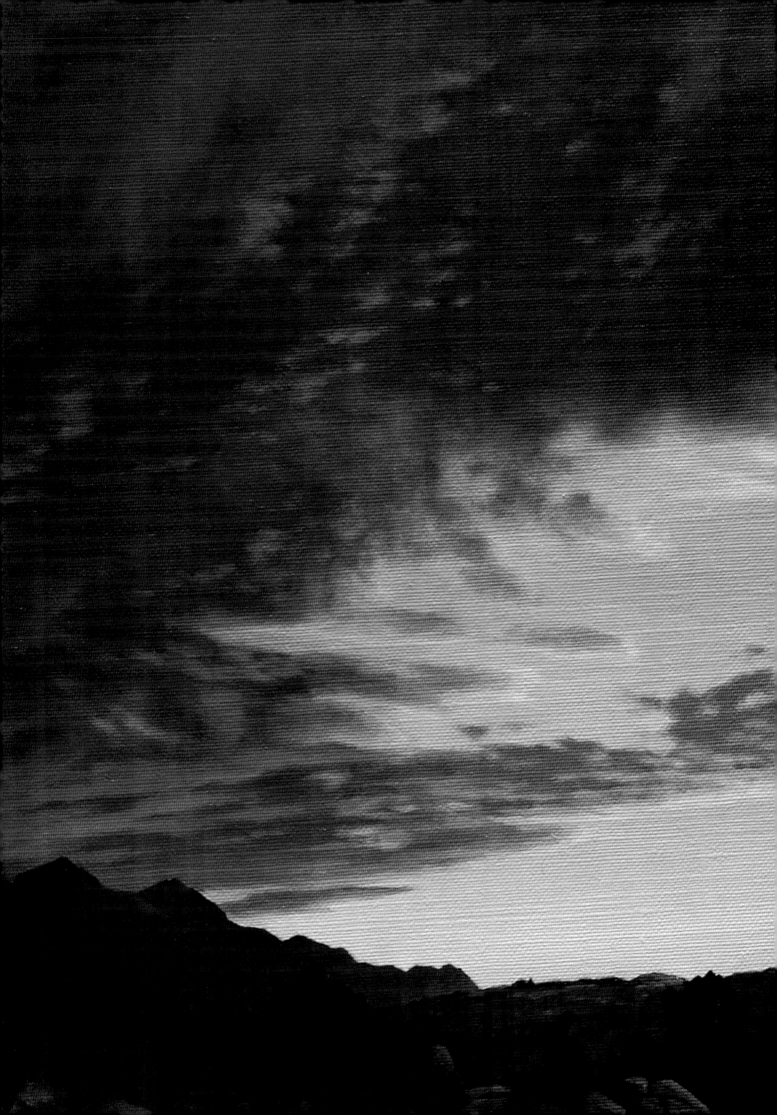

Clouds & Skyscapes

WITH ALAN SONNEMAN

The natural world provides a wonderful ebb and flow of form and color. Clouds add drama to a landscape, and when their splendor is captured in a painting, they also evoke feelings of blustering winds and the scent of moisture in the air. I've always loved observing clouds. Their forms unfixed, they change continuously from one shape to another. To master the art of rendering exquisite skyscapes, one must balance time spent painting with outdoor observation. In the pages that follow, I share my techniques for creating beautiful cloud-filled skies, from taking the initial photo to adding the finishing touches. By following along with the lessons, you will find that you too can paint breathtaking skyscapes!

Clouds

Clouds are classified by form and height: They are either flat or puffy; solid, clumped, or scattered; and thin or layered—no two clouds are exactly alike. Time of day, weather, and location can all affect a cloud's appearance. Also note that any number of different cloud forms can be present in the same skyscape. As an exercise, take a series of photographs of a stormy sky in an hour's time. Note how quickly the clouds change form. Clouds are part of an incredible series of natural phenomena. Water covers more than 70 percent of the Earth's surface and is continuously evaporating into the atmosphere. This, combined with the change of seasons, the Earth's rotation, and other forces of nature, forms the awe-inspiring system of warm and cool air that we call weather.

TYPES OF CLOUDS

There are ten basic cloud groups. Within each group there are different cloud variations and combinations of cloud variations. There are also accessory clouds, which have unique shapes and characteristics and are dependent on the larger clouds they accompany for their continuance.

CLOUD GROUPS

Low-Altitude Clouds

• **Cumulus** are low, detached, puffy clouds that develop vertically in rising mounds or towers and generally have a flat base.
• **Cumulonimbus** are thunderclouds characterized by their extreme height and dark base.
• **Stratus** are formless layers or patches of cloud with diffused edges.
• **Stratocumulus** are low layers or patches of cloud with well-defined bases composed of clumps or rolls.

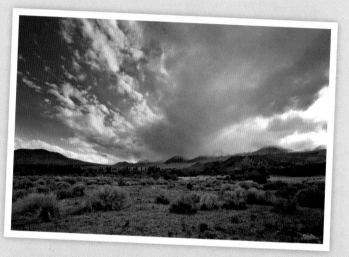

Altostratus clouds forming over the Southern Sierra

Mid-Altitude Clouds

• **Altocumulus** are mid-level layers or patches of cloudlets in the shape of rounded clumps, rolls, or ovals.
• **Altostratus** are mid-level layers of gray clouds that are either featureless or fibrous and often extend over large areas.
• **Nimbostratus** are thick, dark, featureless layers of cloud with diffused bases that cause prolonged rain or snow.

High-Altitude Clouds

• **Cirrus** are delicate white streaks, patches, or bands of cloud and have a fibrous or silky appearance. They are located higher in the atmosphere than any other cloud.
• **Cirrocumulus** are high patches of cloud or tiny cloudlets with a grainy appearance.
• **Cirrostratus** are transparent, milky veils of high clouds that are smooth or fibrous and extend over vast areas. At times they are only visible as a halo around the sun or moon.

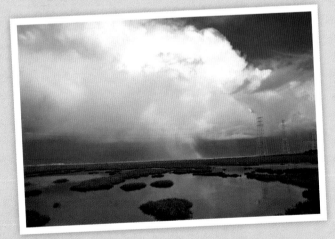

Cumulonimbus clouds forming along a front of low pressure

PHOTOGRAPHY

While I prefer a wide-angle lens (16 millimeter) on a digital single-lens reflex (DSLR) camera, a cell phone can be also be useful in capturing usable images. A wide-angle allows me to see directly through the lens when I take a picture. Take many pictures—think of it as sketching. Once you have an image you want to work from, print it, and then transfer it to your canvas by sketching in your composition freehand, or by projecting it onto your canvas with a projector and tracing the outlines of major elements with a pencil.

Techniques & Palette

There are a few basic terms that I refer to and techniques that I employ in the painting projects that follow. Learning how to achieve desired effects by manipulating the angle of the paintbrush, properly mixing colors, and applying layers of washes and opaque paint will bring depth and lifelike qualities to your paintings.

BASIC TECHNIQUES

Washes

It can be helpful to paint areas of the canvas with thin washes of neutral colors before adding details. Mix a small amount of paint and heavily dilute it with turpentine (if working with oil) or water (if working with acrylic) until it has a watery consistency. Apply the wash over the entire canvas with a large brush, smoothing out brushstrokes.

Wash

Wet into Wet

Applying a new color of paint to an area covered in wet paint is known as painting wet into wet. This technique is useful when blending colors.

Wet into Wet

Scumbling

Applying a semi-opaque coat of paint over a darker color of paint with a dry paintbrush is known as scumbling. The sagebrush at right was added with this technique.

Scumbling

COLOR PALETTE

To keep things simple, I've used a limited number of colors for the paintings in this chapter. The palette below was taken from one of the first modern landscape painters, John Constable. Constable took advantage of the proliferation of new pigments that were developed due to the advancements in chemistry during the 19th century. This palette contains every color needed to render a breathtaking skyscape.

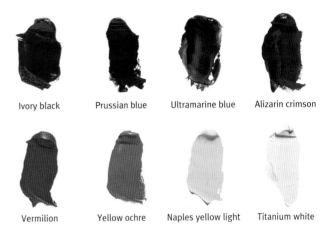

| Ivory black | Prussian blue | Ultramarine blue | Alizarin crimson |

| Vermilion | Yellow ochre | Naples yellow light | Titanium white |

ARTIST'S TIP

Prussian blue is cooler than ultramarine, and it will make the sky appear deeper.

Painting Sunsets

I've added cadmium red medium and cadmium orange to the basic palette above to achieve the intense reds shown in "Twilight in the Wilderness" on page 66 and "Clouds at Sunset" on page 70. These colors were not available until the mid-19th century.

Cadmium orange Cadmium red medium

Add a touch of ivory black to neutralize a color if it's too saturated.

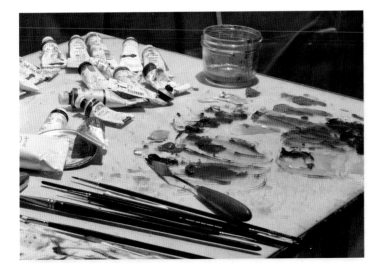

KEY TERMS

Value – the range of light to dark
Hue – the specific color of an object
Saturation – the intensity of color
Composition – the arrangement of forms within the painting
Perspective – the relative appearance of objects in space

Field Observation

The forms and colors across a cloudy sky may seem limitless, but knowing what to look for will make finding a pleasing arrangement of clouds a less daunting task. Seek out interesting patterns, observe the quality of the colors, and think about whether there is a center of interest in the sky and if the landscape below contributes to the scene.

COLOR & FORM

These three images are from the same expanse of wetlands near the San Francisco Bay. In this Mediterranean climate, the window to observe clouds is usually limited to the wet season.

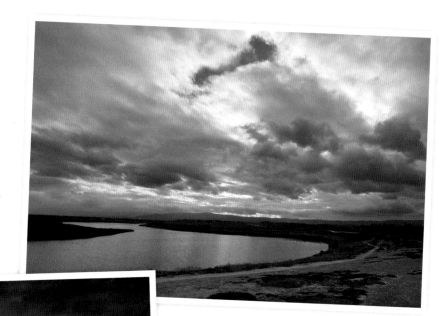

Backlit clouds in the early morning

Clouds at sunset in the late evening

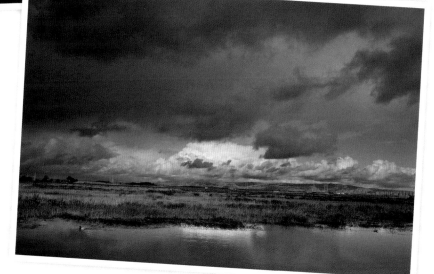

Overhead clouds in the late afternoon

OBSERVATION TIPS

There are many variables to consider when attempting to capture the most dynamic colors and compositions in the sky. Time of day and the position of the observer in relation to the sun can have significant impacts on how the sky appears. Knowing when to step outside and what to look for will help you photograph the perfect skyscape to re-create in your studio.

Time of Day
Light travels the greatest distance through the atmosphere in the morning, late afternoon, and evening, resulting in warmer, richer colors that attribute to the appearance of clouds during these hours.

Time of Year
Increasingly dynamic cloud forms grace the sky as weather systems change with the warming of the seasons. The long days of late spring and summer provide a backdrop for vivid colors in their evening skies.

Direction of Light
Your position in relation to the sun is important when deciding which direction is most visually interesting. Sunsets are usually backlit, while midday clouds are best when viewed from the side, revealing their shadows.

Field of View
Think about the size of the area you are going to paint and how well it will frame the clouds. A focus that's too narrow will feel forced and unnatural.

Center of Interest
The viewer's eye should be directed from the foreground to the background of the scene, and forms should balance within the movement of your painting.

Framing
Once the subject of a painting has been determined, the next step is deciding how to bring out the best composition. A canvas can be horizontal or vertical and rectangular or square. Each shape and orientation affects the composition.

FIELD OF VIEW
Camera lenses are defined by their focal length: the lower the number, the wider the field of view. I set the field of view to approximately 90 or 100 degrees, which is similar to a human's natural field of view. A painting that mimics this range is more natural and less like a window view.

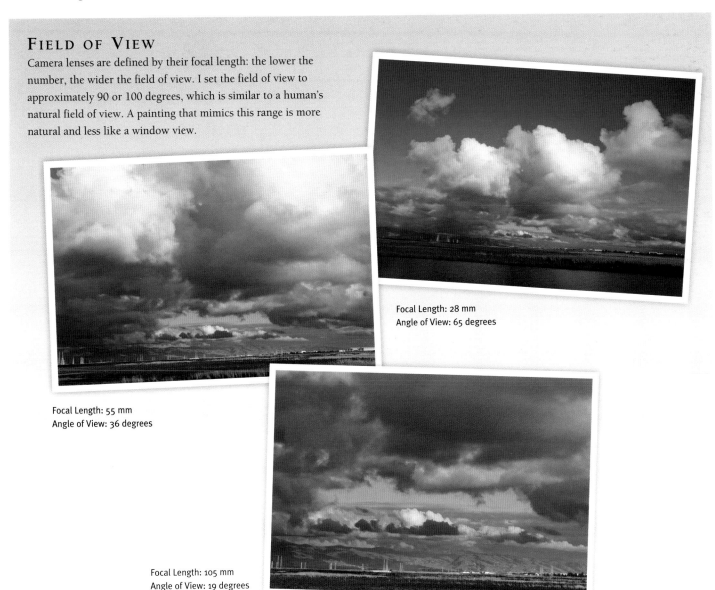

Focal Length: 28 mm
Angle of View: 65 degrees

Focal Length: 55 mm
Angle of View: 36 degrees

Focal Length: 105 mm
Angle of View: 19 degrees

Clouds in Motion

As an early winter storm passes over Owens Valley in eastern California, the valley floor is illuminated by bright sunlight while the distant mountains are blanketed in shadow.

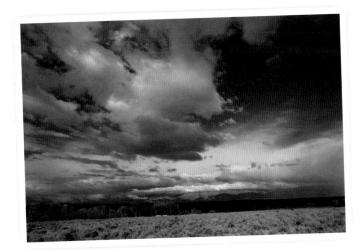

A wide-angle lens accentuates the receding bands of clouds as they bring snow to the White Mountains in the distance.

1. Create a simple line drawing with an HB pencil to define the major elements; then coat the entire surface with fixative so it won't smear or discolor the paint. (A felt-tip marker will bleed.)

2. Once the fixative has dried, fill the sky with a mixture of Prussian blue and ultramarine blue, with more Prussian blue, the cooler of the two colors, in the darker portion of the sky. As you approach the horizon line, predominantly use ultramarine blue with a bit of titanium white.

3. Paint the soft strata clouds in the distance with the lower-sky ultra-marine and titanium white combination, with additional titanium white and a dab of ivory black to naturalize it a bit. Smooth out the transition with a soft brush. The edges of the clouds will have a more finished appearance when the clouds are filled in.

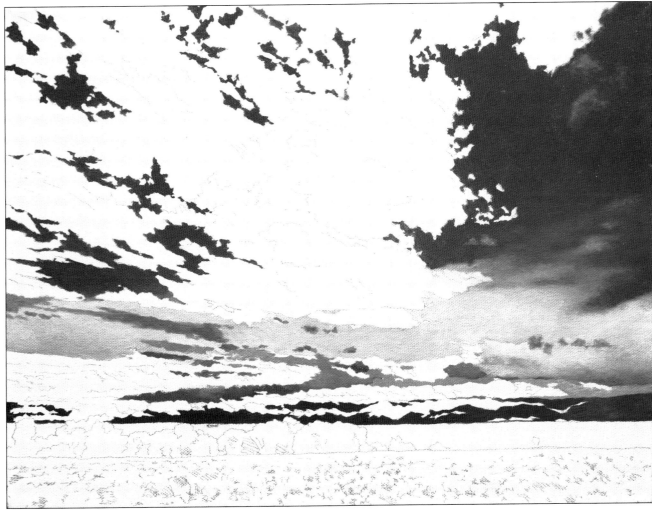

4. With ultramarine blue, titanium white, and touches of alizarin crimson and ivory black, establish the distant shadows on the mountains. Add a little vermilion and a bit more titanium white, and paint the undersides of the distant cloud. The band of strata clouds in the background can be filled in with a light blue-gray mixture.

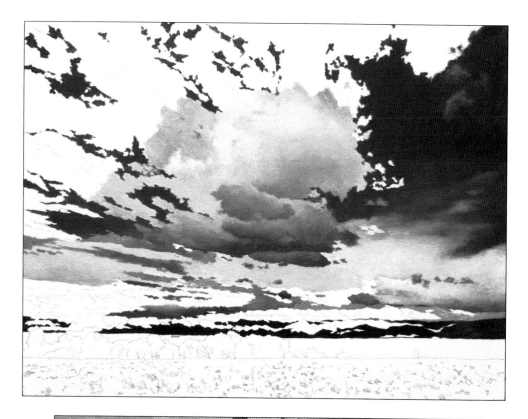

5. With ultramarine blue, vermilion, and titanium white, mix light, medium, and dark values for the clouds. Add more vermilion as the value of your mixture becomes lighter. If the paint color seems too saturated, simply add a touch of ivory black.

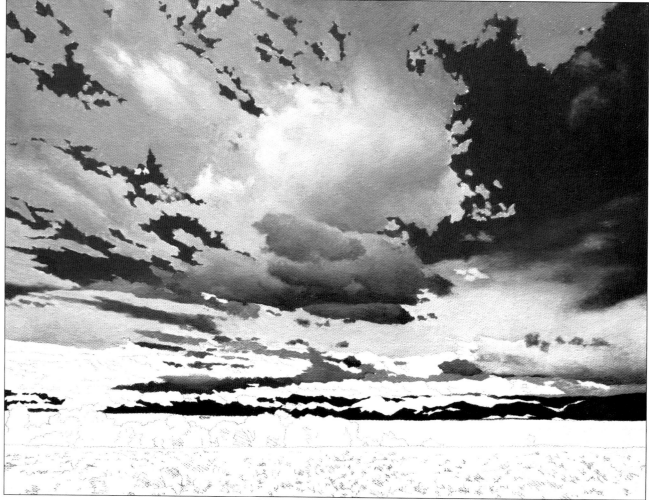

6. Re-create the clouds just as they appear. Blend their edges into the blue sky a bit so that they have a soft feel to them. If the sky appears too light or dark, now is the time to correct it. While the sky is still wet, refine the shapes and adjust the value of the highlights and shadows.

50

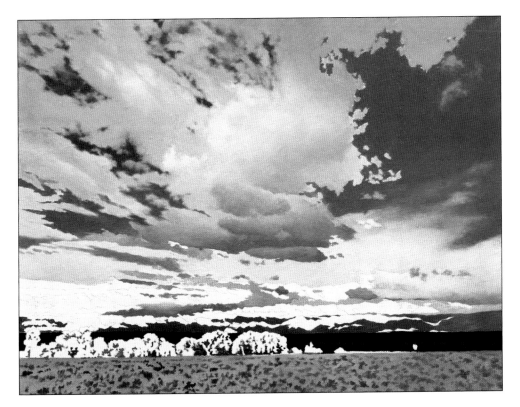

7. Now create a mixture with a slight red hue for the foreground area's under-painting with ivory black, vermilion, ultramarine blue, and a touch of the cloud mixture to lighten it. Fill in the distant hills and the dark band in front of the bluer mountains. Apply a wash of yellow ochre and Naples yellow light into the dark shapes in the foreground brush. With the same color, paint in the shadow areas of the trees.

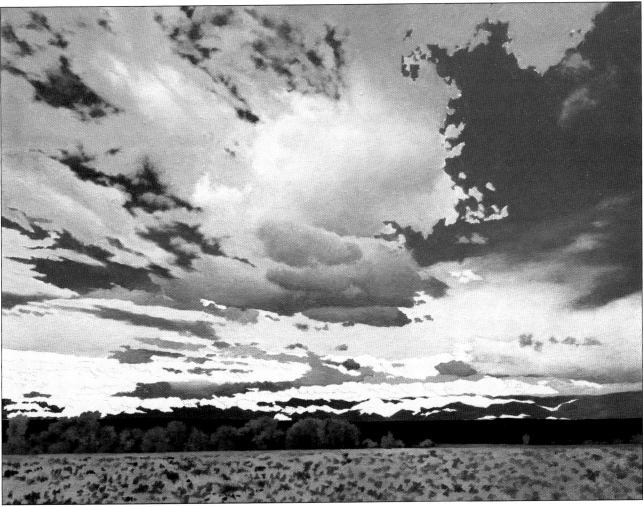

8. Fill in the trees with values of green mixed from Prussian blue, ivory black, yellow ochre, and Naples yellow light. Mix up more of the cloud values for the background clouds, but this time make the shadow color a bit bluer with ultramarine blue. With a small #2 sable brush or a well-shaped synthetic brush, carefully paint the small details. Next add the sunlight reflecting off the mountain tops. (See "Mountains Detail," page 53.) If painting with oil, let the canvas dry for a day or two before continuing. If painting with acrylic, it will dry much faster and you can continue to paint the same day.

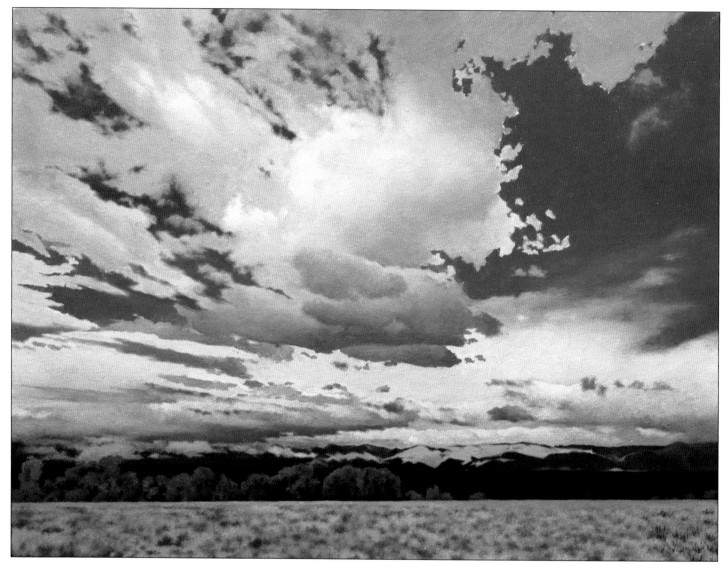

9. If you're using oil paints for this project, apply a light coat of re-touch varnish to bring out the color and to protect the underlying paint. Once this dries (about 30 minutes), add the final layer to the foreground brush. With a combination of ivory black, yellow ochre, Naples yellow light, and titanium white, carefully paint details into the plants and trees. Next, with a small brush, paint the contours and wisps in the leading edge of the clouds. Add a bit more vermilion and Naples yellow light to the lightest cloud value mixture. Use this new warm white color to go back over the lighter areas of the background clouds and to highlight the upper clouds.

DISTANT
MOUNTAINS

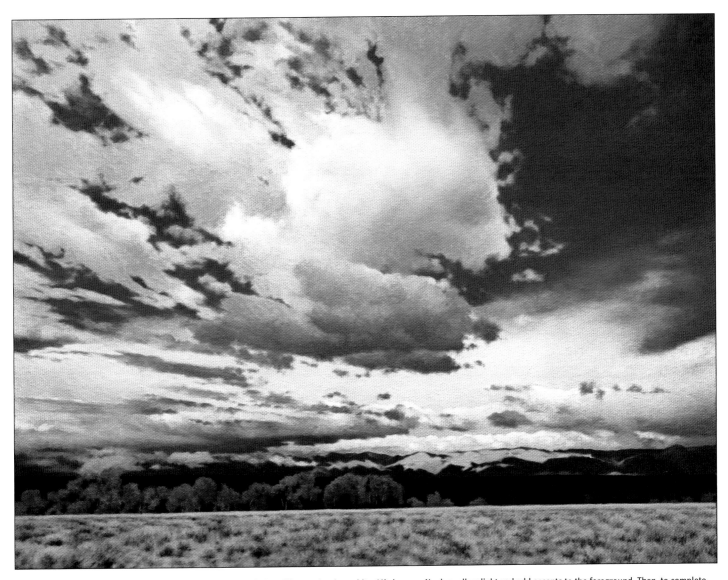

10. Finally, use a small detail brush to reinforce the cloud highlights with pure titanium white. Mix in some Naples yellow light and add accents to the foreground. Then, to complete the painting, add the tree trunks with a medium gray mixture.

MOUNTAINS DETAIL

For the sunlight on the mountains, use Naples yellow light mixed with a bit of the lightest sky color, which will give it an atmospheric appearance. With a little titanium white on the tip of a pointed brush, paint the brightest plains of light.

Illuminated Clouds

When the sun drops behind dark storm clouds the results are often dramatic, with sun rays streaming through the gaps to form columns of light known as crepuscular rays. This phenomenon is wonderfully apparent in this scene from Yosemite National Park.

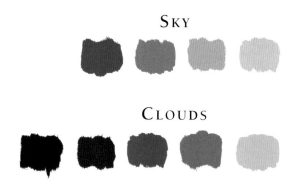

SKY

CLOUDS

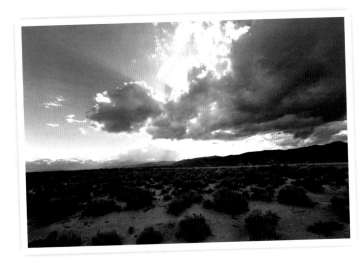

The 25-mile expanse between the photographer and the Pacific Crest in this photo demonstrates atmospheric perspective: The farther away an object is, the less defined it becomes, and the more it blends in with the (typically) blue-toned background colors.

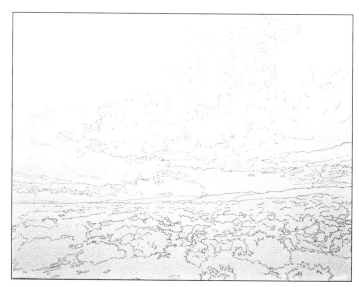

▶ **1.** Begin with a simple line drawing to define the major elements. Spray it with fixative to prevent it from smearing or discoloring when paint is applied. Allow it to dry.

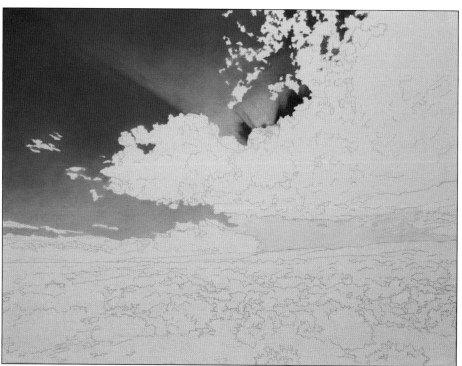

2. Fill in the sky with a blue mix of ultramarine blue, Prussian blue, and titanium white. Add more titanium white to the mixture as you work down toward the horizon, smoothing out the transition with a soft brush. The light rays should all radiate from a common point. Paint the area below the clouds with titanium white mixed with a touch of Naples yellow light.

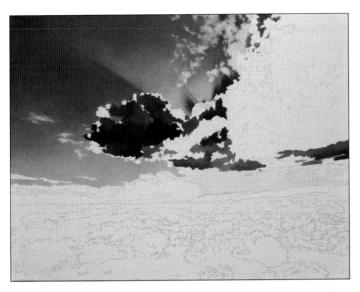

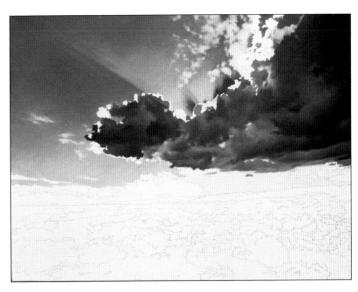

3. Mix a range of cloud colors with ultramarine blue, vermilion, alizarin crimson, and titanium white. Block in the values and shapes that make up the cloud structures. For highlighted areas, use the mixture of titanium white and Naples yellow light from step 2, and then blend the mixture into the sky.

4. Finish painting the dark clouds, defining the shapes of different values within them while the paint is still wet. The colors in the lighter areas of the clouds are warmer than the colors used for their undersides.

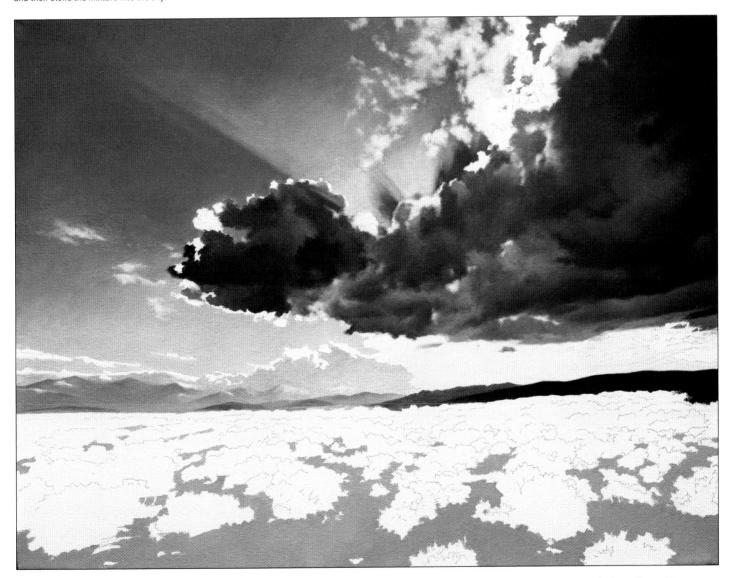

5. Next, paint the sky near the horizon line. A bit of warm-colored paint added to the sky color will make it appear to recede into the distance. Mix a touch of vermilion and ivory black into the sky color to give the clouds on the horizon an atmospheric appearance. Next add ultramarine blue and titanium white to the cloud mixture and apply it to the distant mountains. The hills to the right are filled with ultramarine blue, alizarin crimson, and ivory black. Add a touch of titanium white to the mixture to indicate how the mountains recede into the distance.

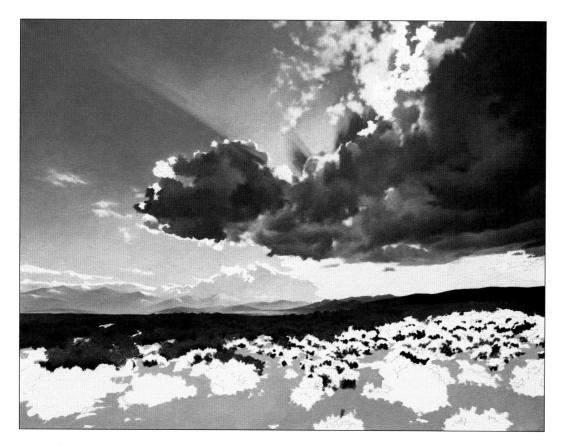

6. Paint the sagebrush below the horizon line with a medium-green mix of Prussian blue, ivory black, and yellow ochre. Use ivory black for the shadows in the foreground plants before filling them with green. For the cooler green in the distance, add Prussian blue to the plant mixture. Then mix ultramarine blue, ivory black, vermilion, and titanium white to make a warm gray to fill open areas of sand.

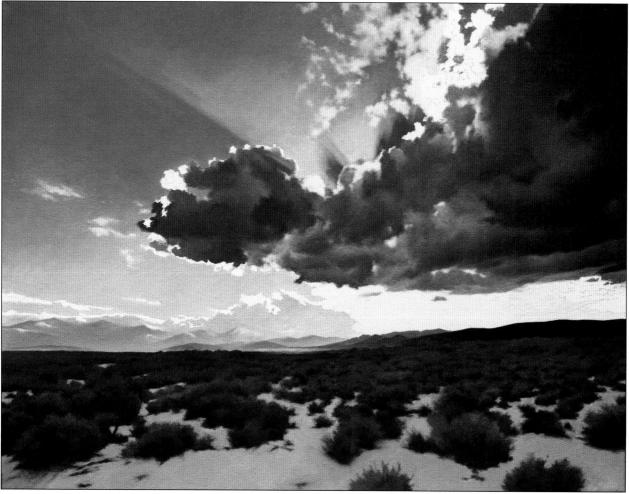

7. Fill in the rest of the foreground highlights with the green mixture and fill in the shadows with ivory black. Maintain a realistic scale, with the rows of plants diminishing in size as they recede into the distance.

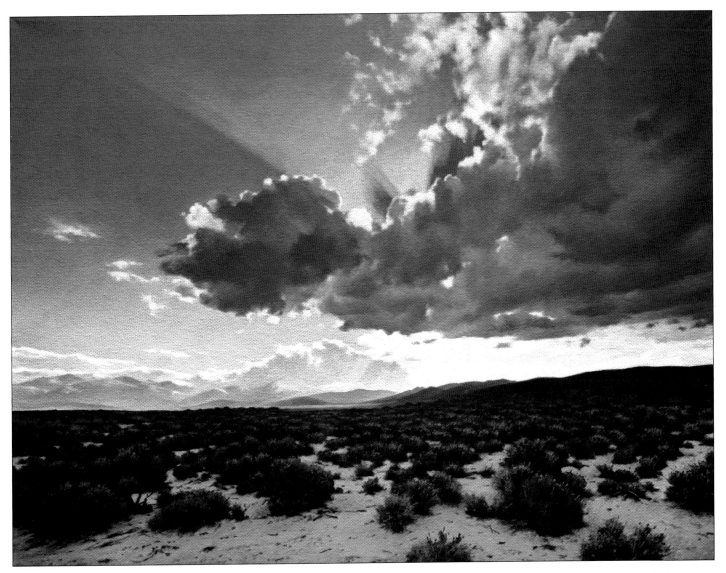

8. Now add the details that will to bring the foreground to life. Carefully paint over the light gray areas with the same color you used in step 6, adding a bit of ivory black or ultramarine blue for darker areas. Use a small, pointed brush to paint detail into areas where the edges of the plants meet the sand. Marks made with small gestures of the paintbrush will appear to be debris and twigs. With a lighter green mixture containing less yellow, go back over the sagebrush to add a few highlights where the sun rakes across the tops of the plants. Be subtle—overdoing it will distract from your center of interest: the clouds. Finally, with a small sharp brush, add a little titanium white to the clouds' edges.

SAGEBRUSH DETAIL

SAGEBRUSH AND GROUND

The soft bush edges are disguised by soft shadows. Add a few marks with a pointed brush to make them convincing.

Midst the Storm

Often the most adverse weather can be the most visually interesting—a storm engulfing the entire sky in a dense blanket of gray can be breathtaking. Whether it be the ominous frontal systems of the Midwest and the tornadoes they spawn, or the winter storms of the Sierra that drop feet of snow, these dark, brooding forms bring an emotional quality with them. Their approach is an invitation to discovery.

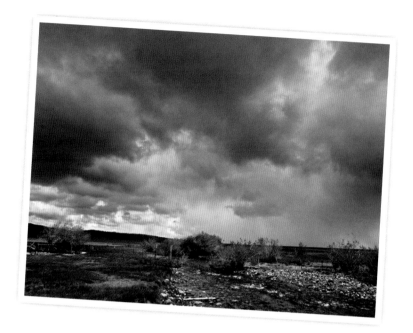

ARTIST'S TIP
The perception of color is relative: The palette swatches for this project may seem dark, but in the context of the painting, they range from light values to a medium gray.

CLOUDS

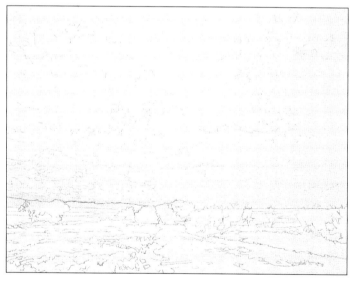

1. Start with a simple line drawing to define the major elements. Take the time to accurately portray scale and perspective. Spray with fixative to prevent smearing or discoloring when you apply paint, and allow it to dry.

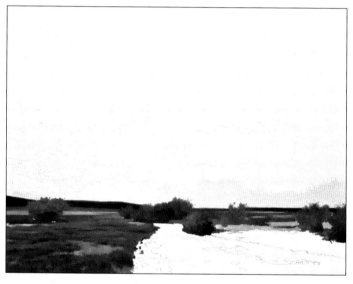

2. Paint the foreground first with greens composed of yellow ochre, Naples yellow light, ivory black, and Prussian blue. This will help set the overall value of the painting. Use a small, pointed brush to imply the texture of the foreground grass.

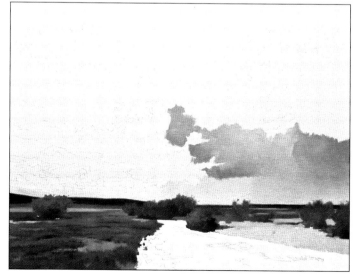

▶ **3.** Use Prussian blue, ultramarine blue, ivory black, and titanium white to mix a range of values for the clouds. Start at the horizon to establish the proper value and hue.

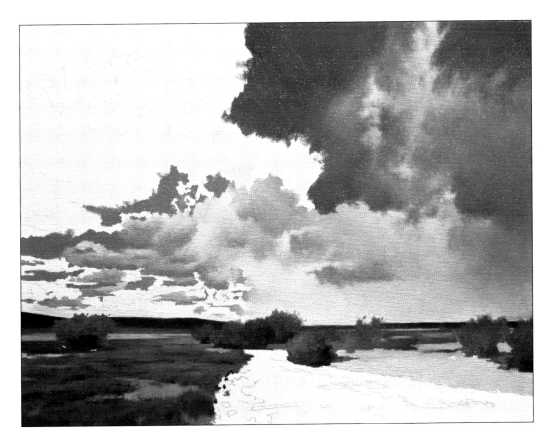

4. As you progress, pay attention to the details that define the clouds' shapes. Paint the undersides of the clouds with a slightly cooler shade than the lighter areas to give them a sense of volume. Carefully blend these transitions, giving the clouds a soft feel.

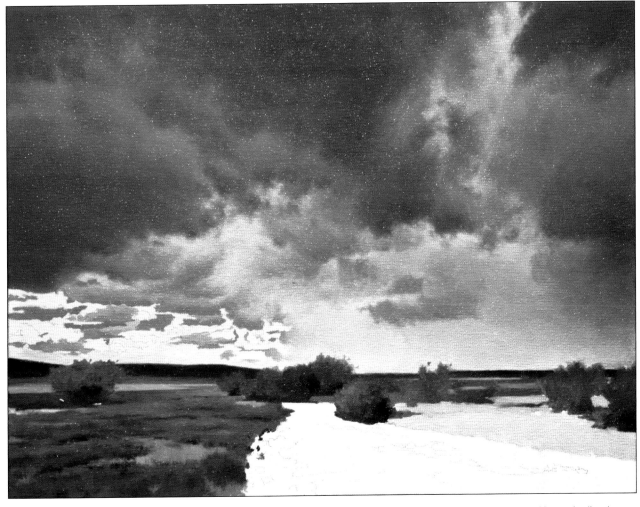

5. Work across the top of the painting with the darkest values in the paint mixture, blending transitions evenly. While the sky is still wet, add more detail to the forms and adjust the color where necessary.

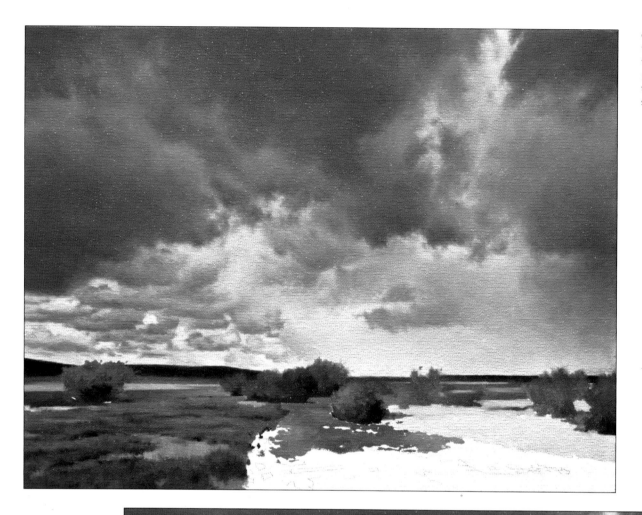

6. Now carefully finish the small clouds on the left with a small, pointed brush. Note the spots where blue sky peeks through.

7. Add a touch of ivory black to the upper cloud mixture; then use it to paint the stream. With a small, pointed brush, paint the shoreline on the left with the foreground color and ivory black, defining the outline of the rocks in the process. Define texture on the right of the shoreline with a mix of ivory black and titanium white.

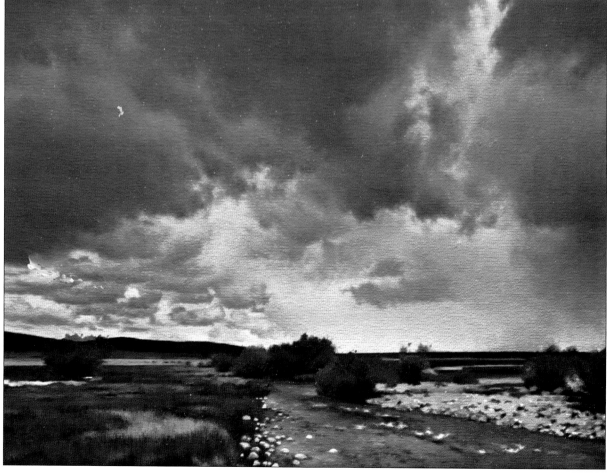

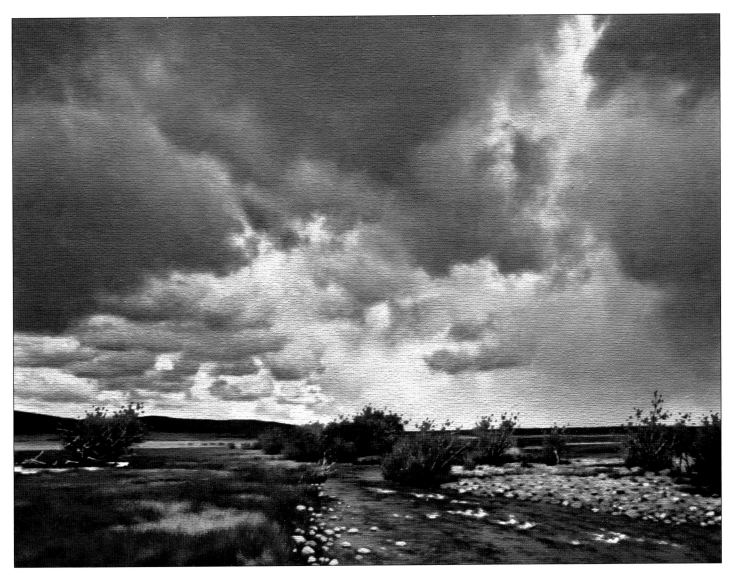

8. Next, begin to add detail to the foreground by refining the grass and bushes with a small, sharp brush for a more lifelike appearance. Add highlights to the stream, giving it a reflective quality. With a dry brush dipped in titanium white, scumble foam onto the water to add a sense of motion. For the shoreline, slowly build up the appearance of rock and debris around the bushes with short strokes of the paintbrush. Don't attempt to paint it all at once; take the time to get it right.

FOREGROUND

TREES

ARTIST'S TIP

A foreground composition that leads the viewer's eye into open space gives
the image a greater sense of depth and volume.

Dutch Sky

When the air is filled with moisture after a storm, the atmosphere takes on a subdued feeling. The first painters to create this sense of space were the Dutch maritime artists Aelbert Cuyp and Jacob van Ruisdael of 17th-century Holland. There was a large demand for accomplished painters during this period from the prosperous merchant class, whose members all wanted paintings of their beloved ships.

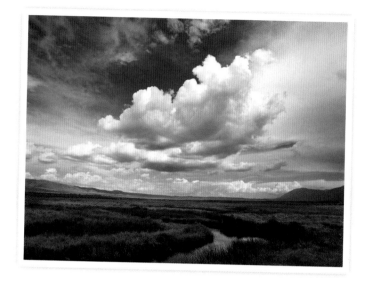

1. Start with a simple line drawing to define the major elements. Take time to portray scale and perspective accurately. Spray with fixative to prevent smearing or discoloring.

CLOUDS

2. Fill in the sky with a mixture of ultramarine blue, Prussian blue, and titanium white. Add titanium white to the sky color for the soft strata clouds in the distance, using touches of ivory black to neutralize the color if it appears too saturated. With a soft brush, smooth out the transition in the sky and add titanium white highlights to the clouds.

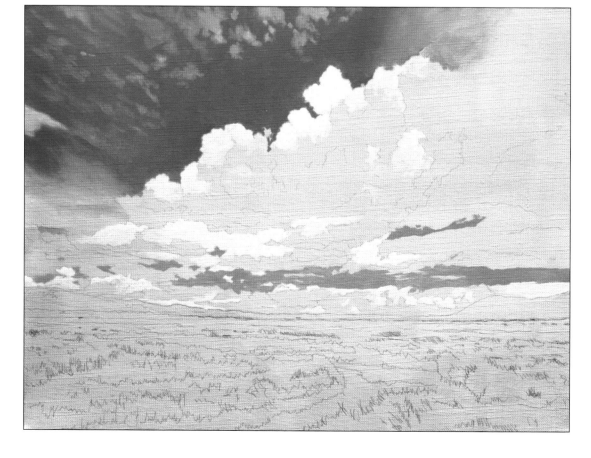

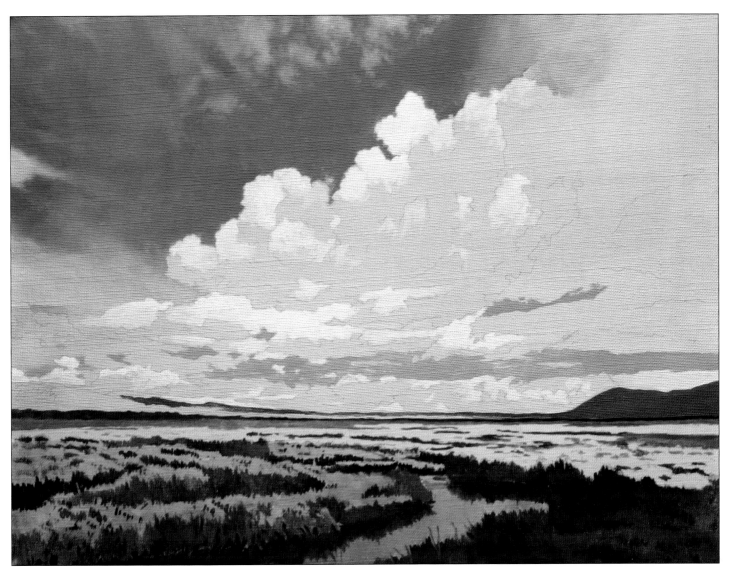

3. Fill in the stream with the blue sky mixture. Paint the shadows reflected in the water with ivory black muted with a bit of ultramarine blue, alizarin crimson, and titanium white.

FOREGROUND DETAIL

FOREGROUND

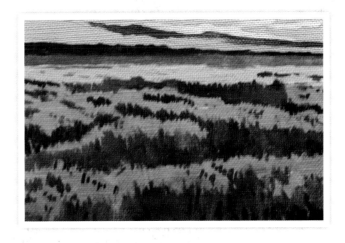

Start working on the foreground by applying a wash to the light and dark areas of the grass with a mixture of ivory black, yellow ochre, and Naples yellow light.

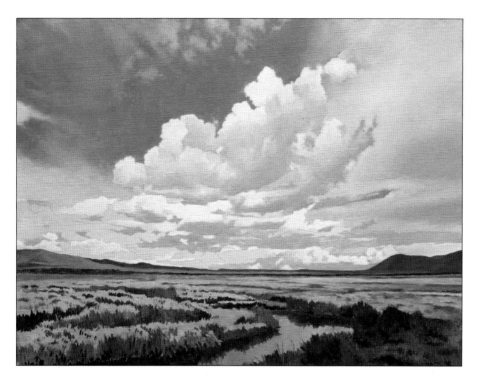

4. Mix a range of neutral grays from ivory black and titanium white with just a touch of blue from the sky mixture; then use it to define the dark shadows in the clouds. Be careful not to overdo it, as the sky should maintain a light appearance. Fill in the altocumulus clouds on both the right and left, blending them into the sky with a soft sable brush. Then paint the distant hills to the left and the mountain to the right with a mixture of ultramarine blue, ivory black, alizarin crimson, vermilion, and titanium white.

5. Mix three values of green for the foreground using ivory black, yellow ochre, and Naples yellow light. With a small, sharp brush, apply vertical strokes to create the grass texture, increasing the amount of Naples yellow light in the mixture as it recedes into the distance.

6. Create a light blue-gray mixture with ultramarine blue, ivory black, and titanium white for the clouds on the horizon. With a small, pointed brush, carefully define the detailed shapes of cloud banks. Then paint the undersides of the center cumulus clouds with a darker shade of blue.

S K Y

M O U N T A I N S

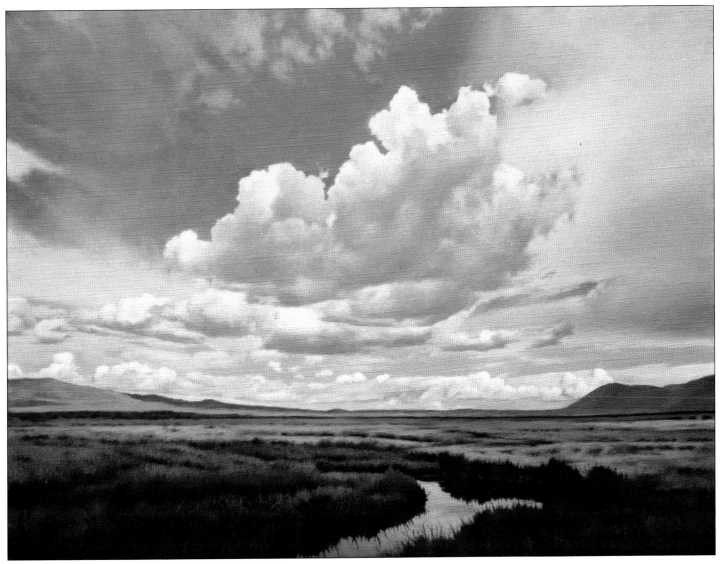

7. Using the palette from the previous step, further refine the cloud details, letting both soft and hard edges define their forms. Add a touch of Naples yellow light to your whites to give the sunlit areas a bit of warmth. If painting with oil, let the painting dry for a day or two to make sure your whites are dry; then spray it with a light coat of retouch varnish to bring out color and protect it. If you're painting with acrylic, the surface will dry much faster and retouch finish will not be necessary. Once dry, add details to the grass, the blades defining the edge of the stream, and the edges of the lighter shapes with a small, pointed brush. Use titanium white to define a few hard edges on the clouds at the horizon.

Twilight in the Wilderness

Artists studying at the Hudson River School—the first recognized art school in the U.S.—sought to capture the grandiosity of the American landscape in their work. Frederic Church was among these artists. He elevated these early depictions by incorporating the effects of light on water and in the sky and by expanding the visible horizon. Church's 19th-century painting, Twilight in the Wilderness, is one of my favorite works, and it serves as the inspiration for this project.

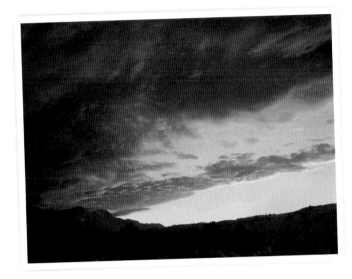

◄ By combining several images, you can create your own composition. The sky and landscape at left are two separate images taken at similar times of day and with the same orientation to the sun.

1. First brush a heavily diluted wash of a light gray mixed from ivory black and titanium white over the canvas. If working in oil, allow the wash to dry overnight. Once the wash is dry, compose a simple line drawing to define the major elements. Spray with fixative to prevent smearing or discoloring when paint is applied, and allow it to dry.

2. Create an underpainting for the foreground with the general colors you see in the photo reference. For the trees, use ivory black and cadmium orange, and mix vermilion, alizarin crimson, ivory black, and titanium white for the distant mountains.

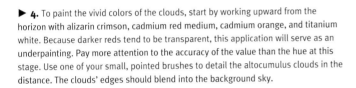

3. Examine the contrast between the shadows of the foreground and the luminance of the horizon. This will lead to selecting a mixture of ultramarine blue, alizarin crimson, vermilion, Naples yellow light, and titanium white to fill in the open areas of the sky.

CLOUDS

SKY

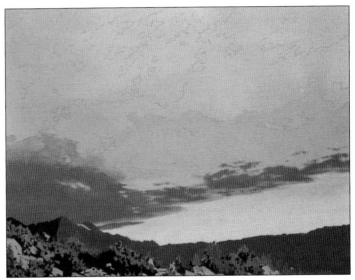

▶ **4.** To paint the vivid colors of the clouds, start by working upward from the horizon with alizarin crimson, cadmium red medium, cadmium orange, and titanium white. Because darker reds tend to be transparent, this application will serve as an underpainting. Pay more attention to the accuracy of the value than the hue at this stage. Use one of your small, pointed brushes to detail the altocumulus clouds in the distance. The clouds' edges should blend into the background sky.

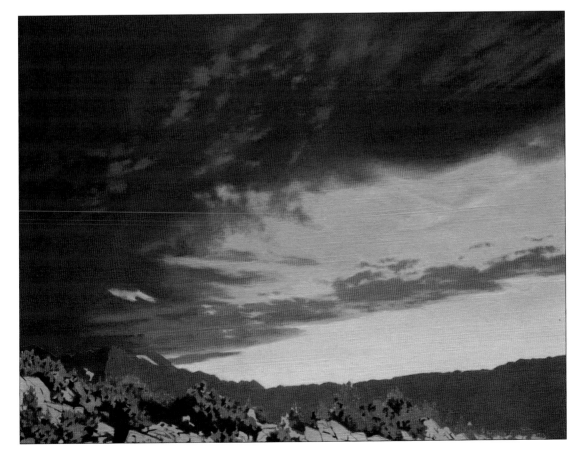

5. Continue to paint upward into the clouds: First lay in the brighter highlights, and then fill in the darker values around them with either a soft sable brush or a bright size 6. The color transitions are very subtle. Working wet into wet will help the colors blend smoothly. Blend the edges when necessary within the different layers of cloud clusters.

6. Now that the sky's values have been determined, focus on the darkest areas. Apply a mix of ivory black, cadmium red medium, and cadmium orange to the trees and brush in the foreground. This area appears black, but there is a slight variation in color that defines the forms within it. Don't be afraid to exaggerate this a bit. The entire painting should be suffused with a warm, rich feeling of saturated color. The touch of red will push the forms forward in space. Add the details to the ridge-line on the right with a bit of ivory black mixed with ultramarine blue and a touch of titanium white.

MOUNTAINS

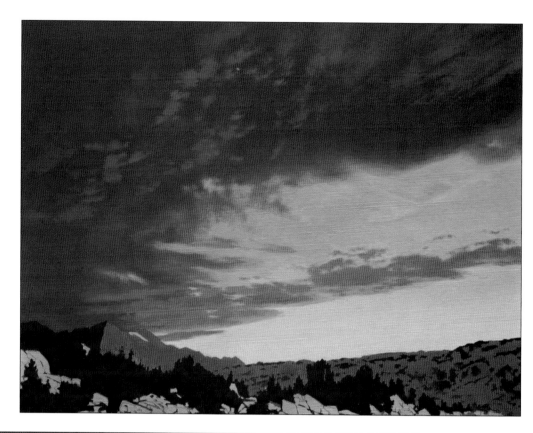

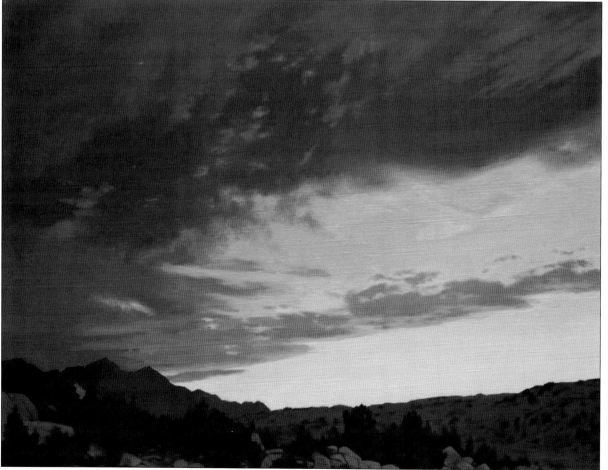

7. Continue to establish the contrast in the composition. Carefully finish the rocks along the bottom edge of the painting using a small, pointed brush and a mixture of ultramarine, cadmium red medium, ivory black, and titanium white. With a color that's a shade darker than the rock mixture, fill the ridgeline on the right. The final value of the mountain on the left can be established with cadmium red medium mixed with a touch of ultramarine blue and ivory black, which will de-saturate the red hue. With a thin wash of a blue-violet mixture, cover areas where blue sky peeks through the clouds in the upper-left corner of the painting.

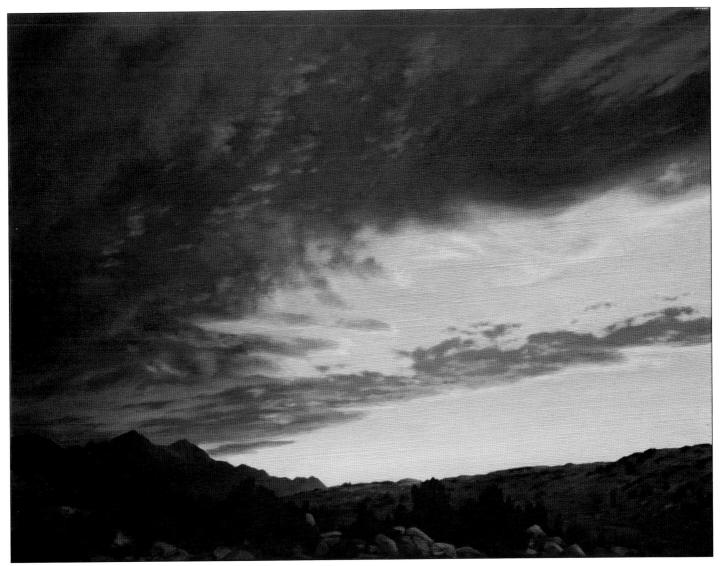

8. With successive layers of color, gradually find the right values and hues for the finished painting. The darker red, which is the midtone of the clouds, is composed of alizarin crimson, cadmium red medium, and a touch of ultramarine blue. With alizarin crimson, ultramarine blue, and a touch of ivory black, paint the shadowed areas in the upper-right corner of the sky. With a mixture of Naples yellow light, cadmium orange, and titanium white, highlight the lower edges of the clouds. Next, revisit the rocks in the foreground and right-side ridge with a small, pointed brush, refining detail with a diluted wash of color. I've decided to darken the mountain on the left so that it coincides more successfully with the intense color of the sky.

FOREGROUND DETAIL

FOREGROUND

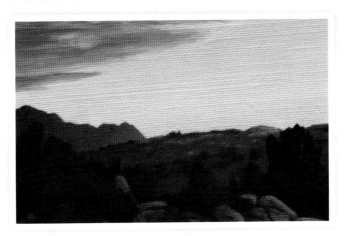

Dabble cadmium orange with a small, dry brush onto the areas catching the last rays of light. To depict the cracks and faces of this mountain, apply dark red with a small, sharp brush. Lastly, add a few bright dashes of cadmium orange where the sunlight catches on the rocks along the ridge near the painting's center.

Clouds at Sunset

As the day passes, clouds gradually take on warmer, more saturated tones. The moment the sun meets the horizon and its rays are distorted by Earth's atmosphere, the sky appears to burst into flame. The more moisture or dust in the atmosphere, the greater the intensity of color.

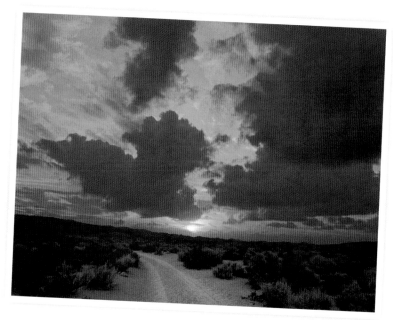

▶ **Studying Form** By organizing clouds' awkward shapes into an appealing composition, our attention is drawn to the overall feeling of the space and not the specific forms.

1. Before sketching, paint the canvas with a heavily diluted dark sienna wash mixed from ivory black and cadmium orange. Let it dry (overnight if painting with oil). By applying this neutral midtone to the canvas, the sky color will appear as a highlight. On a white canvas, the blue would appear to be dark. This allows you to better judge color values as you proceed. Next, define the major elements with a simple line drawing. Take time to portray scale and perspective accurately. Spray the surface with fixative to prevent it from smearing or discoloring when paint is applied, and allow it to dry.

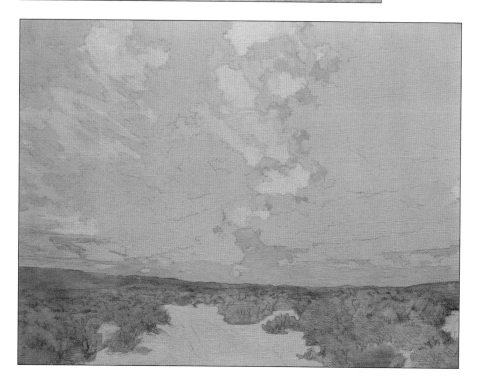

ARTIST'S TIP
Given the intensity of color at sunset, include cadmium orange and cadmium red medium in your palette of colors.

2. Begin to establish the basic values of the scene in their appropriate hues. Add a touch of ultramarine blue and alizarin crimson to titanium white for the sky. Use a mix of cadmium orange and titanium white for the sunset, and paint a wash of ivory black mixed with a bit of cadmium orange over the brush.

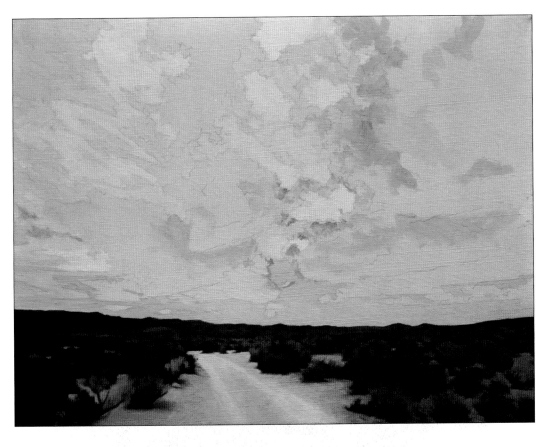

3. Paint the sagebrush below the horizon line to define the level of darkness the painting will have. Mix several dark values of green using ivory black and cadmium orange. Block in the shadows with ivory black first; then move to articulating the shapes with various shades of green. Use cadmium orange, Naples yellow light, and titanium white to create a warm color for the road, adding a touch of ivory black in areas of shadow near its edges.

ARTIST'S TIP
Because color changes in sky scenes are often subtle, it may be helpful to test mixed colors for accuracy directly on the surface of the reference photo.

CLOUDS

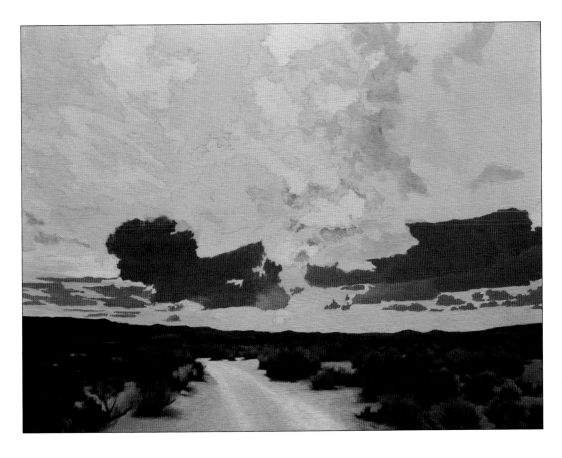

4. By beginning with clouds at the horizon and working upward, the accuracy of the values will be more apparent. These clouds are a range of colors mixed from cadmium red medium, cadmium orange, alizarin crimson, and touches of ultramarine blue added to reduce saturation when needed.

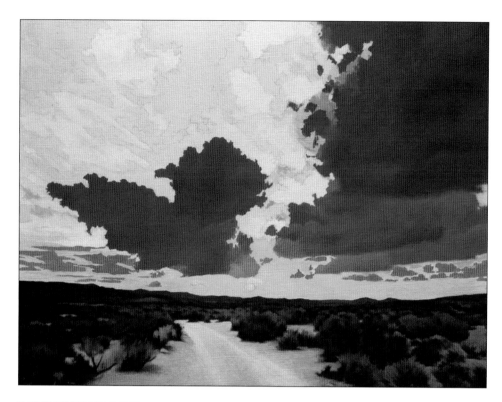

5. The clouds become darker toward the top of the frame with a predominance of cadmium red medium and alizarin crimson with cadmium orange or ultramarine blue added, depending on the desired value. A touch of titanium white will reduce the saturation when needed.

S K Y

R O A D

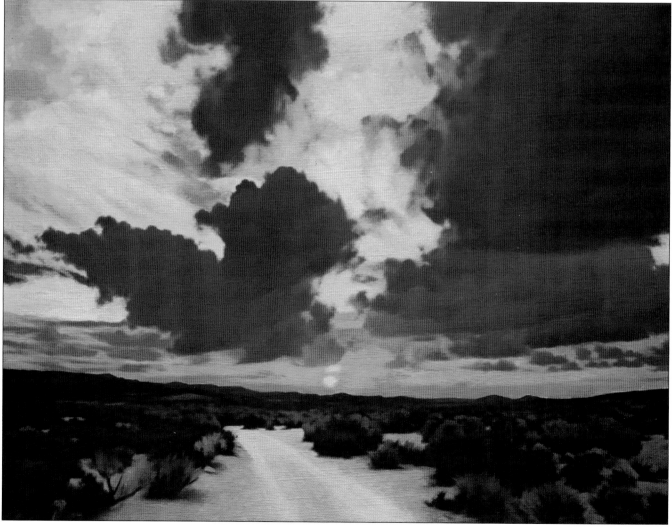

6. Employ the wet-into-wet technique to paint the lighter areas of clouds and the sky. For the sky, use a small amount of ultramarine blue and alizarin crimson mixed with titanium white, adding a touch of cadmium orange toward the horizon. The lightest clouds are painted with cadmium orange and titanium white. With a short brush, blend the clouds' soft edges.

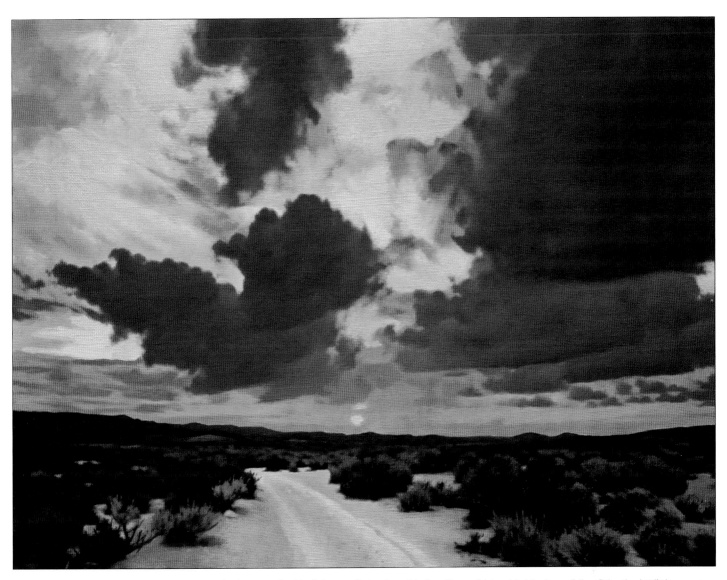

7. Allow the painting to dry and then, if working with oil paints, spray it with a light coat of retouch varnish. Once the varnish has dried, begin carefully refining the details in the foreground brush with a combination of ivory black, cadmium orange, Naples yellow light, and titanium white. Next, employ the scumbling technique to add detail to the highlights in the bushes, making them appear more realistic. Using the same technique, work texture into the road with slightly lighter and darker values of the color you used in step 3. Make a final pass over the clouds, adding detail to the edges and bringing their hues into balance. With just a touch of color and a little painting medium, blend smooth transitions between colors in the clouds and sky.

ARTIST'S TIP

Long wavelengths of light from the sun, which are red in nature, penetrate the atmosphere at sunset, infusing the landscape with warm colors. Even colors that appear green are actually composed of unsaturated reds and oranges.

CHAPTER 4

Sunsets

WITH TOM SWIMM

For thousands of years, people have watched in awe
as the setting sun lights up the sky and clouds with a
palette of indescribable color. Painting a sunset is both a
challenging and exciting endeavor for artists, as the color
possibilities are infinite and the mood can be somber or
glorious. There are no rules for how to do it, but there are
disciplines that can help you capture emotion and a sense
of reality. Working step by step, you'll see how subtle
color application and different brush techniques can alter
the feeling of a sunset landscape or seascape. In addition
to experimenting with these lessons, I encourage you to
spend time studying sunsets in detail to uncover all of the
incredible nuances of light and color.

Basic Techniques

Here are a few methods for applying and blending color that can be used for both oil and acrylic painting. You can combine and vary these methods in many ways to achieve a range of results. Try experimenting on a blank canvas to get a feel for how these can be used in your paintings.

GRADATION
Load your brush and apply a thick layer of paint. Then, using medium, allow the paint to thin out as you near the bottom of the canvas.

SCUMBLING
Load your brush with a small amount of paint (without thinning) and apply in a circular "scrubbing" motion.

DRYBRUSH
Wipe your brush so that only a small amount of paint remains and use sweeping motions to apply it to your canvas.

▶ UNDERPAINTING
Applying an initial layer of paint to your canvas—called an "underpainting"—tones subsequent layers and creates harmony in a painting. Work from dark to light, allowing some of the previous layers to show through.

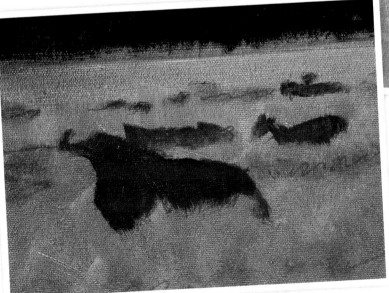

◀ SILHOUETTE
Foreground shapes are usually darker and less defined when backlit by the setting sun, but they still have subtle color variations. Avoid the tendency to paint these as "black" two-dimensional shapes. You can see that these animal silhouettes have touches of red, brown, and green, even though they are very dark and lack detail.

Sunset Techniques

Y ou will learn many ways to capture sunset colors in the lessons of this book, but below you'll find a few examples that show how color application can create depth and drama.

COLOR HARMONY

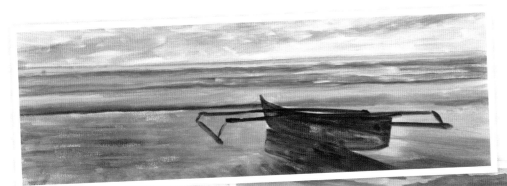

Establish the darkest values and shapes with a solid underpainting. Keep it loose and spontaneous at this stage and don't overwork the details.

Notice how a thin wash of warmer colors complements the cooler underpainting and allows it to show through.

LAYERING

Here's another example of how an underpainting can create a unifying effect. In the first image, I established the basic shapes and colors. In the next image, I added stronger color and softened the edges to create a very realistic mood without a lot of detail.

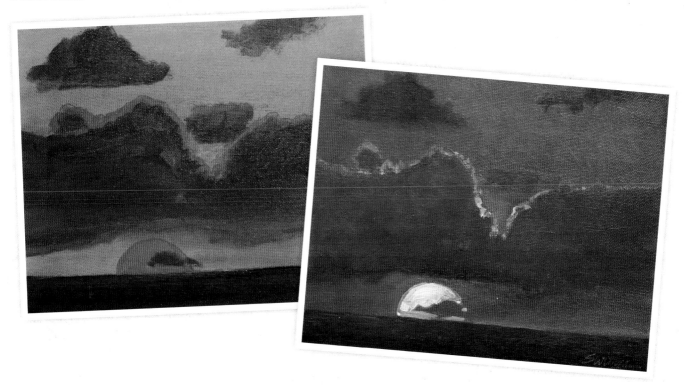

California Coast

I have always found inspiration in sunsets. It used to be difficult, however, to photograph them without losing definition in the shadow areas. With today's digital cameras, capturing nature's true colors and fine details—important elements when trying to reproduce them in a painting—is a possibility.

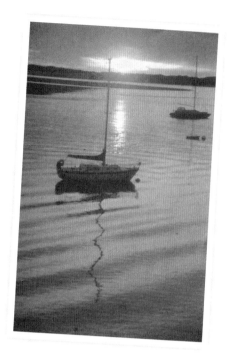

PALETTE

Original painting done in oil

alizarin crimson • cadmium orange • cadmium red light • cadmium yellow light
cerulean blue • dioxazine purple • permanent blue • phthalo violet • Prussian blue
raw sienna • titanium white • ultramarine blue • yellow ochre

▶ This photo was taken in Morro Bay, along the Central California coastline. After taking several sunset photos, this one turned out the best. It captured the mood and color of the fading light, and I also liked the way the yellow of the sunset's reflection accentuated the contrast of the deep blue ocean.

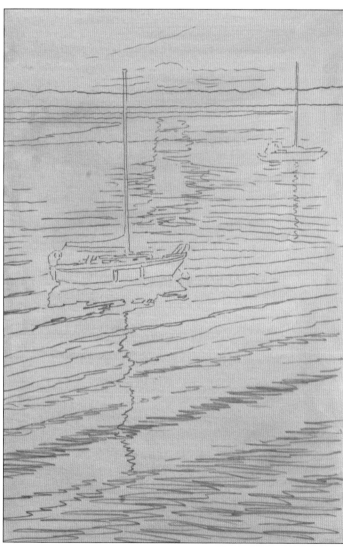

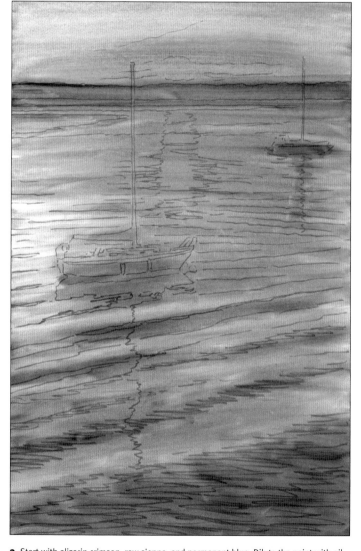

1. Using a felt-tip marker, start with a simple sketch to define the major elements. After the sketch is complete, cover the entire canvas with a thin coat of unbleached titanium acrylic. This gets rid of the bright white of the canvas and also seals the marker ink so it does not bleed into the oil colors later on.

2. Start with alizarin crimson, raw sienna, and permanent blue. Dilute the paint with oil painting medium #2 or a comparable alternative. Beginning with the sun, sky, and water reflections, block in large areas of color with a flat brush using raw sienna and alizarin crimson. Fill in the water, boats, and hills with permanent blue. Keep the paint thin and transparent, allowing the sketch to show through.

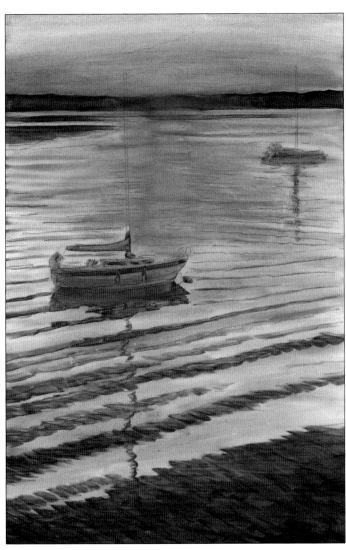

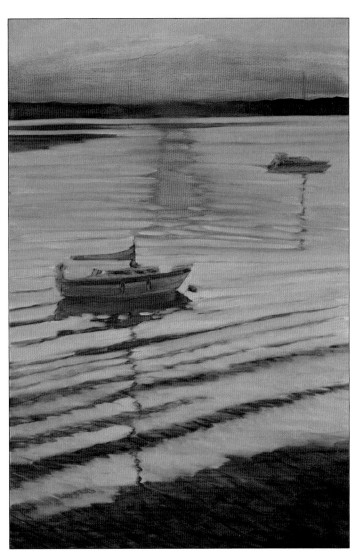

3. Add Prussian blue, ultramarine blue, and yellow ochre to your palette. Starting with the darkest area of water at the bottom, use Prussian blue to block in the large areas of color in the foreground. Mix in some of the other blue colors as well to give it variation. Use more paint and less medium, and crisscross your brushstrokes to simulate the ripples in the water. Do the same for the boats and the hills, using the edge of the brush to define details. Finally, add another layer of color to the sun, sky, and sun's reflection using the yellow ochre. Add some of this to the center portion of the hill and horizon as well and blend it at the edges.

4. With a large amount of permanent blue and white (two parts white to one part blue) on your palette, add contrasting color to the sky and water to create the shapes that will define the sunset. Load the brush and keep the paint fairly thick. Since most of the details are now defined, you can begin to cover some of the sketch lines that might be showing through. Start with the sky, blending the color into the sunset area, and then continue down the canvas, filling in the water.

ARTIST'S TIP
Try painting upside down! You will find that this technique makes visualizing the composition and proportions of the drawing easier. Try painting this way when working on areas that might be difficult to render. When you turn the painting right side up, the accuracy may surprise you.

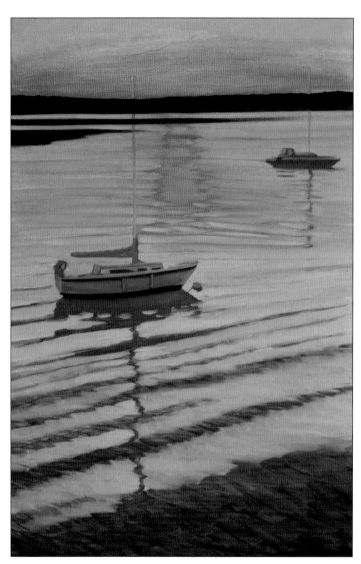

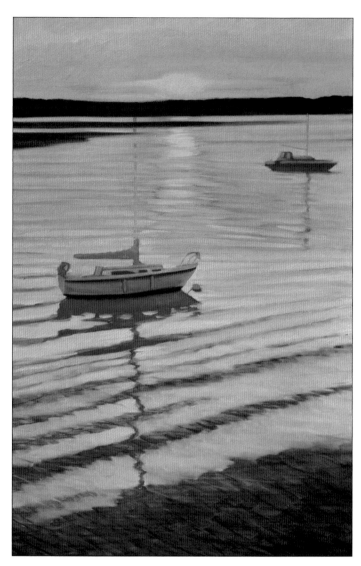

5. Beginning with the boats, "draw" details into the painting. Add cerulean blue to the palette and create a medium and a light value, mixing in white and permanent blue. Using the edge of a small flat brush, fill in the darkest shapes first. Start at the bottom of the large boat using Prussian blue for the length of the hull, and then add the windows and other details. Add crimson to the bottom of the boat and blend it into the reflections. Follow the same process to create the far boat, but use less detail; then redraw the masts with the edge of the brush. Finally, block in the hills and dunes in the water along the horizon using phthalo violet mixed with permanent blue, blending the edges where they meet the sky and water.

6. Premix the following four colors with white: dioxazine purple, phthalo violet, cadmium orange, and permanent blue. Using a large flat brush, start at the top and add another layer of blue to the sky. Work your way down the canvas, adding the violet and purple mixtures and blending the edges. Do the same for the water by using sweeping brush-strokes to define the ripples. Use the orange mixture and fill in the areas of sun, sky, and sun reflections. Painting over some of the mast details is fine, but be sure to leave enough to serve as a guide later on.

WATER DETAILS

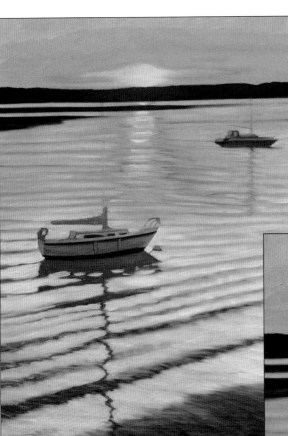

7. For this step, you'll fill in the areas of water with the brightest highlights. Mix permanent blue, white, and a little phthalo violet. Start at the bottom and use less paint as you advance to the horizon. Add another layer of color to the sunset and reflections using three colors: cadmium orange; cadmium orange and cadmium yellow light; and cadmium yellow light and white. Start with the middle of the hill at the horizon by applying cadmium orange and blending it into the existing color. Fill in the area of sun and reflections with the orange and yellow mixture. Using the yellow and white mixture, add another layer on top. Load the brush with thicker paint and add the same colors to the ripples in the water, blending as you go along.

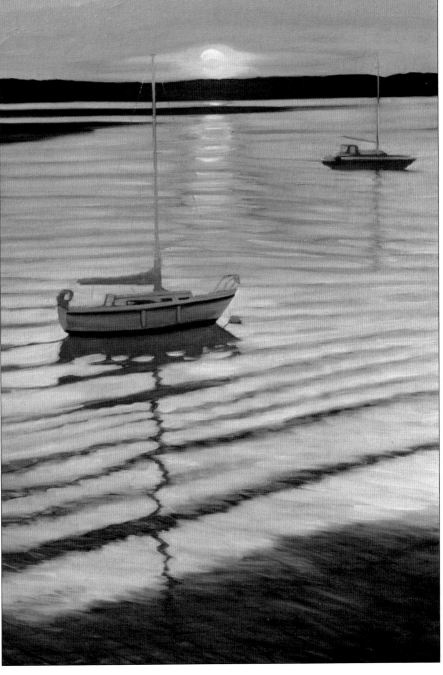

8. You're almost there! Using a mixture of phthalo violet and white, paint the masts by using the edge of the brush to pull the color down. To provide some variation, you can add a little blue to this as well. Be sure to hint at the boat rigging with a few randomly placed brushstrokes.

9. Next, heighten the intensity of the sunset by adding cadmium red light to the center of the hills and blending. Finally, use the yellow and white mixture to add more highlights to the sun and the brightest reflections in the water. Add a few flecks of the orange and violet mixtures to the boats to suggest reflections of the setting sun.

African River

The African landscape is unlike any other on earth. The colors of the sky have a rich quality that is unique to the continent, especially at sunset. The reference photo used for this lesson was taken while cruising on the Zambezi River near dusk. The hazy hills in the background and the soft fading light of the sun created a very inspiring mood. I also like the crisp, sharp reflections on the water. This is a perfect example of Mother Nature's glory!

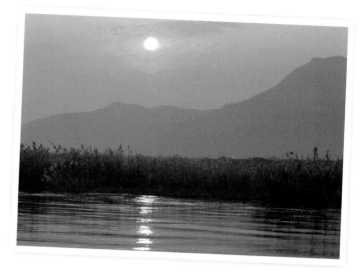

PALETTE

Original painting done in oil

alizarin crimson • brilliant yellow • burnt sienna
burnt umber • cadmium orange • cadmium red light
cadmium yellow light • dioxazine purple
medium magenta • Naples yellow • Payne's gray
permanent blue • permanent green light
phthalo violet • raw sienna
sap green • titanium white

1. Using a marker, sketch a minimum amount of detail onto the canvas—just enough to serve as a guide that will allow you to draw as you paint. Next, apply a thin layer of medium magenta; this underpainting will serve as a warm base color.

2. Now you'll define the major elements in the painting: the sky and clouds, hills, grassy marshland, and water. Dilute a large flat brush with a generous amount of medium, and then pick up the color and brush it on with loose, sweeping brushstrokes. Using raw sienna, start with the sky and section of water where the sun is reflected. Next, add permanent blue to the hills and water; then use a mix of sap green and Payne's gray for the grassy marsh area and the darker water reflections. Pull the blue into the lower portion of the sky and use it to define the clouds.

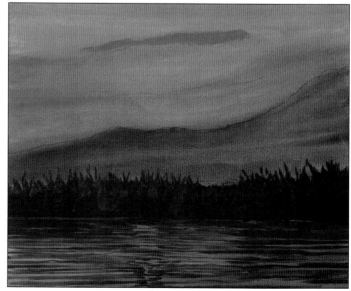

3. Load a flat brush with a thick mixture of sap green and alizarin crimson and block in the grass. Darken some of the area with Payne's gray, using the edge of the brush to establish the reeds of grass along the top. Use the same dark colors to establish ripples in the water. Distribute flecks of burnt umber to the tops of the marsh reeds.

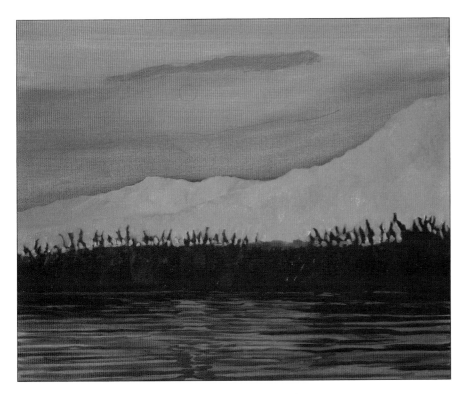

4. Add the following colors to your palette: equal parts titanium white, phthalo violet, and Payne's gray; equal parts permanent blue, titanium white, and Payne's gray; and permanent blue, Payne's gray, and a little bit of titanium white. Load the brush with the violet color and paint the distant hill on the left using random brushstrokes. Use the flat of the brush to define the top edge, varying the shapes to keep it realistic. Repeat with the second color. Then use the darkest shade and continue down the mountain, painting around the shapes of the reed at the top of the grassy area.

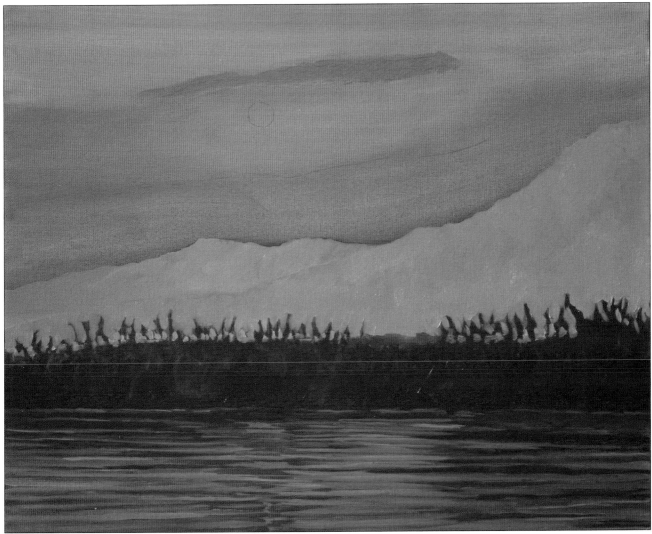

5. Next you'll create two colors. Mix phthalo violet, titanium white, and Payne's gray; then mix permanent blue, titanium white, and Payne's gray. Using thicker paint, introduce these colors into some of the gaps of color in the water reflections. Keep your brushstrokes fluid and horizontal and blend the colors into each other as you go along. The idea is to create variations of colors that will simulate ripples in the water.

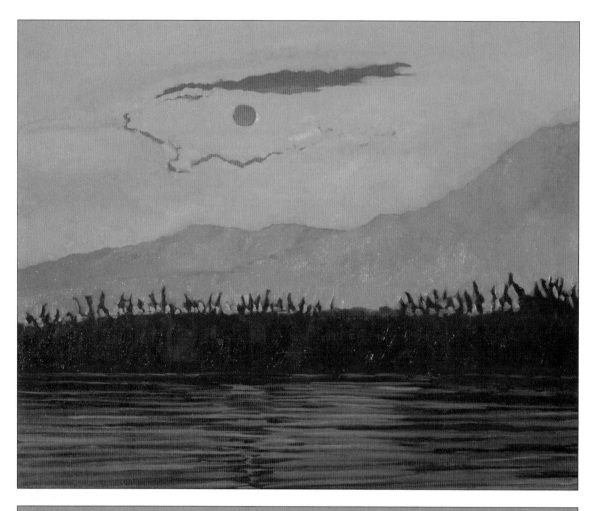

6. In this step, we'll begin adding color to the sunset. First, mix what's left of the violet color from Step 4 with an equal part of titanium white and a dab of cadmium orange. Next, mix one part cadmium red light, one part phthalo violet, and two parts titanium white. Be sure to mix generous amounts of these two colors so that you don't have to stop along the way and try to remix them. Start at the tops of the hills and work your way up, loading the brush with the first mixture and using the oil painting medium for a smoother flow. You can pick up a little bit of permanent blue as you go along to create variations. Then, take the second mixture and work it into the middle area of the sky, painting around the sun and the clouds.

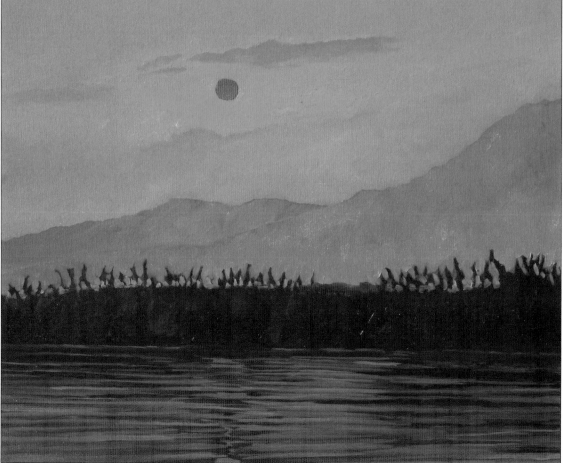

7. Here we'll blend and smooth out the sky. Mix one part titanium white and one part phthalo violet. Using a small flat brush, paint the darker cloud shapes that surround the sun. Use the reddish color mixture from Step 6 and work this into the existing paint.

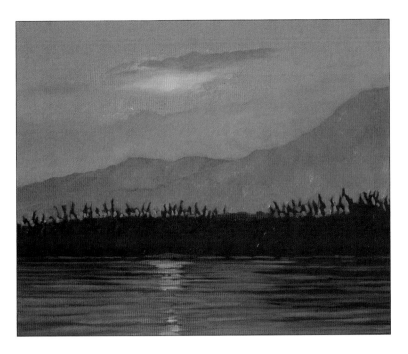

8. Add cadmium orange, cadmium red light, cadmium yellow light, and Naples yellow to your palette. Mix the orange and cadmium yellow light together. Using the edge of a smaller brush, fill in some of the highlighted areas in the middle of the water. To create the stronger reflected colors, use cadmium red light and cadmium orange. Next, load the brush with Naples yellow. Fill in the sun circle and blend the paint to create the yellowish "flare" in the middle.

9. Mix three colors in equal parts: permanent green light and cadmium red light; burnt sienna and Payne's gray; and burnt sienna and cadmium orange. Using a small brush, start with the greenish mixture and apply some highlights to the top and middle sections of the grassy area. Pull this color down into the darker shadows. Next, add the second color to the darker areas in the water reflections. Use the lighter brownish mixture to dab some additional highlights to the reeds.

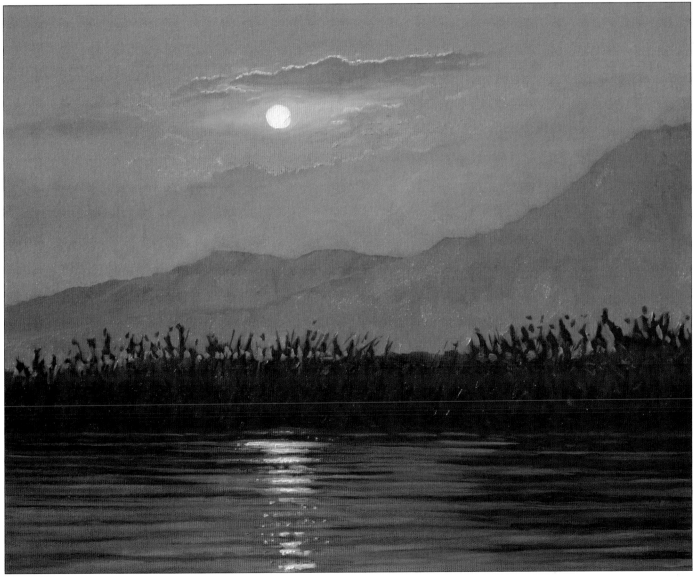

10. For the sky, add brilliant yellow to your palette and mix two new colors: titanium white with a dab of cadmium yellow light, and titanium white with a small amount of cadmium red light. Take the yellowish mixture and add color to the tops of the clouds above the sun. Do the same with the reddish mixture for the clouds below the sun. Tie these colors into the water reflections by adding some small, thick highlights and pinpoints of color. Finally, load the brush with brilliant yellow and fill in the sun circle with very thick paint.

Moody Pier

With their abstract architecture and textures, wooden piers make for interesting subjects to paint. I took a photo of this one just after the sun had disappeared below the horizon. The effect was very soft and warm—a little different from the strong colors and intensity of some of my other sunset compositions. I felt this would be a nice lesson for capturing a subtle mood.

PALETTE

Original painting done in oil

burnt sienna • burnt umber • cadmium orange
cadmium red light • cadmium yellow light
cerulean blue (hue) • dioxazine purple • flesh
king's blue deep • king's blue light
medium magenta • medium yellow
Payne's gray • titanium white

▶ **1.** Using a black felt-tip marker, render a sketch that captures the perspective and proportions of the original photo. Next, prime the canvas with a transparent layer of medium magenta acrylic.

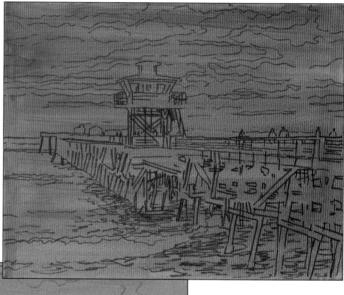

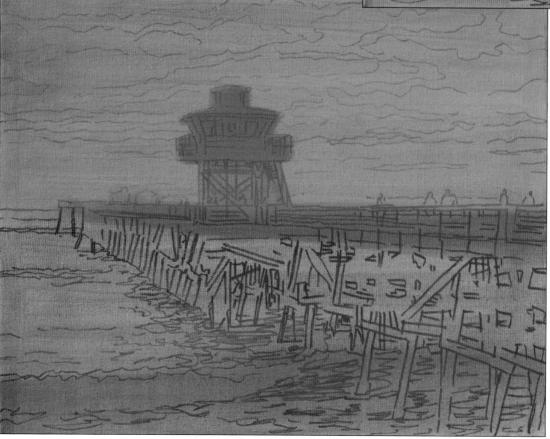

2. Add king's blue deep, cerulean blue, and Payne's gray to your palette. Dilute the oil color with oil painting medium so it brushes on easily. Using a large flat brush, block in the colors with a transparent wash. For the sky and ocean, use king's blue deep; then add cerulean blue to the waves in the foreground. Add a mixture of cerulean blue and Payne's gray to the upper part of the pier.

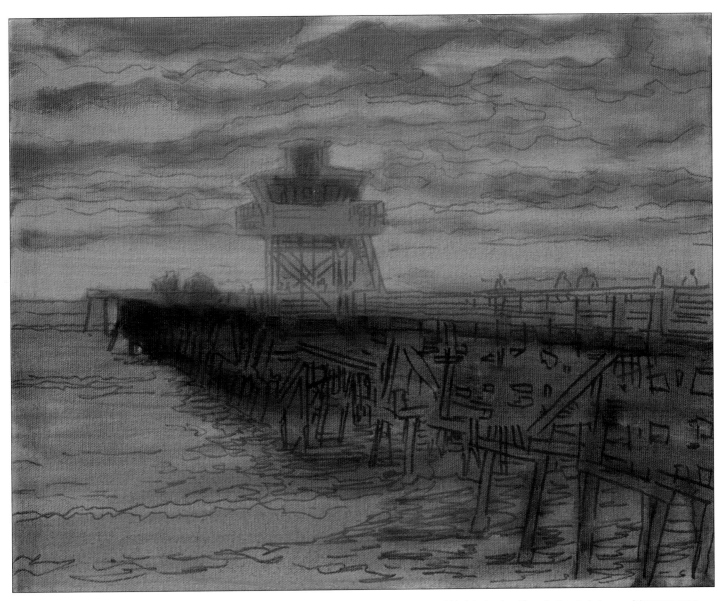

3. In this step, we'll contrast the cool blues with warmer hues. Mix equal parts burnt sienna and Payne's gray and block in the pier pilings. For the shaded areas of the tower, use a darker mixture by adding more Payne's gray. Next, add a dab of cadmium orange to the highlighted areas in the sky.

PIER DETAIL

You don't have to be concerned with staying in the lines at this stage, but make sure the paint is transparent enough to see the sketch beneath.

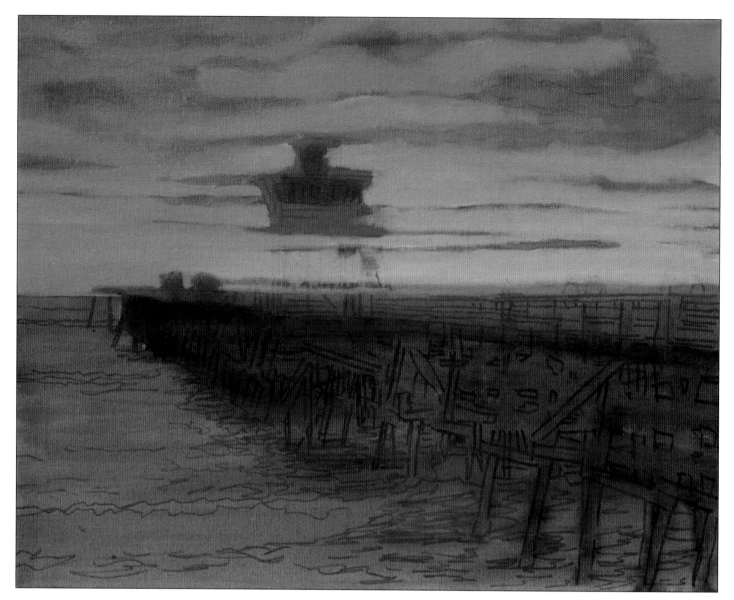

4. Next, we'll establish the cooler colors in the sky using thicker paint and a smaller brush. Begin with a mixture of two colors: equal parts king's blue light and titanium white. Load your brush and begin painting at the horizon line on the right-hand side; allow the color to blend with the orange underpainting. As you work upward, cover parts of the drawing, but leave some showing through as a guide for later. Then mix one part cerulean blue and dioxazine purple with two parts titanium white. Continue all the way to the top, using a drybrush technique for blending.

PIER DETAIL

Variations in brushstrokes and paint thickness will add interest and give the sky a luminous quality.

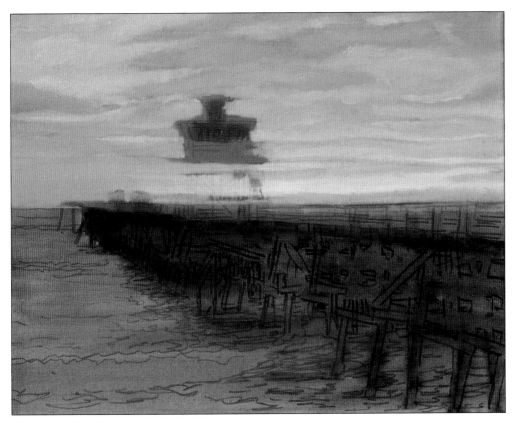

5. Fill in the cloud areas with a layer of underpainting to add depth and dimension. Mix one part cadmium orange with three parts titanium white. Using a smaller brush, work this mixture into the unpainted areas of the sky and clouds, softening the edges as you go. You can also use some of the blue mixtures from Step 4 to help define the shapes.

▼ **6.** Begin painting the ocean using three colors: the dark blue mixture from Step 4; equal parts king's blue light, cadmium orange, and titanium white (light gray); and equal parts king's blue deep, cadmium orange, and titanium white (dark gray). Starting with the dark gray, fill in the highlighted areas on the right side of the pier using random brushstrokes. Continue on the left with the light gray using horizontal brushstrokes for the water. Use the dark blue mixture to create more interest and variation in the foreground waves.

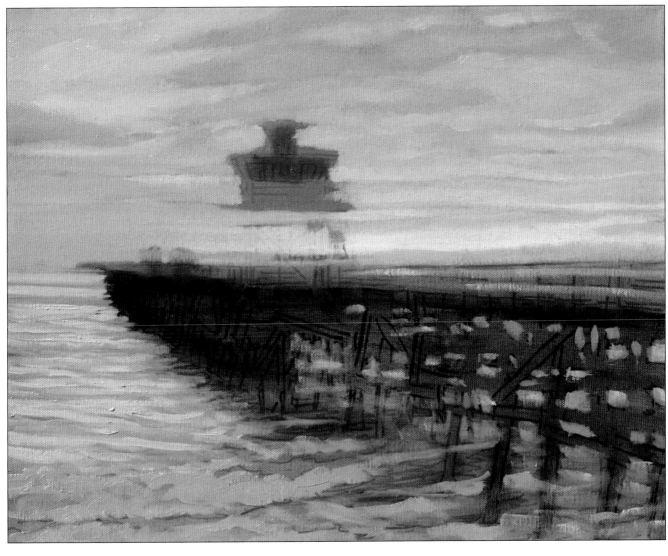

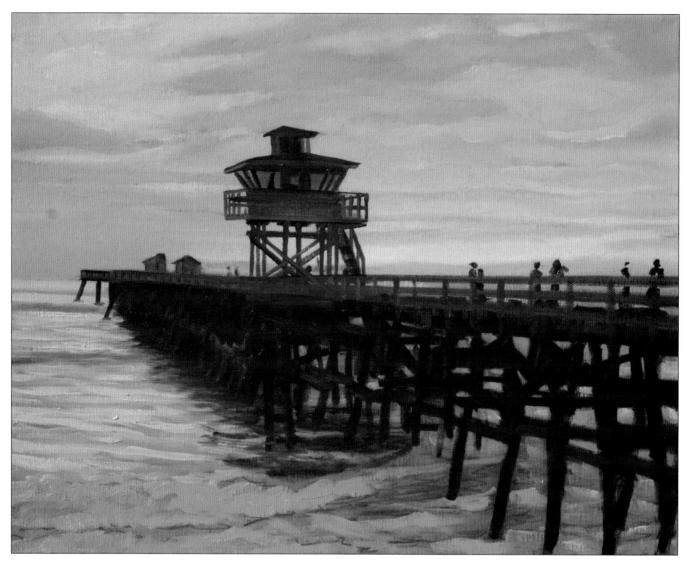

7. In this step, we'll begin painting the pier. First, add Payne's gray, cerulean blue, king's blue deep, and burnt umber to your palette. Using your smallest brush, sweep a mixture of king's blue deep and Payne's gray onto the left end of the pier. Referring to the photo, "draw" in the details using variations of light and dark color. Combine the burnt umber and Payne's gray for the darkest areas, allowing some of the highlights from previous steps to show through. Pull the darker colors into the ocean on the left to suggest a reflection from the pilings.

PIER DETAILS

After you've painted the ocean, some of the underpainting should still show through.

In these close-ups, notice the subtle variations of blue and gray. The figures are suggested with only a few dabs of color.

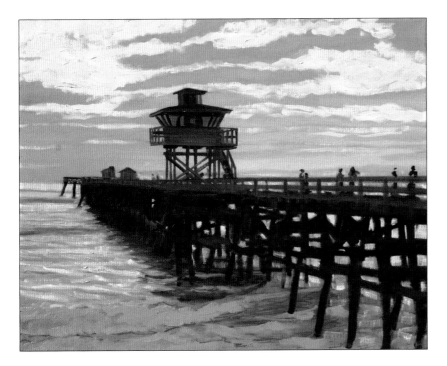

8. Adding another layer of color to the sky and water will enhance and harmonize your sunset. Mix three colors for this step: one part cerulean blue and four parts titanium white; one part flesh and four parts titanium white; and a combination of the first two mixtures. Begin with the first mixture and fill in the sky areas. You can use a larger brush, adding highlights and adjusting as you go along. Follow this with the flesh mixture for the tops and bottoms of the clouds. Use thicker paint and vary your brushstrokes, blending as you stroke. Use the third mixture for the ocean and brighten some of the highlighted areas where the water is showing through the pier.

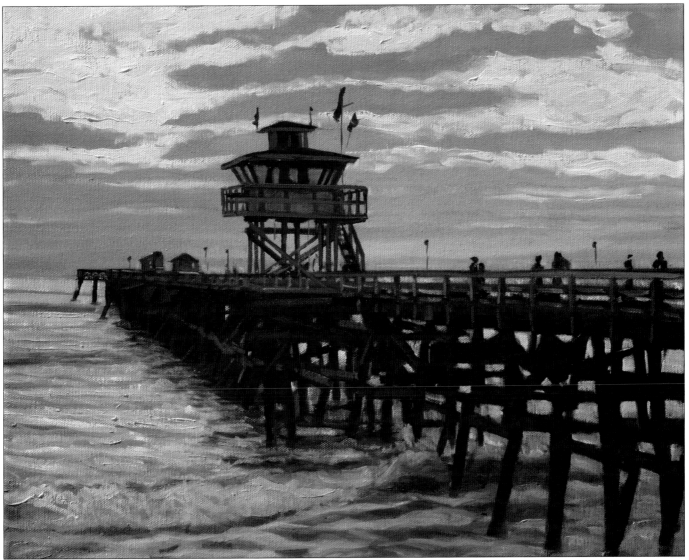

9. A few final details and touch-ups will complete your sunset scene. Rely on your artistic eye and instincts to create your own individual work of art. Scan sections and compare them to the reference photo to identify areas that need to be adjusted or enhanced. For instance, notice the darker contrasts underneath the pier and the bright orange flash of color on the wave in the foreground. Plan your final touches and colors based on the effects you want to bring to your painting.

New Mexico Mountain Sunset

The next time you view a sunset, study what the setting sun does to the objects and landscape behind you. A sunset scene doesn't always have to show the sun slipping below the horizon line. This scene I captured in New Mexico demonstrates cool shadows at the base of the mountain and a warm glow on the snow-capped peaks.

PALETTE

Original painting done in oil

alizarin crimson • burnt sienna • cadmium orange
dioxazine purple • flesh • king's blue deep
king's blue light • Payne's gray
permanent blue • raw sienna • sap green
titanium white • violet gray • yellow ochre

▶ **1.** This is a simple composition with very large shapes separated into three distinct areas: sky, mountain, and foreground. Using a felt-tip marker, draw the major lines and shapes while referring to the photo. Prime the canvas with a layer of unbleached titanium.

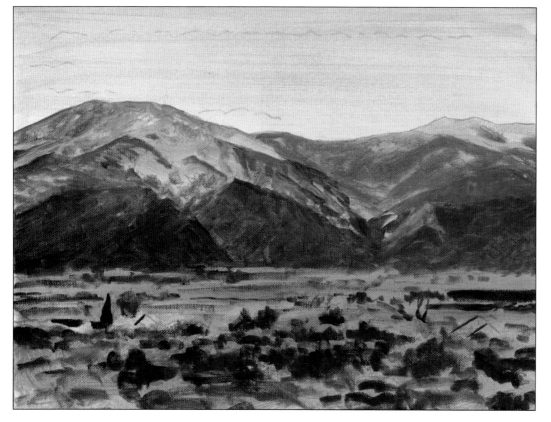

2. Next, squeeze five colors onto your palette: king's blue deep, raw sienna, burnt sienna, sap green, and permanent blue. With a large flat brush, thin the paint with oil painting medium and apply a wash of color to define and separate the largest areas of color. Use king's blue deep for the sky; permanent blue for the mountain base; burnt and raw sienna for the top of the mountain and the foreground; and sap green and burnt sienna for the foreground vegetation.

3. With the canvas still wet from Step 1, we'll paint the sky. Add king's blue light to the palette, as well as a mixture of alizarin crimson and titanium white. Load your brush with color and begin blocking in areas with the pink mixture. Vary your brushstrokes and let some of the blue underpainting show through. After that, blend some of the blue into the existing color. Use the side of your brush to soften the edges and define the line where the sky meets the top of the mountain.

4. Next, we'll work on the mountain range. Mix two colors on your palette: equal parts burnt sienna, dioxazine purple, and flesh; and the same three colors as before, with more flesh for a lighter, grayish color. Using a small flat brush, "draw" in areas of color using the photo for reference. Look at the subtle differences in the shapes and color intensity, using the dark color first, and then add further details with the lighter color. Notice that a lot of the underpainting from Step 2 is still visible.

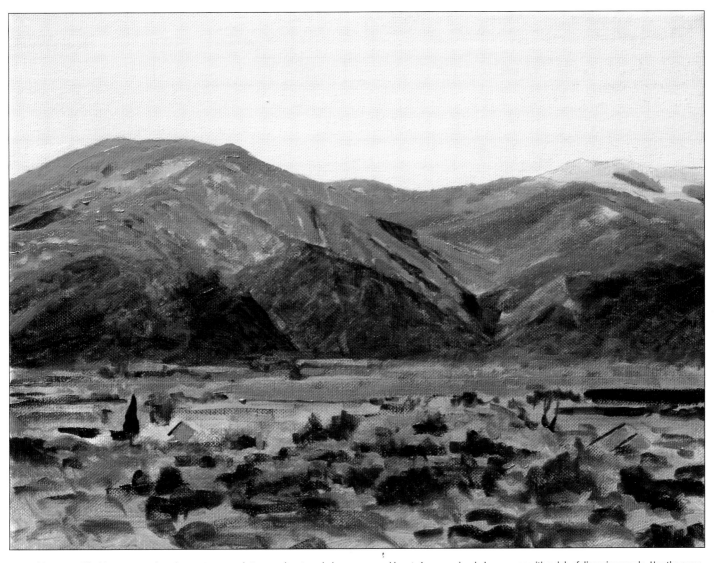

5. For this step, we'll add two more color mixtures to your palette: equal parts cadmium orange and burnt sienna, and cadmium orange with a dab of dioxazine purple. Use the same technique as you did in Step 4, and continue adding color to the areas that contain more intense color and highlights. Start with the darkest color and vary your brushstrokes to create interesting shapes, and then continue with the brighter orange mixture. Place a few dabs of color in the foreground.

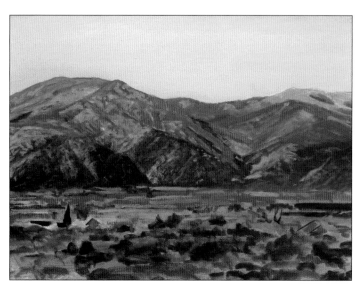

6. First, brush violet gray onto the shadow areas to suggest snow. Use the edge of the brush to create thinner lines, and don't overwork or cover up what you've already painted. The key here is to apply soft pressure and let the brush do the work. Continue defining all the shapes in the mountain. Next, use the same color to break up the foreground areas.

ARTIST'S TIP

If you don't want to purchase violet gray paint, you can make your own by mixing equal parts dioxazine purple, Payne's gray, and titanium white.

MOUNTAIN DETAIL

A drybrush technique works well here, pulling the color across and down, allowing it to fade into the underpainting.

Although you haven't rendered any precise details, the painting still has a feeling of depth and realism.

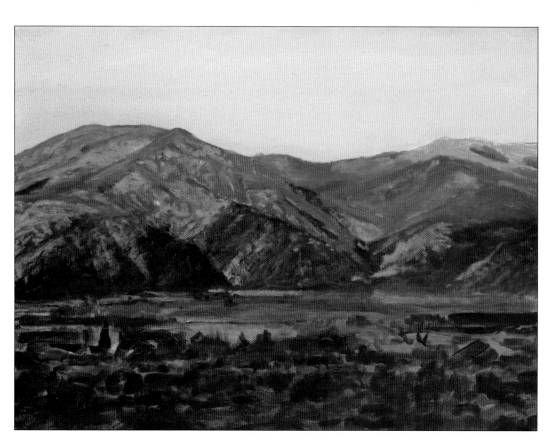

7. For this step, we'll add some darker values to the foreground and base of the mountain. This will heighten the contrast and depth, and it will also create a balance between the cool and warm color hues. Using burnt sienna thinned with oil painting medium, apply a transparent "glaze" of color onto the foreground and base of the mountain. You can use a scumbling technique to soften and blend the edges where they meet the other colors in the underpainting.

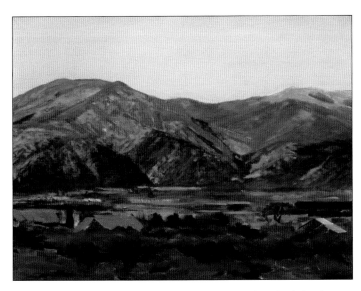

8. Using burnt sienna, dioxazine purple, and Payne's gray, reinforce the darker shapes and add more detail to the buildings and the foliage in the foreground. Then use a mixture of chromium oxide green and titanium white for the buildings on the left and king's blue light for the rooftop on the right.

MOUNTAIN DETAIL

I also added a few yellow brushstrokes in the distance to suggest patches of sunlit snow.

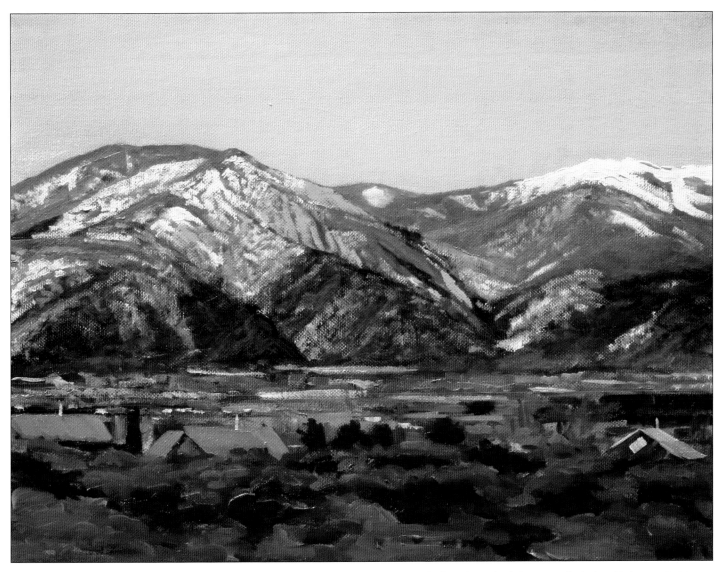

9. Mix equal parts of the following colors: cadmium orange and titanium white; flesh and titanium white; and yellow ochre and cadmium orange. Beginning with the second mixture, load your brush and begin filling in the snow. Use the other colors in the same way, adding highlights to the sides of the mountain and some of the foreground areas. Continue making small adjustments as you go along, stepping back from the painting to check your progress. Once you're satisfied with your final product, step back and admire your work!

Cloudy Beach

Living at an elevation above my town allows me to experience the breathtaking panoramic views of the landscape below. This perspective also gives me some spectacular sunsets, so I always have my camera ready. Sunsets are particularly dramatic after a storm because the clouds are broken, and this day was exceptional.

▶ I took a series of shots on this day as the sun was disappearing. I was especially inspired by the progression of color from deep blue to orange and red, and then back to an even deeper violet.

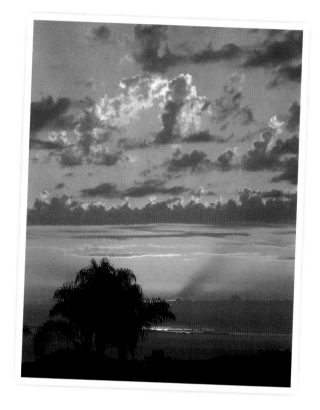

PALETTE

Original painting done in acrylic

acrylic medium: gloss

alizarin crimson • brilliant purple • cadmium orange

cadmium red light • cadmium yellow medium

cerulean blue • cobalt blue • dioxazine purple

light blue violet • Payne's gray • sap green

titanium white • unbleached titanium • yellow ochre

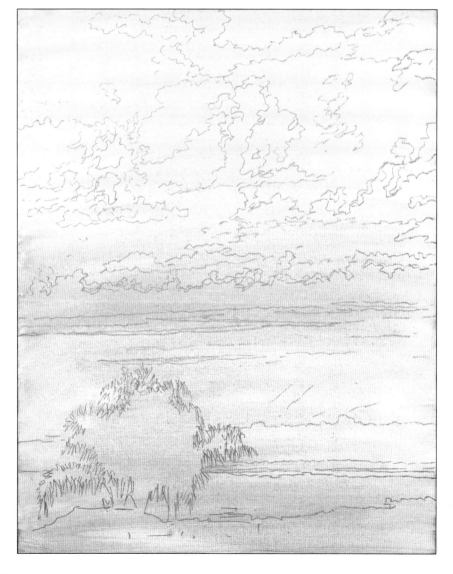

1. Using a felt tip marker, render enough detail from the photograph to serve as a guide while painting. To establish the tonal gradation from top to bottom, wet a large brush with water and lightly brush on light blue violet, brilliant purple, yellow ochre, and then brilliant purple again at the bottom.

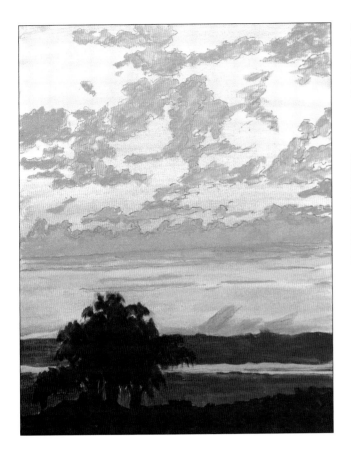

2. Next, mix equal parts dioxazine purple and titanium white, add a little bit of gloss medium, and block in the top half of the clouds. Repeat this step using a mix of yellow ochre and titanium white, allowing the paint to blend while it's still wet. Add some yellow ochre to the center portion of the sky. Add a mixture of cerulean blue and Payne's gray to the two darker cloud strips at the bottom. Finally, mix sap green and Payne's gray together and block in the trees in the foreground.

3. Now we'll continue to work on the dimension of the trees. Load the brush with alizarin crimson and Payne's gray, and go over the trees and foreground area once more, varying the brushstrokes and paint thickness. After you've added a second layer of color to the foreground, apply cadmium red light to the lower section of the sky and the top of the cloud that goes through the trees. You can also add a few specks of color to create openings in the trees. Finally, use the red mixture to add streaks to the yellow portion of the sky.

TREE DETAIL

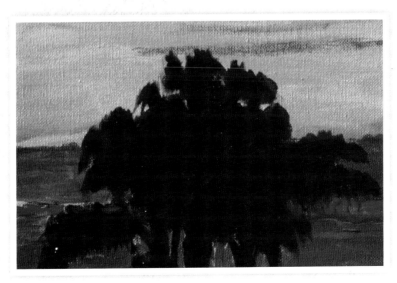

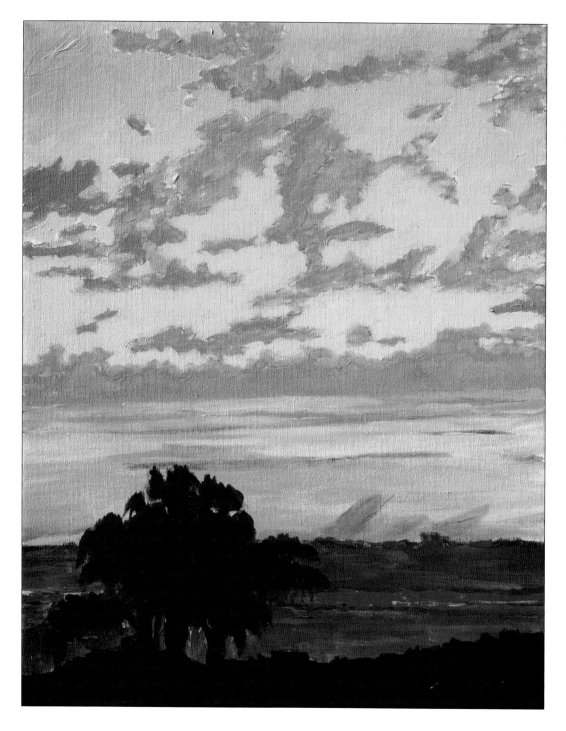

4. In this step, you'll intensify the color of the sky. Starting with a mix of cobalt blue and titanium white, fill in the sky beginning at the top. Paint around the clouds and vary your brushstrokes. As you move down, add a mix of cerulean blue and titanium white, blending as you go. If you'd like, add a dab of gloss medium to help the paint flow. Continue working downward, adding a mixture of yellow ochre and titanium white as you move toward the middle and lower section of the sky. The idea is to create the changing sky color from top to bottom, much the way a real sunset appears.

SKY
DETAIL

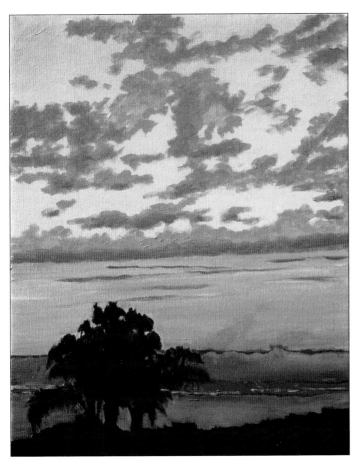

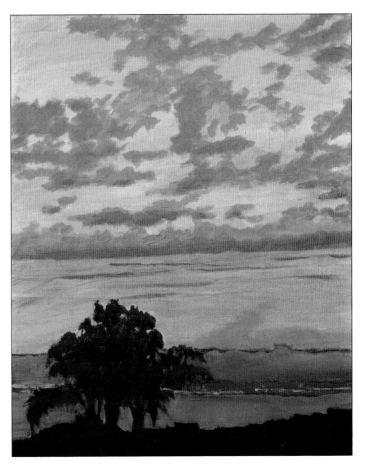

5. Next, we'll add warmer color values to the clouds. Mix equal parts dioxazine purple, yellow ochre, and titanium white. Work your way down the painting with varying brushstrokes, filling in the darkest shadows in the clouds as you go. Allow some of the underpainting to show through and continue covering the sketch lines with thicker paint. Next, blend the dioxazine purple, cerulean blue, and titanium white; then begin filling in the medium tones and the bluish "flare" at the bottom. Using a combination of alizarin crimson and titanium white, add another layer of color under the long strip of clouds near the bottom of the painting, and then add some to the small streaks in the middle of the sky.

6. In this step, you'll use a classic painting technique: glazing. Simply put, glazing is the layering of a single color that covers a large area of the painting. Dip the large brush into the glazing medium. Add cadmium orange to your palette and push this around with the brush to create a watery mixture. Starting at the top of the painting, apply this mixture with very large, sweeping brushstrokes and work your way down. Work the color so that it's transparent, allowing the underpainting to show through. As it dries, you'll see that it blends into what's already been painted, creating an illusion of depth.

GLAZING DETAIL

In this close-up, you can see how the effect of glazing blends with the colors underneath. In this case, it's done to unify the underpainting and create a gradation in the sky.

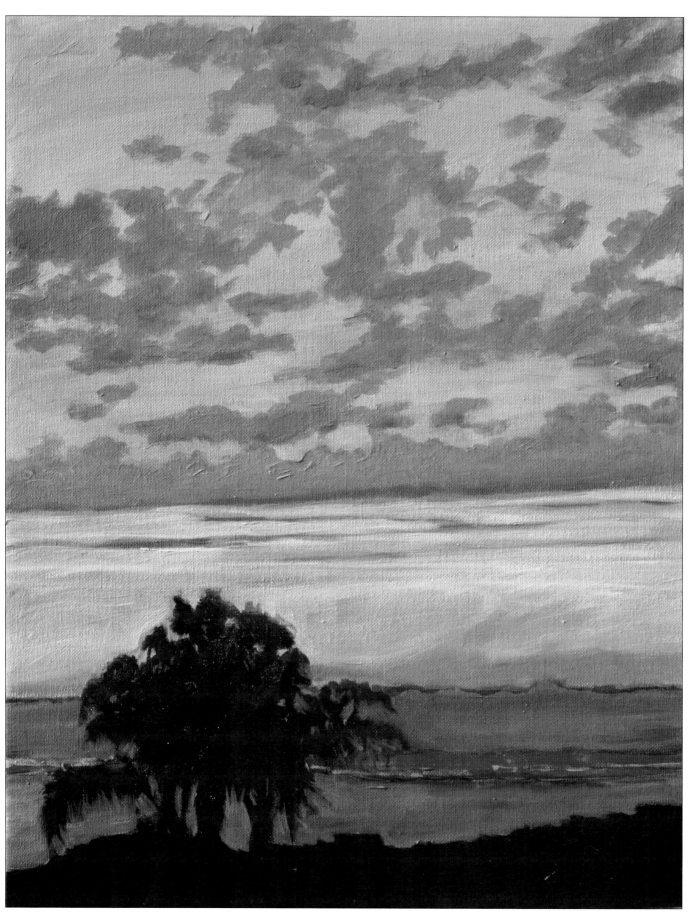

7. Using a small brush, apply a mixture of dioxazine purple and light blue violet to the darkest shadows in the clouds. Use the photo for reference and allow some of the other colors and underpainting to show through. Next, blend together the unbleached titanium, cadmium orange, and cadmium yellow medium. Add this to the bright middle section of the sky to add variation and brighter highlights. You can also use some drybrush technique to blend the colors.

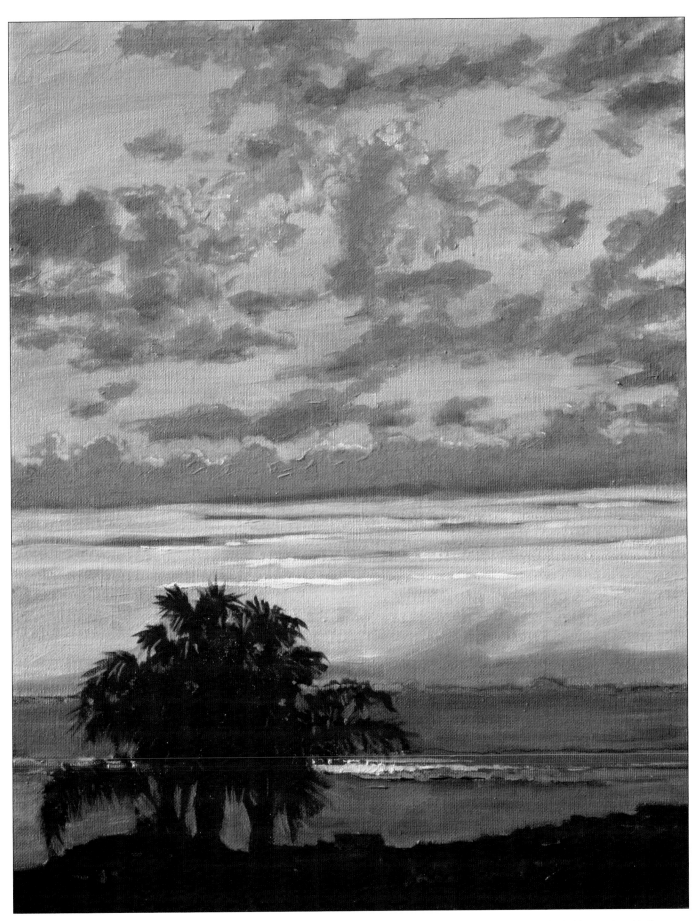

8. This last step will bring your sunset to life. Apply cadmium yellow medium in a thick layer where the sun is breaking through the lowest clouds. You can also add a few highlights of this color along the tops of the clouds. Next, mix titanium white with cadmium yellow medium and add another layer of highlights to the tops of all the clouds and some of the horizontal streaks in the sky. Finally, create a mix of sap green and alizarin crimson. Use the edge of the small brush much as you would a pencil and "draw" some of the branches of the tree with the paint.

African Grassland

This photo boasts a beautiful African sunset with an unbelievable mixture of cloud shapes and colors. The inspiring view is intensified by the presence of water buffalo and antelope in the distant grasslands.

PALETTE

Original painting done in oil

alizarin crimson • brilliant yellow • burnt sienna
cadmium orange • cadmium red light
cadmium yellow light • chromium oxide green
dioxazine purple • flesh
king's blue deep • king's blue light
Naples yellow • Payne's gray
permanent green light • phthalo violet
Prussian blue • raw sienna
sap green • titanium white

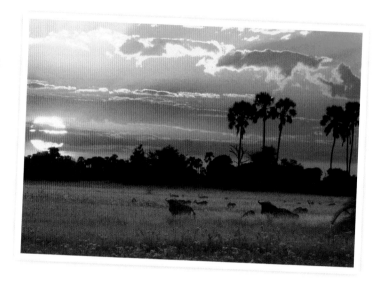

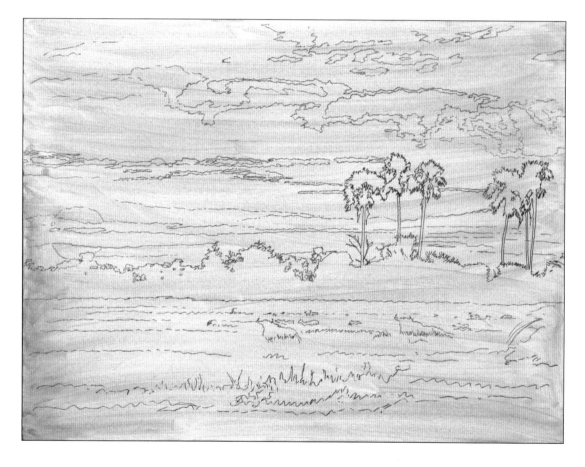

1. Using a black felt-tip marker, create a fairly detailed sketch. To make it easier, I projected the reference photo onto the canvas. After finishing your sketch, prime the canvas with a mix of yellow ochre and water, keeping it thin enough for the sketch to show through. This warms the white of the canvas and covers the marker ink so that it won't bleed through into the oils that will soon be applied.

ARTIST'S TIP

I use an Artograph® projector, which is available at most art supply stores. They have sharp focus and require little maintenance. Simply place a flat image inside the projector and project it on the canvas. I usually hang the canvas on a pegboard so it is against the wall. Moving the distance and changing the focus allows you to project the image in different sizes.

2. First, cover the canvas with a thin wash of oil painting medium to dilute the colors. For the beginning palette, use sap green, chromium oxide green, dioxazine purple, burnt sienna, and raw sienna. Starting at the bottom, use the two greens to block in the grass. Next, add raw sienna to the upper left part of the field to establish the setting sun. Block in the center area with the trees and darker foliage using dioxazine purple, sap green, and burnt sienna. Paint the sky using burnt and raw sienna, keeping the color a little bit lighter on the left side.

TREE DETAIL

At this point in your painting, don't worry about being detailed; just keep your brushstrokes loose and free-flowing.

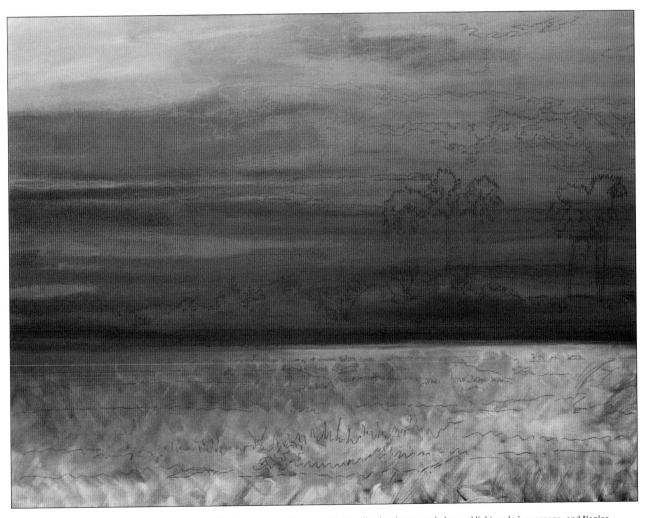

3. In this step, we'll apply the following four colors while the wash from Step 2 is still wet: alizarin crimson, cadmium red light, cadmium orange, and Naples yellow. Starting at the tops of the trees and working upward, apply alizarin crimson. Use a large flat brush and blend into the existing paint. Keep the paint thin so that the drawing still shows through, but keep the color fairly strong. As you do this, take note of the color differences in the clouds and begin to separate them into darker and lighter areas. Continue all the way to the top, using the red, orange, and yellow as shown. After you've finished the sky, apply some crimson to the darker tree line that goes across the horizon. Add some cadmium red light to the top left of the grassy area, fading it into the grass.

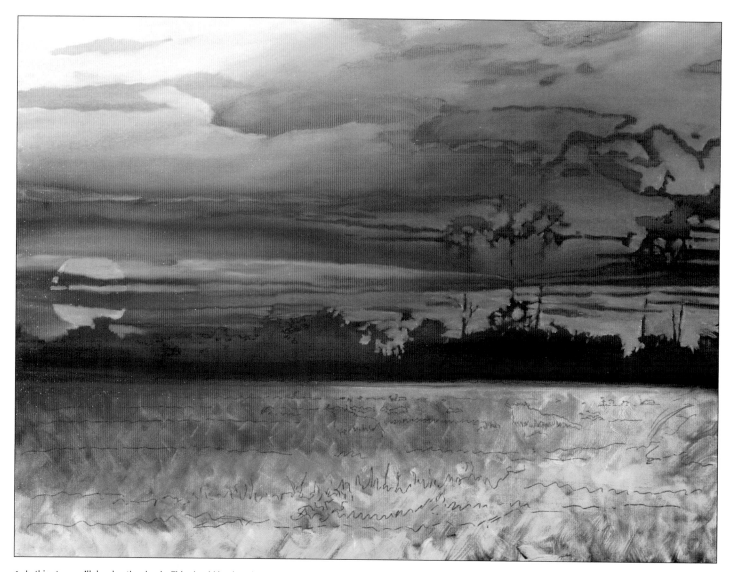

4. In this step, we'll develop the clouds. This should be done in one session while the paint is wet to create a smooth transition of colors. Add king's blue deep and king's blue light to your palette. Load a small brush with paint and work the color into the areas on the right, using the photo for reference. As before, allow the paint to blend in with the underpainting to create subtle variations, gradually fading the color as you get closer to the sun. You can also use a drybrush technique to pull the colors together. Be sure to paint around the trees, leaving enough reference for the later steps.

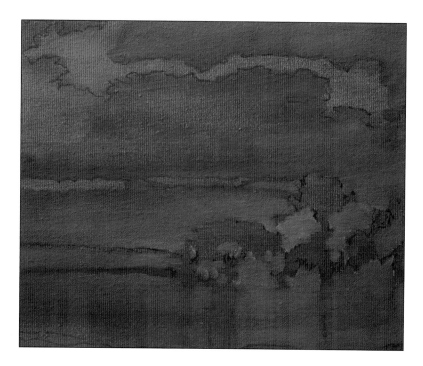

5. Using Naples yellow, employ the same techniques as in Step 4 to brighten up and define the clouds on the left. You can also add some small hints of additional color using cadmium red light and phthalo violet.

6. Load your brush with Naples yellow and block in the sun.

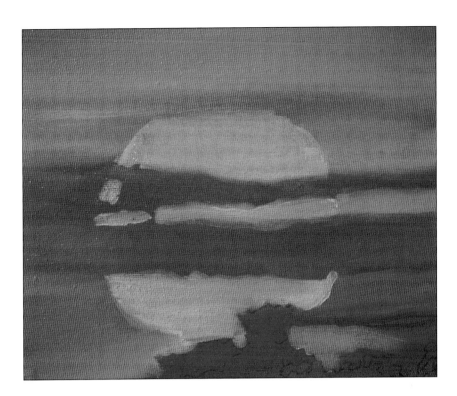

To create the strong highlights on the tops of the clouds, load the brush and "bead" the color, letting the paint fall randomly without working it into the surface.

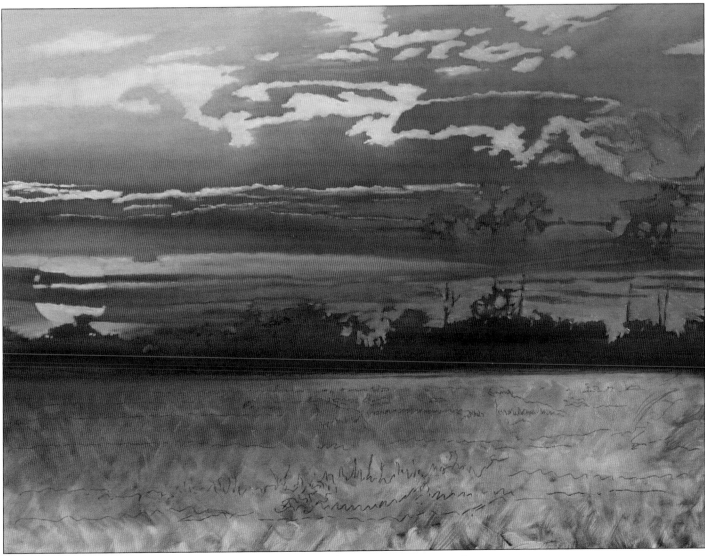

7. Next, we'll lighten and define the areas of sky where the sun is shining through. Premix two colors: equal parts titanium white with both cadmium yellow light and cadmium orange. Load your brush with the yellow mixture, filling in and blending the sky starting at the top left. Gradually work your way down, adding the orange mixture as you get closer to the sun.

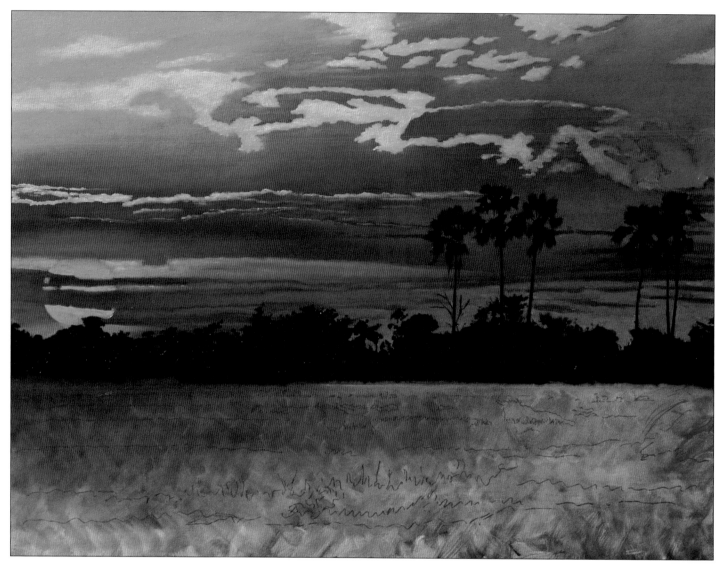

8. In this step you'll learn why it's important to establish a good foundation with the underpainting. We'll paint the palm trees and bushes to create a silhouette effect against the glowing sky. Select a smaller brush that allows for detailing, and add equal amounts of alizarin crimson, sap green, and Prussian blue to your palette. Load your brush with paint and begin filling in the areas that are still visible in the drawing. Start at the tops of the trees and work down and across, using Prussian blue and alizarin crimson on the right side and gradually adding more sap green and alizarin crimson on the left. Leave some openings in the tree line and "flick" the brush on one end to create the palm tree fronds. As you move downward, establish a horizontal line at the base of the tree line, but don't try to make it perfectly uniform.

Don't try to paint every individual branch. Just let your brush do the work.

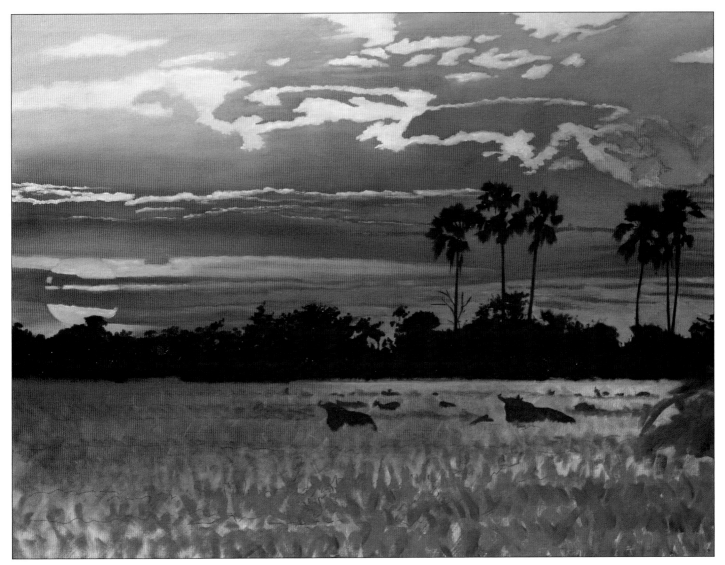

9. Next, we'll concentrate on adding detail and color variations in the foreground. Set up your palette with sap green, chromium oxide green, burnt sienna, and Payne's gray. Mix the two greens together and move across the grass area with random, crisscross brushstrokes. Allow some of the lighter colors in the underpainting to show through and gradually fade the colors as you move from right to left. To render the animal silhouettes, mix burnt sienna and Payne's gray and use the photo for reference. It takes only a dab of color to capture the shapes.

DETAILS

The effect of the fading sunlight will be enhanced if you keep the warmer colors on the left and the cooler colors on the right.

The wildlife doesn't need to be perfectly rendered; you can simply suggest the animals using abstract shapes.

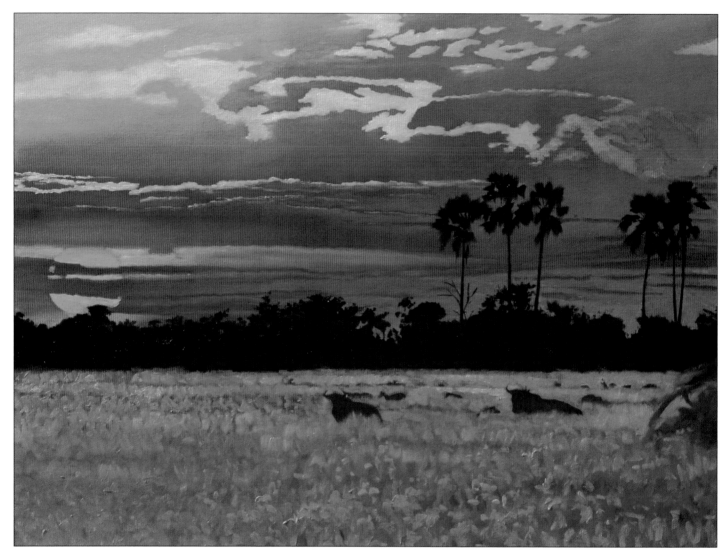

10. Finish the foreground with one more layer of color. Start with a mix of chromium oxide green, flesh, and Naples yellow, and work across using crisscross strokes to fill in some of the gaps. Eliminate any of the sketch lines that are still showing through, but leave some of the underpainting. The goal here is to create a lot of variation in color shapes and textures. As you work upward and get closer to the bottom of the tree line, add a few dabs of red and orange to further the effect of the fading light. Finally, use your first color mixture to paint random little strokes of color to suggest the blossoms in the foreground.

DETAILS

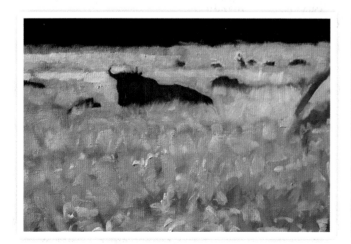

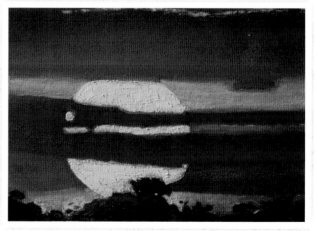

Keeping your paint thick will add texture and dimension to your painting, making it more lifelike.

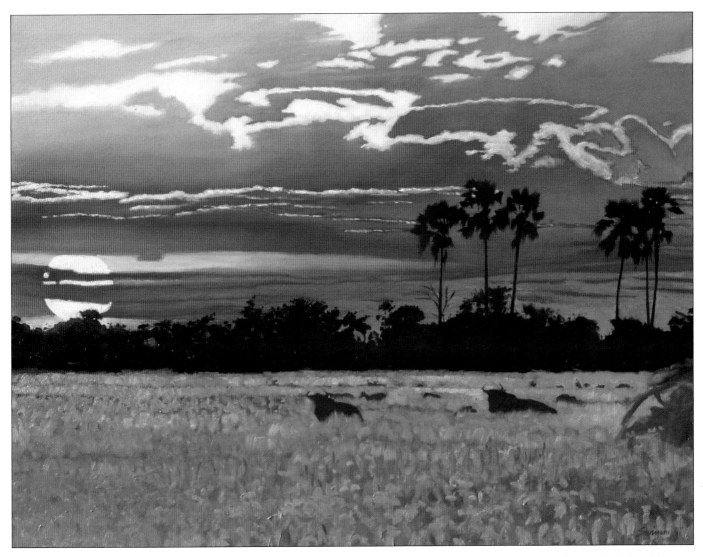

11. One more layer of highlights over the sky and sun will bring your sunset to life! Load a small brush with a mixture of cadmium orange and cadmium yellow light, and begin to add the brightest areas. Use the brush to soften the edges around the clouds, and vary the strength of the color and brushstrokes. Add the following colors to white as you work your way left: cadmium orange, cadmium yellow light, and brilliant yellow. Blend them together, with the lightest colors being closest to the sun. Use a drybrush technique to keep the paint thick and work the colors together. Finally, take the brightest color mixture and add one more layer of color to the sun. After you've finished, get rid of any hard edges by softening the color with the edges of the brush.

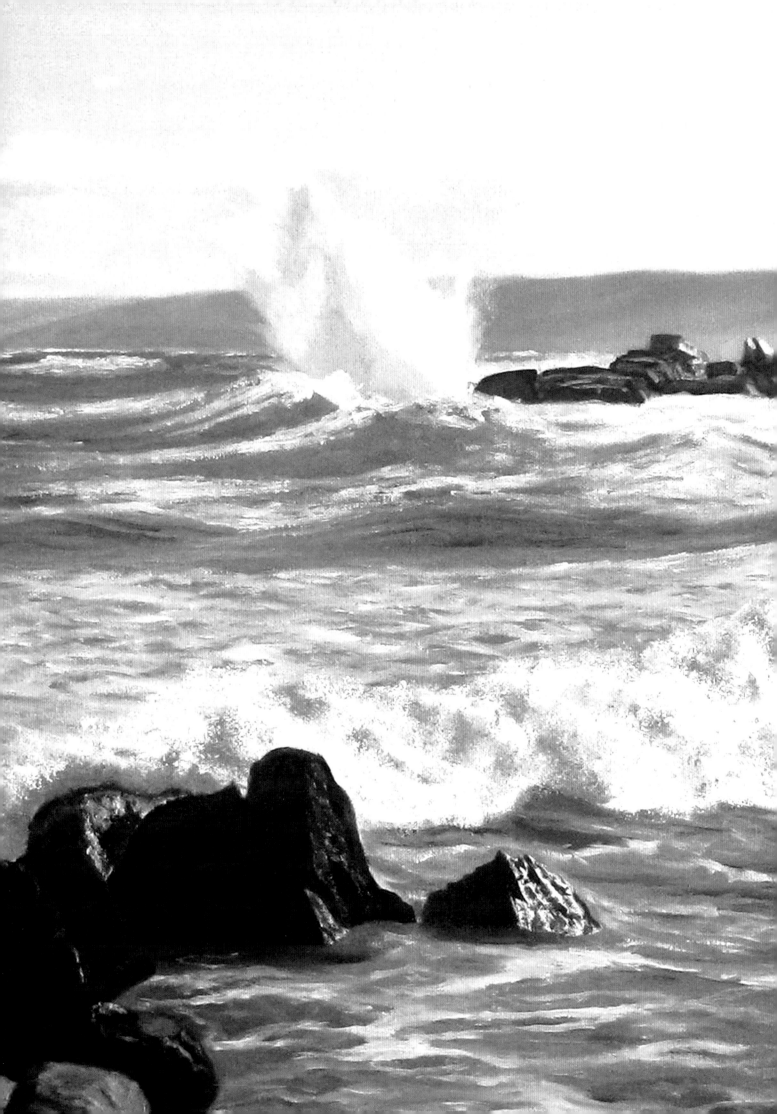

CHAPTER 5

Oceans & Seascapes

WITH MARTIN CLARKE

Welcome to the incredible, diverse world of painting the ocean, the coast, and the sea. In this chapter, we'll explore how to paint several different seascapes in oil using a number of simple yet effective techniques. In the process, you'll discover the versatility of oil paints, which are forgiving and produce wonderful color. With their long drying time, oils are ideal for blending, and they can produce areas that are completely smooth or very textured. Oils are an ideal medium to portray the ever-changing moods and drama of this very special subject: the sea.

Tips

HORIZONS

Horizons are an important aspect of seascapes because they must be straight and level—a wavy or misaligned horizon will detract from the finished piece. Use a ruler or a mahl stick to draw a straight line across your support for the horizon. Keep in mind that the horizon is in the distance and thus needs to have a soft edge. If possible, paint your sky and your sea horizon lines at the same time, and blend the edges together wet into wet. Use a clean, dry brush and lightly run it along the horizon line, cleaning it frequently. (Again, use a mahl stick if necessary.) The edge should be distinct, but not hard. A straight, level, soft horizon is something often neglected by newcomers to seascapes, but it is an essential element, so pay close attention to it.

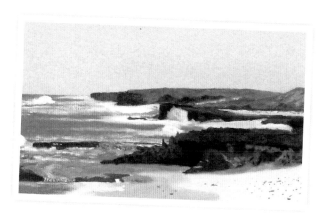

EDGES

Almost all edges in a seascape are soft. Clouds, skies, water, and even rocks almost always have soft edges. Most rocks in a seascape are weathered and rounded to some degree, and soft edges promote this roundness of the form. If the rocks are jagged in the foreground, or if they are part of the focal area, some edges may be harder, but try to keep them to a minimum. Sand and most forms of vegetation also have soft edges. If grasses are part of the focal area, harder edges may be necessary.

COLOR

I use the Munsell color system, which defines color in three dimensions: hue, value, and chroma. I highly recommend adding a Munsell color book and color chips to your reference library.

HUE

Hue refers to the actual color, such as red, blue, green, etc. Believe it or not, hue is the least important element in painting.

VALUE

Value is the lightness or darkness of a color. Value is the most important element and is often the most difficult to grasp. If one reduces a scene to grayscale, only the values are left. They are fundamental in shaping form, providing drama and light, and promoting interest in a scene. If a value range is too close, the scene may lack depth. Values can be tough to judge accurately and a guide is often needed. Value cards or strips can be downloaded from the Internet or purchased from art supply stores. As a good beginner's exercise, I recommend creating a set of value cubes. Start by painting the first block white, the next block grayish white, and so on until you reach black.

CHROMA

Chroma refers to a color's intensity. If realism is the objective, chroma should be low. In nature, most colors are low in chroma. One way to consider color in nature is to think of the colors as grays with a touch of hue added. Generally, chroma is more important in portraiture and figurative work, but low chroma is also important in seascapes.

MEDIUMS

A medium is an additive that you add to your paint to help thin the consistency or speed drying time, among other functions. There are a variety of oil paint mediums on the market. I use a "fat" medium, and I use just enough to enable a good paint flow. In oil painting, the rule for applying paint is "fat over lean." This refers to the amount of oil in the mix and how it relates to drying time. More oil takes longer to dry, and you do not want a slow-drying mix under a fast-drying (low oil) mix, as this will result in cracking and flaking of the paint. To prevent this, use paint straight out of the tube whenever possible. If it is a stiff paint, use just enough medium to allow for good paint flow off the brush. I generally paint thinly, and I use the same medium sparingly throughout the piece. I dip the tip of the brush into a small container of medium. Mixing too much medium with the paint can lead to problems of adhesion to the support, as the binder (the oil) is diluted too much.

Techniques

PAINTING FOAM

Ocean foam can be difficult to paint. It is chaotic in form and includes many value variations. There is, however, a simple method to produce very convincing results. This process should be done wet into wet.

Step 1: Mix two values of water shadow using a low chroma blue-gray: one a value two, the other a value five. On the foam line, paint in the value five shadow hue along the entire foam line.
Step 2: Next, wearing a glove, dab a coarse sponge in a little medium and the value two hue. Blot randomly down the foam line.
Step 3: Using another sponge, dab titanium white along the foam line.

The wet into wet dabbing action aims to blend some of the values, thus facilitating variation, while the sponge introduces randomness in the form.

SPOTS

At times, tiny spots of paint are needed to create certain effects, such as grainy sand. The process can be tedious and time consuming when using a brush. A simple solution is to use a toothbrush and palette knife. Dip the toothbrush in medium and add paint to the brush. With the bristles upwards, run the palette knife along the bristles from the front of the brush to the back. This propels tiny spots of paint from the toothbrush onto the support. The result creates small spots of paint. With a little practice, the paint can be directed and controlled.

DRAGGING

This is a useful brush technique, suitable for all sorts of effects, including suggesting dark background waves, highlights on wet rocks, background highlights, or adding texture to rocks. For control, a smaller, long-bristled, long-handled stiff brush is best. Add paint to the length of the bristle on one side only. Holding the brush at an acute angle to the support, start with the dry side of the brush on the support, pressing lightly against the canvas. Begin the stroke and slowly rotate the brush, gradually bringing the paint into contact with the support. The high points of the support will grab the paint off the brush in a speckled effect. This method works best on fabric supports where the surface is slightly uneven.

SPARKLES

One of the unique aspects of seascapes is capturing the way light reflects off the water—from a blinding glare to dancing sparkles. On a reasonably dark background (the contrast is needed to make the sparkle stand out), add a small dab of titanium white using a small flat or round brush. Next, using a small round brush, tease the dab of paint out, up, down, right, left, and diagonally. Drag the dab outwards. Do this to all similar dabs to create a blurred impression for realistic sparkles.

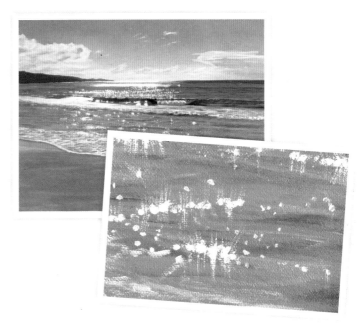

Ellenbrook Shore

This scene encompasses many of the elements typical of a seascape—sand, surf, rocks, clear waters, and a big sky. The shadows on the rocks and breaking wave face suggest that the sun is shining brightly. It's a delightful scene where one can almost feel the sand and the wind and hear the crashing surf.

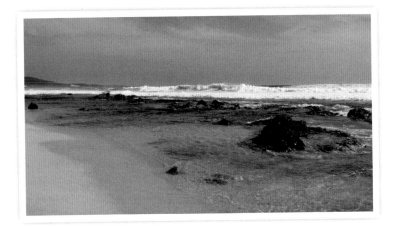

Using photo processing software, I isolate the various colors within the scene. Often, a color can be deceptive when viewed as part of the whole, and it can be helpful to view each color separate from the scene.

PALETTE

Australian gray • Australian leaf green light • burnt sienna
cerulean blue • chromium green oxide • ivory black
Naples yellow • Payne's gray • phthalo blue • raw umber
sky blue • tasman blue • titanium white • turquoise
ultramarine blue • yellow ochre

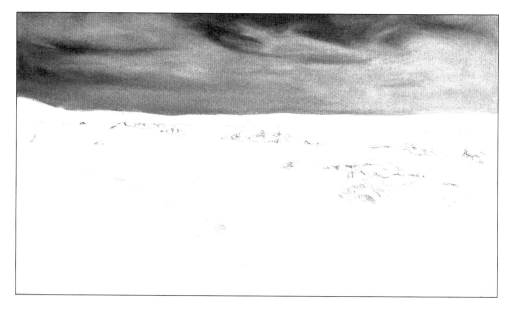

1. With the main elements sketched in, start painting the sky using a mix of ultramarine blue, phthalo blue, tasman blue, and titanium white. In the upper part of the sky, apply the mix across the whole canvas. Load a small amount of sky blue and titanium white onto the brush, and mix them together on the canvas. This will create a slightly uneven mix, which is ideal for suggesting distant cloud layers. Once the sky is covered, blend titanium white into the sky color and add clouds.

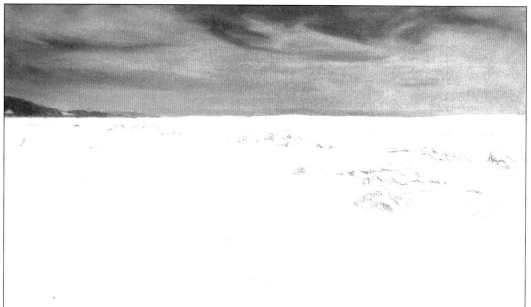

2. Mix the sky color with a tiny bit of phthalo blue, Payne's gray, and titanium white to create the faintest, most distant land mass. Add more Payne's gray and a touch of chromium green oxide to the same mix and begin painting the darker mountain. For the lighter land patches, use the mountain mixture and Australian gray (an Art Spectrum proprietary mix). Keep your edges soft as you paint.

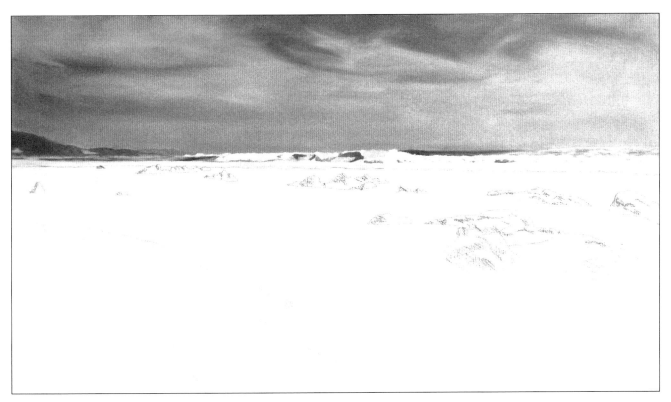

3. For the darker sea, paint a mix of Payne's gray and titanium white with a small amount of phthalo blue. Next, randomly dab the mix along the horizon line to indicate the wave; then paint over the area with titanium white, blending unevenly to suggest a foam-covered wave. For the wave shadow, add cerulean blue and titanium white to the sea mix. This shadowed area on the wave is important, as it forms part of the secondary focal area and draws the eye deeper into the scene. Paint the shadowed area and dab randomly again with titanium white to suggest the broken, foaming wave. Paint the area of the pitching wave using turquoise mixed with titanium white. Finally, add titanium white along the length of the wave to create the foam.

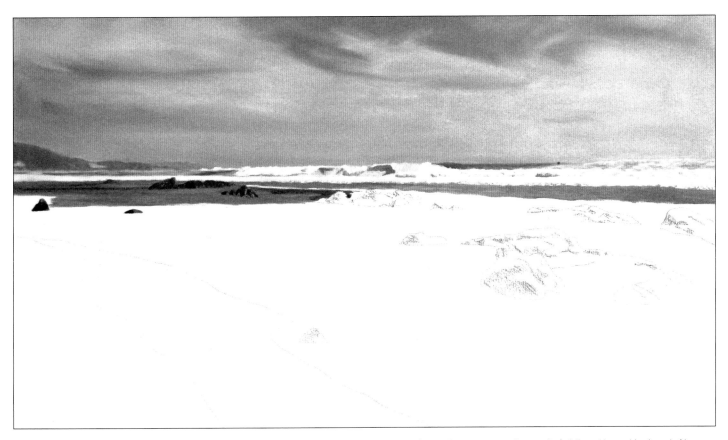

4. Begin the rocks using raw umber, Payne's gray, titanium white, and yellow ochre. First paint the darks (a mix of Payne's gray and raw umber), followed by a mid-value mix (the darks mixed with titanium white). Next, with a small round brush, redefine the dark areas, adding dabs to simulate roughness. Finish by adding highlights using a lighter value rock mix. As the rocks approach the foreground, the darks get progressively darker and the detail increases.

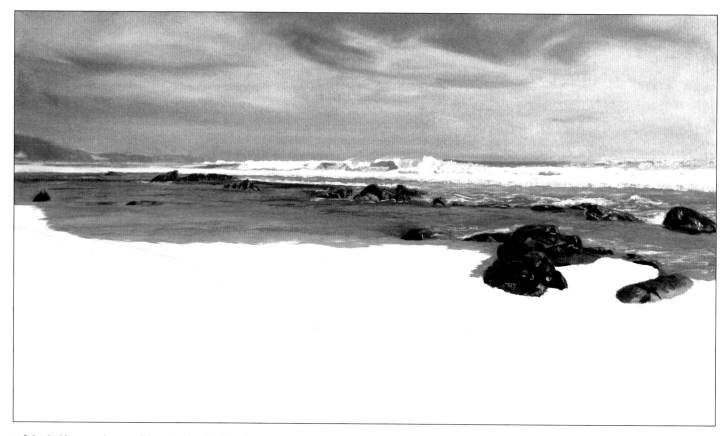

5. Paint the blue sea color around the rocks, dragging Payne's gray over some areas to suggest submerged rocks. To suggest the green hue of the water, blend a mix of chromium green oxide, Payne's gray, and titanium white into the sea blue where the water is coming into the shore. Next, add this green color to a new mix of Payne's gray and titanium white and another mix of Australian leaf green, Naples yellow, and titanium white. (By now, you should have mixed three different colors.) Dip your brush into medium, and load each side with a different hue. Use a figure-eight brushstroke to add the paint to the green areas on the canvas. As you move down the canvas, introduce more white into the brush blending. Mix in light green, blue, and gray at random to cover the area of the shallows. Finish by painting all of the remaining rocks in the foreground.

ARTIST'S TIP

Instead of buying Australian gray, you can mix your own using titanium white, red iron oxide, and brown iron oxide. The result should be a pinkish gray. To create Australian leaf green, mix equal parts iron oxide brown, chromium green oxide, and cadmium yellow. To create tasman blue, mix equal parts dioxazine violet, phthalo blue, and titanium white.

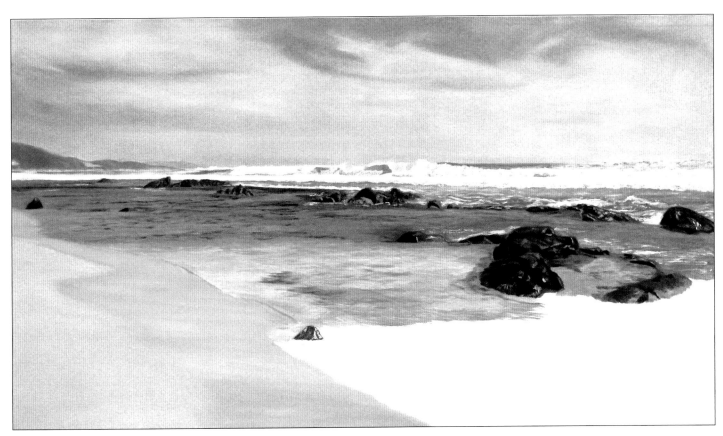

6. You're almost done! Next we'll begin painting the sand. The dry sand is a mix of Australian leaf green light, Naples yellow, raw umber, and titanium white. This area is the easiest part of the painting. The coverage is uniform, with no visible brushstrokes or texture. For the wet sand, mix burnt sienna, ivory black, and titanium white. Apply the color with horizontal strokes and gently blend wet into wet at the water's edge. Finally, add some wave shadow hue (from Step 3) mixed with titanium white over the wet sand area.

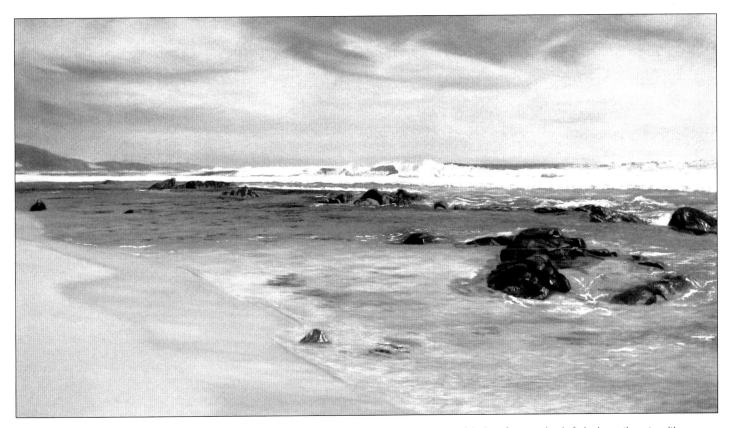

7. Using a mix of the light green hue (from Step 5), raw umber, and Payne's gray, fill in the shallow area to the right of the large foreground rock. Go back over the water with figure-eight brushstrokes, adding more dark green hues where necessary. Finally, apply titanium white to various areas to suggest foam around the rocks and on the water.

Eruption

I like this photograph because it perfectly captures a rocky coastal scene, with early morning light showing the contrasts on the rocks. Plus, the large spray in the center provides an excellent focal point.

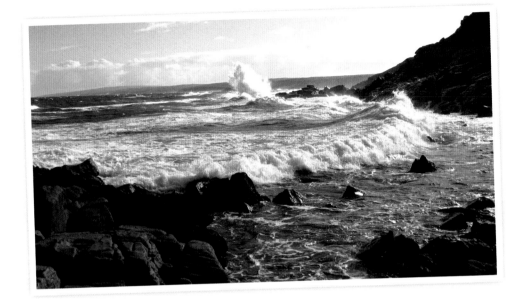

1. Sketch in the foreground rocks with great detail. Loosely draw in the other areas to establish their positions on the canvas.

2. The sky in this piece is quite high in value, and varies from lower value on the left to the highest value on the right. Mix together video blue, a tiny bit of phthalo blue, and titanium white. Using a 2-inch flat brush, apply this color to the upper section of the sky, adding titanium white as you move from left to right. Next, add a little Payne's gray to your original mix and apply to the lower section of the sky, leaving a small section of white in the middle. Add titanium white to the same section as you move from right to left, increasing its concentration as you move right. Use circular brushstrokes, aiming for unevenness in the application. The resulting value differences will suggest clouds.

3. The distant land varies in value from light on the left to dark on the right. Add Payne's gray to your sky mix, producing a value a little lower than the sky gray. Apply this color to the furthest point of land to the left. As you move to the right, add more gray until you are near the midpoint, where you can add a touch of chromium green oxide. To the right of the focal point spray, add more Payne's gray and chromium green oxide.

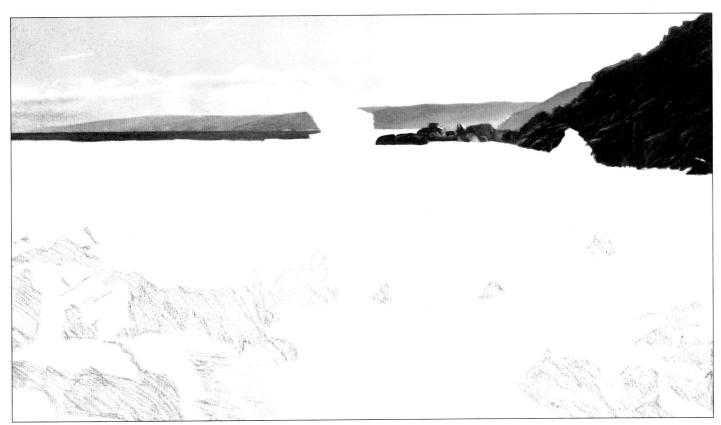

4. The colors for the cliff and middle rocks are video and phthalo blues, titanium white, and Payne's gray. For the middle rocks next to the big spray, mix all four colors together. This same color is also used up the ridgeline. Use a diagonal stroke, following the line of the cliff, taking care to vary the thickness of application. For the rest of the cliff area, apply Payne's gray in varying diagonal strokes, with curves, sharper angles, and long and short strokes. Nearer the foreground area of the cliff, use more deliberate strokes for the rock formations. When the whole cliff is painted, go back over the area with your first color mix to add highlights. Nearer to the cliff foreground, use some of the sky mix (from Step 2).

ARTIST'S TIP

Phthalos are extremely powerful pigments;
use them sparingly!

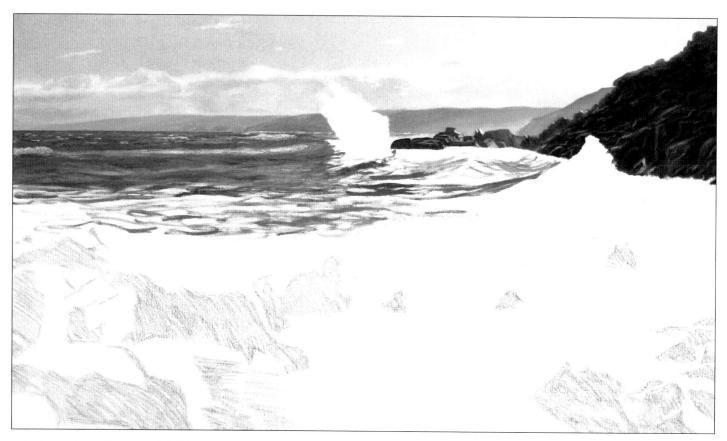

5. For the sea, mix together one part phthalo blue, one part titanium white, and two parts Payne's gray. Brush this blue-gray hue across and down the sea; then create the shadowy areas by dabbing the area with darker blue. Next, add patches of titanium white to portray the crests. In the foreground, add some of the blue-gray mixture. (Brush on roughly to add more texture.) Finally, go back over the entire area with titanium white to portray a swirling, foamy sea.

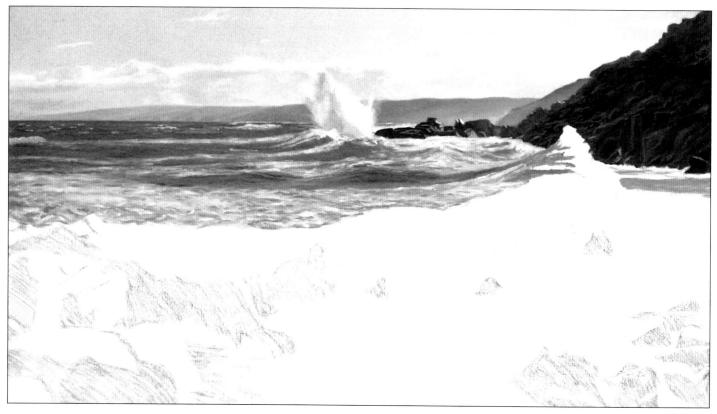

6. Continue working on the same area from Step 5. Add a touch of phthalo blue and titanium white to the sky shadow mix from Step 2 to create large spray. Next, paint the rest of the sea using the sea shadow color (from Step 5) mixed with ultramarine blue and titanium white. Dab your brush in titanium white; then drag it across the middle and background areas to create the whitewater crests. In the sea foreground, use a sinuous curved brushstroke to mix the white with the underlying blues for a convincing heavy whitewater color variation.

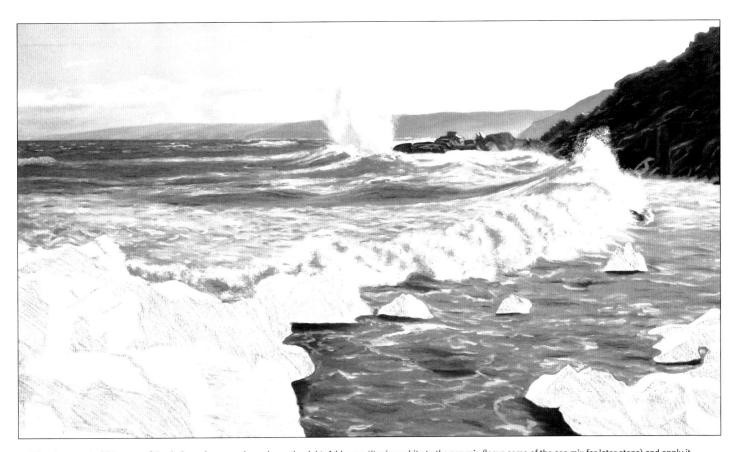

7. Using the sea mix, fill in some of the darker colors near the rocks on the right. Add some titanium white to the sea mix (leave some of the sea mix for later steps) and apply it from right to left, uniformly covering the area. As you paint to the left, add in the darker sea mix. Once you get to the base of the rocks on the far left, add in some more Payne's gray. Taking a smaller flat brush, go back to the area on the left and start adding darker values in short, slightly curved strokes. Finally, with a heavy hand, go back and add titanium white to the area on the right, as well as the highlights and foam patterns as you move left.

8. For the wave foam line, mix together phthalo blue, ultramarine blue, Payne's gray, and titanium white. With a downward curving shape to simulate the breaking action of the wave, paint this hue into the foam line area. Dip a coarse sponge into your medium, load it with titanium white, and dab it along the foam line, overlapping the blue-gray brush marks. Using another sponge, repeat this process with the blue-gray hue, dabbing down the line. To complete the sea, go back to the area in front of the foam line and add more darks to the section on the left, finishing with some titanium white.

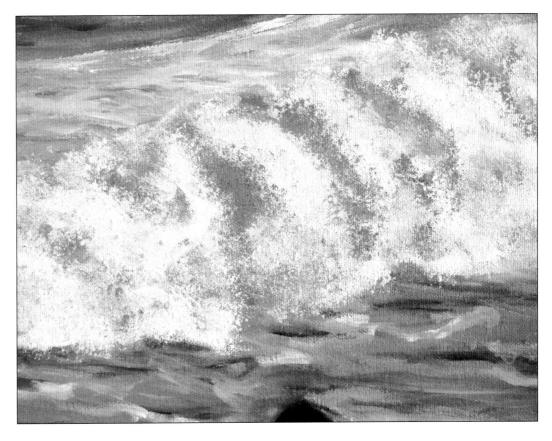

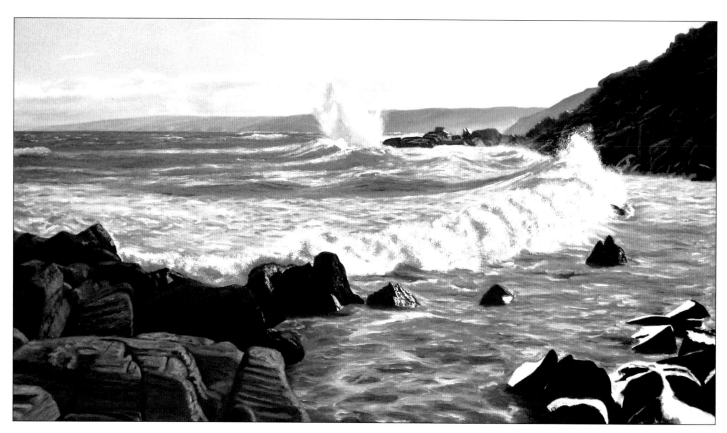

9. Paint in the darker background rocks using mostly Payne's gray mixed with a bit of raw umber. For the highlights on these rocks, use Payne's gray mixed with a bit of titanium white. Next, fill in the lighter foreground rocks with your sea mix (Step 5) mixed with Payne's gray. Create lighter portions of the rocks with a combination of raw umber, yellow ochre, titanium white, and the sea hue mixed right on the canvas. Finally, add highlights with yellow ochre and titanium white. The rocks to the right are simpler: The dark areas are Payne's gray; the light areas are the sea hue mixed with a bit of Payne's gray. Use titanium white to add the highlights.

ARTIST'S TIP

After you've laid down the color on the rocks, go back and redefine the darker areas with your small round brush, painting thinner lines and dabbing to introduce a rough surface texture.

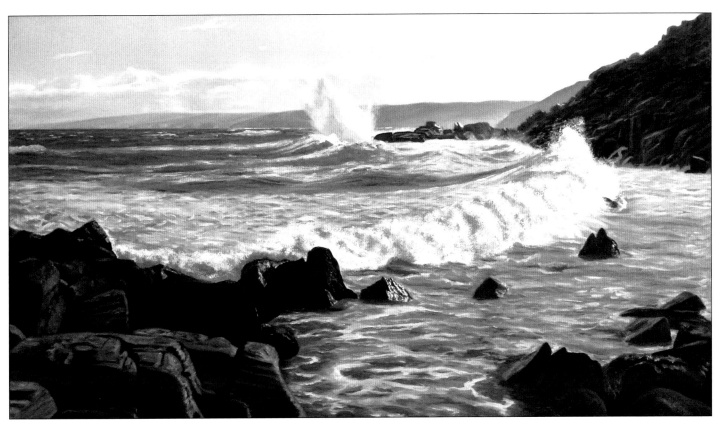

10. Touch up some foam lines in the foreground, add a few patches of blue foam, finish the rocks, and call it finished!

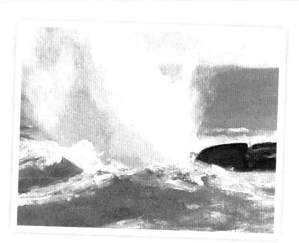

Island Shore

I liked this photo because it boasts a sun-drenched coastline with receding headlands and colors suggestive of warmer waters. The expansive foreground contains a great deal of interest, with variation in forms, hues, and values, making for a challenging and interesting piece to paint.

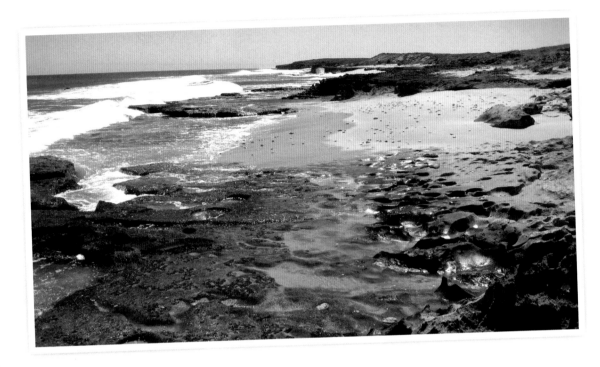

PALETTE

Australian leaf green • Australian leaf green light • burnt sienna • cerulean blue
chromium green oxide • ivory black • light flesh • Payne's gray • phthalo blue
raw umber • titanium white • turquoise • ultramarine blue
vasari video blue extra pale • yellow ochre

1. Lightly sketch in the scene, indicating the major areas and taking more care in drawing the foreground. In this scene, very little sky is required to indicate a bright, cloudless day. Mix together a dab of phthalo blue, vasari video blue extra pale, and titanium white. Using a 2-inch flat brush, apply color evenly over the whole sky.

2. For the sea, mix together phthalo blue, cerulean blue, Payne's gray, and titanium white, blending it with the horizon as you go. Allow to dry. Next, mix together chromium green oxide, Australian leaf green, Payne's gray, and titanium white. Begin filling in the large land mass near the top right of the canvas. As you go, mix some of the sea color with Payne's gray and fill in the most distant headland head. Randomly dab some burnt sienna and raw umber to give a mottled effect suggestive of vegetation.

3. Once the sea section has dried, add some titanium white using dragging brushstrokes in the distant areas. Next, brush titanium white onto the whitewater areas using a small stiff filbert. Add the reef using raw umber, Payne's gray, and titanium white, filling in the darker areas first, followed by the lighter sections. For the sea to the right of the whitewater in the mid foreground, load half of the brush with the sea hue and the other half with turquoise, chromium green oxide, Payne's gray, or titanium white, and mix the colors on the canvas. Apply color first; then add titanium white wet into wet.

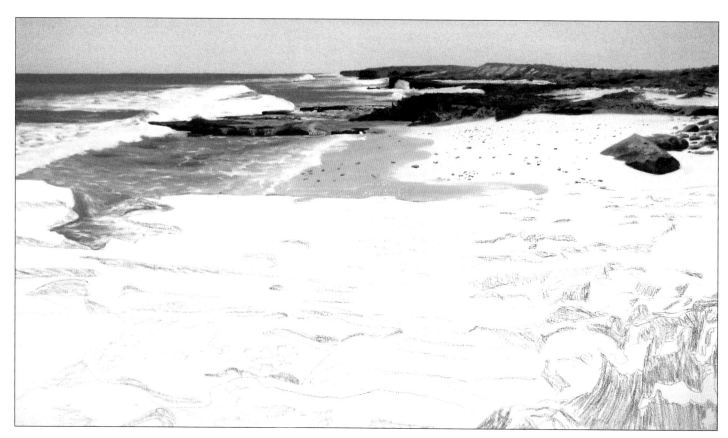

4. Begin the darker shadows on the rocks using burnt sienna, Payne's gray, and titanium white. For the lighter shadows, use Australian leaf green light, Payne's gray, and titanium white. Paint the redder rocks using burnt sienna and Payne's gray. For the darker rocks, use a mixture of Payne's gray, burnt sienna, and titanium white. Mix burnt sienna, yellow ochre, and titanium white and begin painting the sand area. If it seems too light, add Payne's gray or light flesh; then add vasari video blue extra pale over some areas to suggest reflected sky. Fill in the sea up to the land area, slightly intermixing the colors. Finally, add the whitewater area along the shore with titanium white.

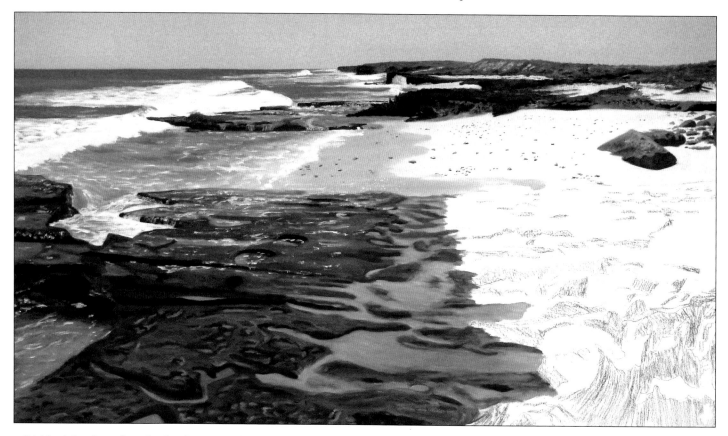

5. Paint the dark reef areas first using chromium green oxide and ivory black. For the wet reef areas, apply a mix of chromium green oxide, ivory black, and titanium white. Next, apply a low-chroma green, mixing in occasional dabs of raw umber. Go back over the area, randomly dabbing in Payne's gray or green oxide. Use a mix of the sea color and cerulean blue to fill in the pools, and add raw umber to receding reef areas. Darken the sea mix with ultramarine blue and Payne's gray to add shadows in pools and to darken the rear reef areas. Using a dragging brush technique, add titanium white near the back of the reef.

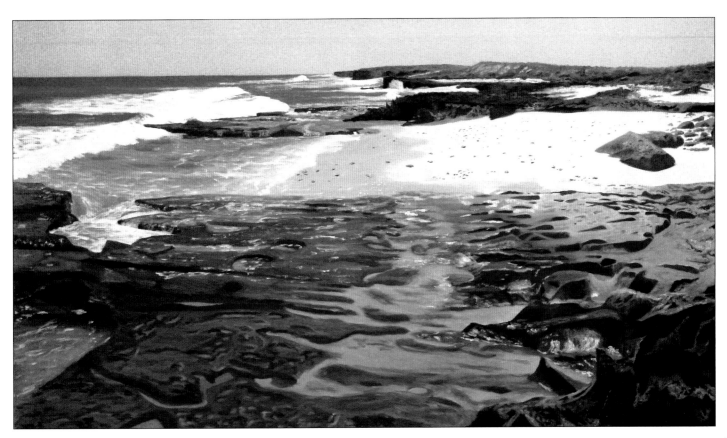

6. Apply burnt sienna and yellow ochre to the rocks at right. Add a bit of yellow ochre and chromium green oxide to the areas at left. Bring the rock system forward, gradually increasing the amount of burnt sienna, yellow ochre, and green oxide in both the shadow and lighter areas. On the rocks near the reef, add some of the sea mix to indicate wet rock reflecting the sky. In the hollows, use yellow ochre and the sand mix to indicate shallow pools. For the foreground shadows, use a mix of burnt sienna, yellow ochre, and ivory black, applying the paint randomly. Use the same technique to apply titanium white to the lighter areas. Finally, dab or drag titanium white over various areas to portray dappled, shadowed rock.

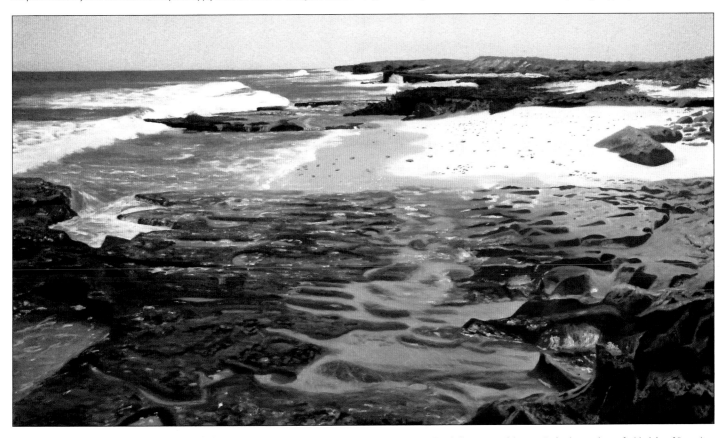

7. Step back and evaluate your work. Add more turquoise, cerulean blue, Payne's gray, and titanium white to the shallow areas of the sea. Go back over the reef with dabs of Payne's gray, adding definition to the shadows. Apply chromium green oxide over the reef to increase the green hue. Finally, add a bit of titanium white for sparkles of light.

Foaming Waters

A turbulent, rocky coastline, patches of light, and loads of movement in the foreground make this an interesting scene.

PALETTE

burnt sienna • ivory black
Payne's gray • phthalo blue
phthalo green • raw umber
tasman blue • titanium white
ultramarine blue

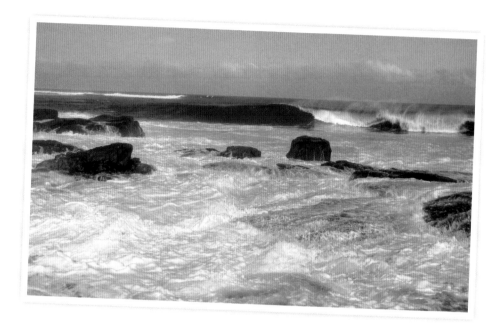

1. Draw a simple sketch, blocking out the major areas.

FUN FACT!

The background wave shown in Step 3 is an internationally known surf break called Margaret River's Surfers Point. It's home to an international surfing competition each year.

2. For the upper half of the sky, mix together phthalo blue, tasman blue, and titanium white. Paint this mix evenly across the upper half of the sky using a 2-inch flat brush. Mix ultramarine blue, Payne's gray, and titanium white, and loosely brush this color across the lower half of the sky. Next, brush titanium white between the two colors, creating a smooth transition.

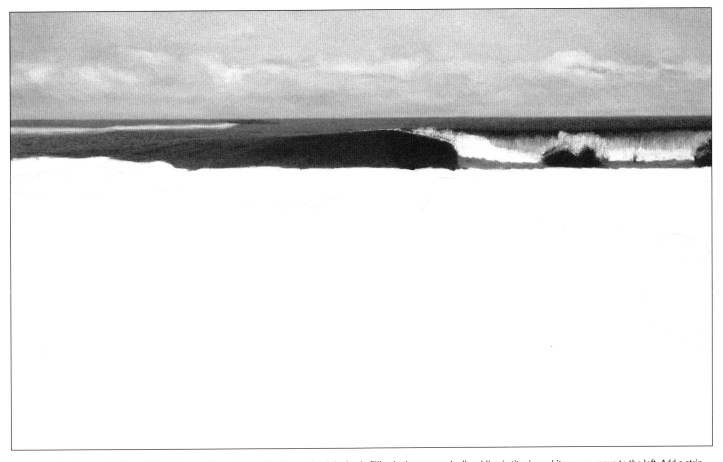

3. Mix together ultramarine blue, phthalo blue, and Payne's gray. Starting on the right, begin filling in the sea, gradually adding in titanium white as you move to the left. Add a strip of titanium white to the left background to indicate the foam trail of an outer break and a horizontal stroke of the sea mix. Using light, short strokes, add some of the sea mix into the lighter area on the left to simulate waves and choppy water. As you move into the wave, add a mix of phthalo blue and phthalo green and a mix of Payne's gray and titanium white. Paint the darkest areas first and then dab titanium white along the top.

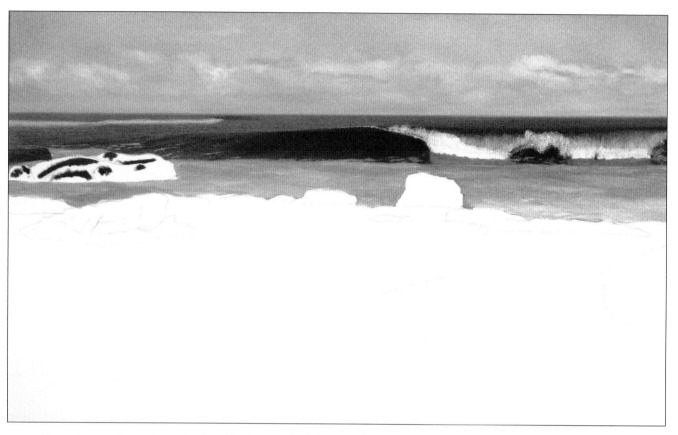

4. The midground foam is not pure white, but is in fact a blue hue. To achieve its likeness, mix phthalo blue, titanium white, and Payne's gray, followed by a mix of tasman blue, titanium white, and Payne's gray. Using a short, figure eight brushstroke, quickly paint this area, picking up each color and applying it at random. Add some titanium white to the area, blending it wet into wet.

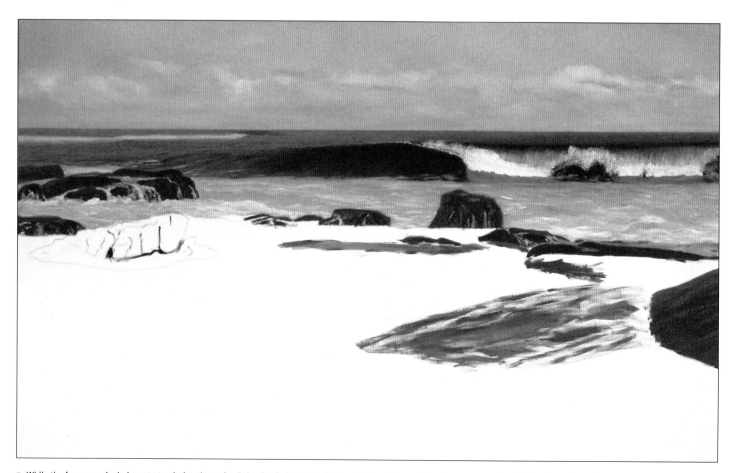

5. While the foam area is drying, start painting the rocks. Paint the darker areas first, using the dark sea mix and some raw umber. Dab on the paint to give a rough, rocklike appearance, painting some areas loosely, as they will eventually be submerged in water.

6. Use raw umber, burnt sienna, ivory black, and titanium white to paint the prominent rock on the left side of the canvas. Paint the darker areas first, followed by increasingly lighter values. Do most of the mixing on the canvas, as this provides a good combination of hues and values. Dab titanium white in some spots for highlights.

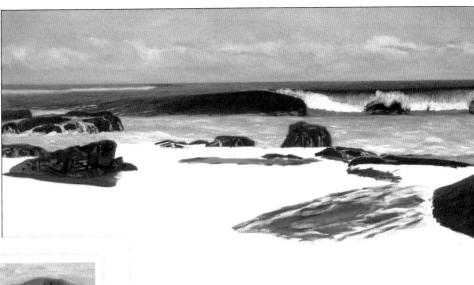

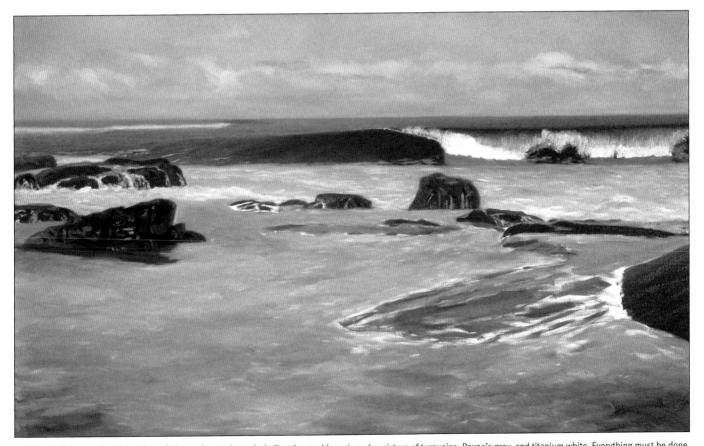

7. Paint the foreground with a variety of blue and green hues, including the sea blue mix and a mixture of turquoise, Payne's gray, and titanium white. Everything must be done wet into wet, so move quickly using figure eight brushstrokes to create movement and texture.

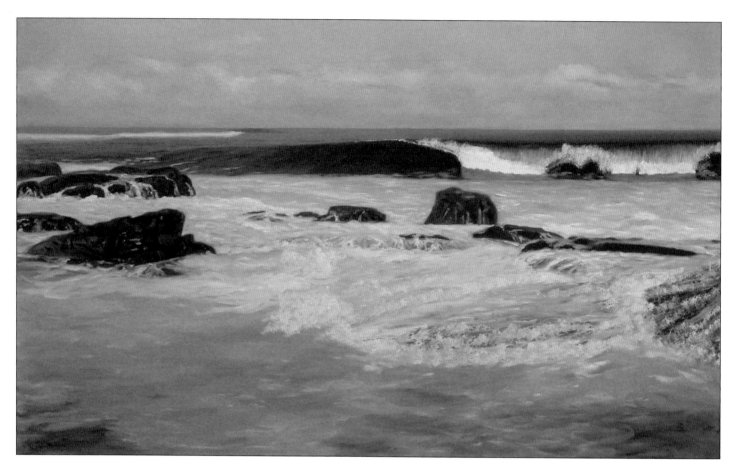

8. Next, add titanium white to the wet underpainting, again using figure-eight brushstrokes to create the foam. A note on the brushes: For vigorous brushwork, worn flats seem to work best. They can stand the rapid brushstrokes and do a good job blending the paint wet-into-wet. Another invaluable tool is a coarse sponge. For areas where the foam is particularly turbulent, dip the sponge into a bit of medium and titanium white, and then lightly dab it onto the canvas.

ARTIST'S TIP

Seafoam is not all white or of a high value. Rather, it often consists of a range of green and blue values.

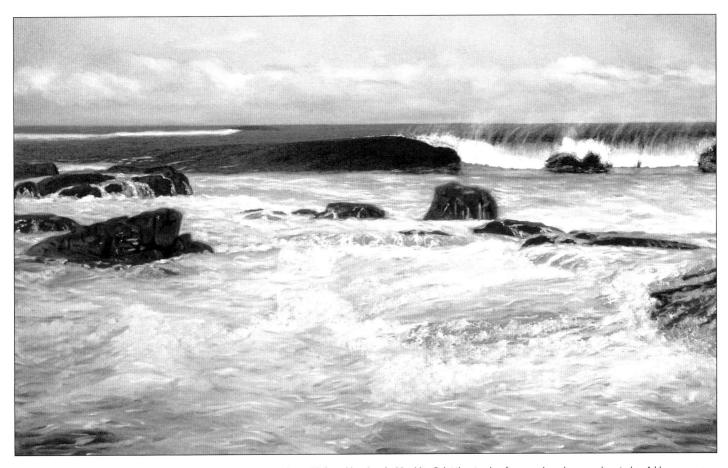

9. At this point it's time to evaluate your painting. Soften the wave's edges with foam blue tinted with white. Paint the streaks of spray using a long, curving stroke. Add more raw umber and Payne's gray to the rocks. Step back and enjoy your work!

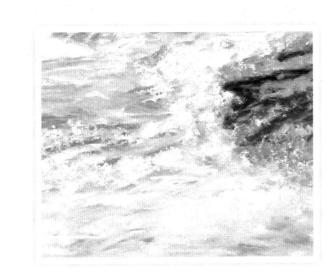

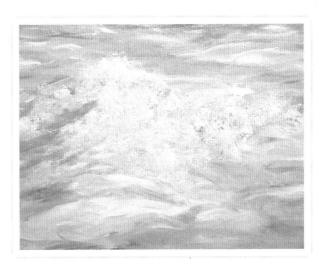

An Unridden Wave

This scene captured my attention because it is all about light and movement. The light green, backlit wave provides an excellent focal point, which helps promote depth and distance in the scene.

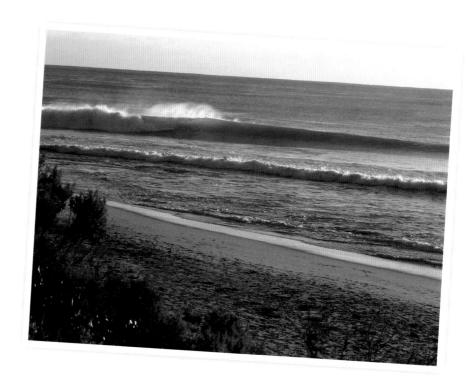

PALETTE

Australian gray • Australian leaf green blue shade • chromium green oxide • ivory black
Naples yellow • Payne's gray • phthalo blue • raw umber • titanium white

1. After creating a light pencil sketch, begin to paint in the sky. To capture its unusual color, mix together Naples yellow, Australian gray, and ivory black. Using broad brushstrokes, fill in the entire area. Next, mix together phthalo blue, Payne's gray, and titanium white and begin filling in the sea.

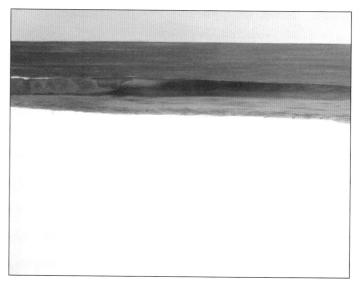

2. Continue painting the sea uniformly across the canvas. Next, introduce lighter values by lightly dragging titanium white wet into wet across the sea. For the lighter area of the backlit wave, mix together chromium green oxide, Naples yellow, and titanium white; then paint the area thickly. For the darker area of the wave, use a mix of chromium green oxide, Payne's gray, and titanium white, adding more of the sea mix as you move right.

3. For the foamy areas, mix together phthalo blue, Payne's gray, and titanium white. Apply the mix across the foam area, adding in more white as you move across the canvas.

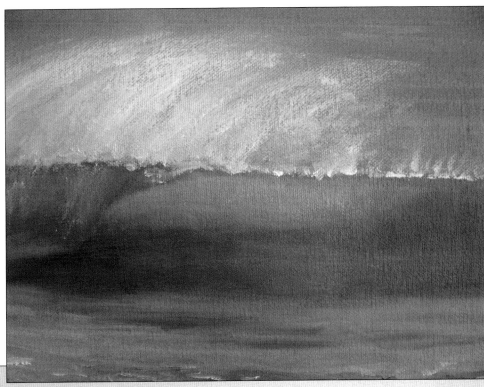

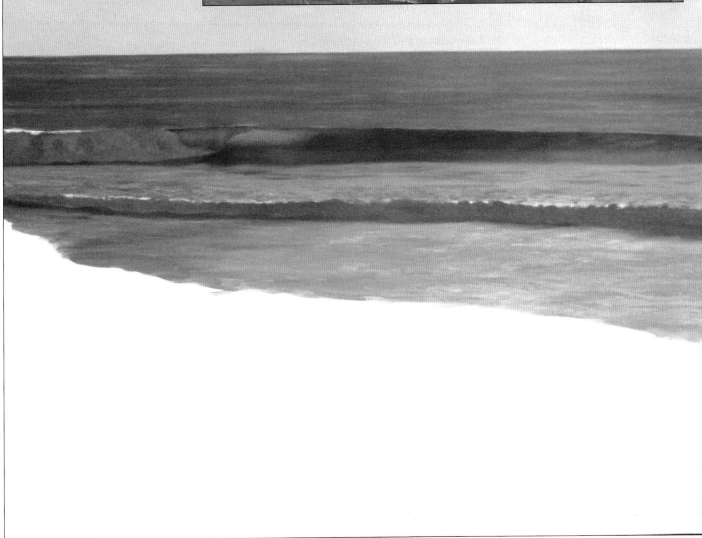

4. Now add more white to the sea blue mix and paint it horizontally across the canvas, adding a strip of foam. Add a strip of the original sea blue mix just below the foam to indicate shadow. Then using the darker foam mix from Step 3, paint another strip across the foam line, leaving the upper edge jagged and the lower edge smooth. Using a coarse sponge, add some white on the left upper edge of this strip. When the paint is tacky, sponge titanium white along the top of the foam line.

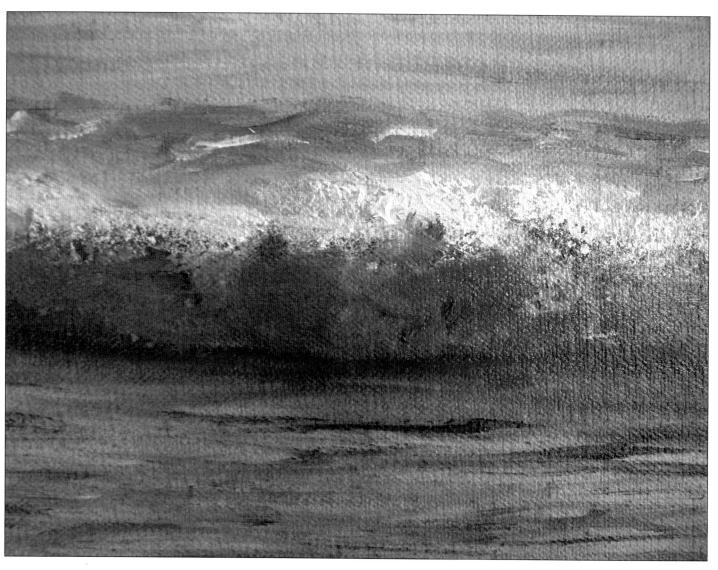

5. For the wavelets and disturbed water, add Payne's gray to the sea blue mix and paint in strips in the lighter area between the wave and foam line. Next, apply titanium white in random strips, wet into wet, to create foam.

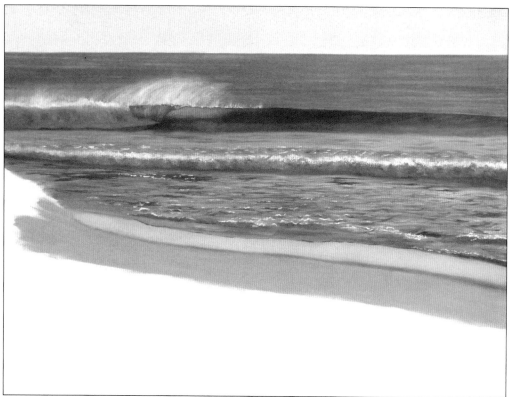

6. Next we'll focus on the area in front of the foam line and the sand. First, add Payne's gray to the dark sea mix from Step 2 and brush it onto areas on the right and left of the canvas. Using the foam blue from Step 4, fill in areas near the sand in choppy, wave-like motions. Add titanium white to the tops of the wavelets to indicate foam. For the spray above the large wave, use a soft brush to draw titanium white up and away from the wave in a curving motion. Use Payne's gray and the sea mix blended with titanium white to paint the sand.

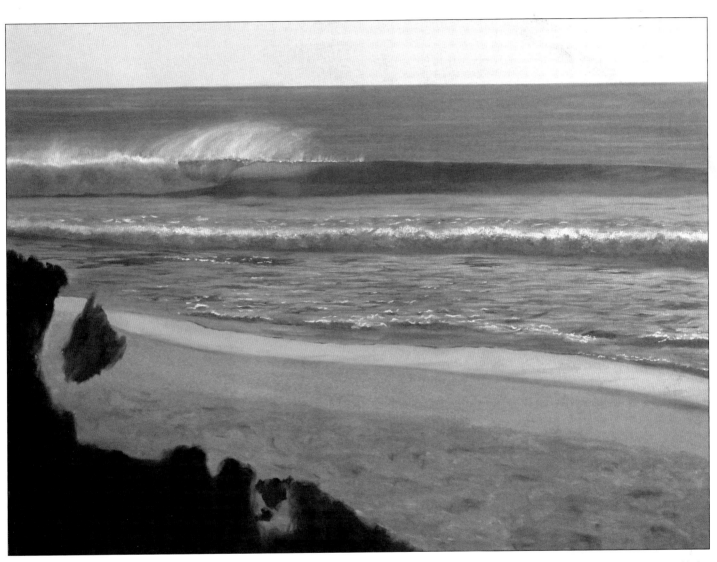

7. Brush in the rest of the sand area using a mixture of raw umber, Naples yellow, ivory black, and titanium white. For the uneven areas of sand, alternate between adding ivory black and titanium white in a figure eight motion. Block in the vegetation with a blend of chromium green oxide, Payne's gray, and titanium white.

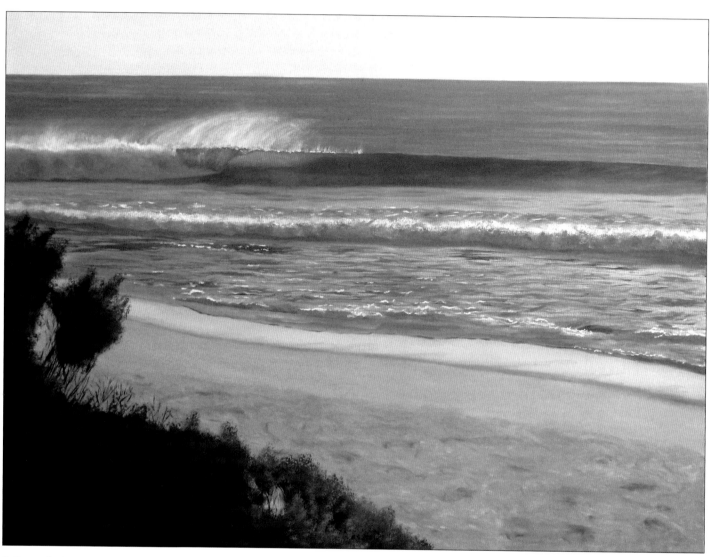

8. Next we'll add more detail to the vegetation. To suggest branches and twigs, add raw umber and ivory black with a small round brush. Using a coarse sponge dipped in some medium, add varying shades of green (dark, mid, and light values made up of chromium green oxide, Australian leaf green blue shade, Payne's gray, and titanium white). Lastly, finish with chromium green oxide and leaf green blue shade for highlights.

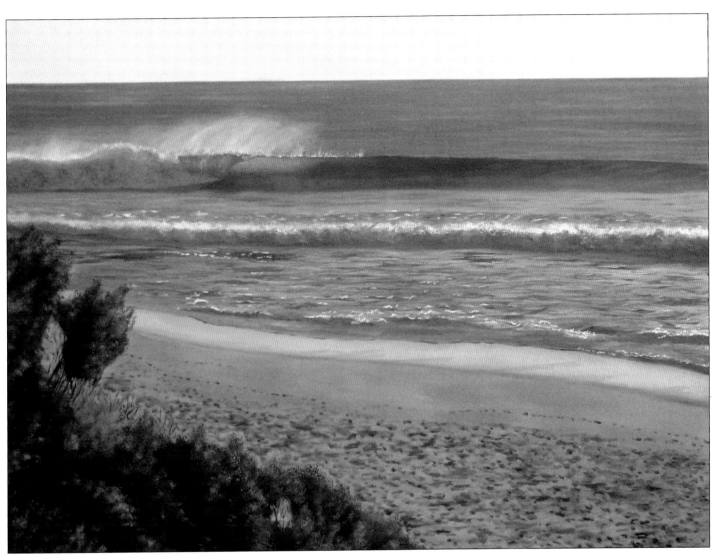

9. When the first layer of mottled sand is dry, go back over it with the sand mixes, increasing its rough appearance. Finally, using a soft brush, glaze some Naples yellow in the white spray area and in some of the white of the middle foam line to further illustrate the color of the afternoon sun. If you are satisfied, then it's done!

ARTIST'S TIP

Use the same technique for painting foam to create vegetation. Lay down the darkest value first; then dab various green, yellows, etc., on top for realistic results.

The Reef

This reference picture is actually a combination of four photographs. They were each taken in the same place on the same day, but I found interesting elements in each of them.

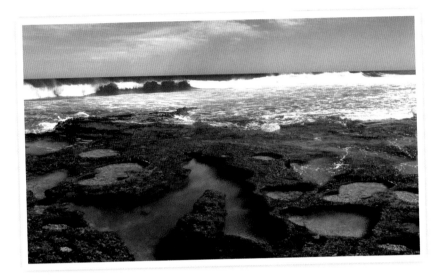

1. Sketch in the forms, taking care to establish the rock pool shapes. You don't need to be particularly detailed; the sketch is just there to serve as a guide. For the sky, mix together phthalo and ultramarine blues tinted with a touch of titanium white. Using broad brushstrokes, apply the paint across the top of the canvas, gradually adding titanium white as you move toward the horizon line.

2. While the sky is drying, mix together phthalo, cerulean, and ultramarine blues with Payne's gray and titanium white, and loosely paint in the sea. Mix sapphire, turquoise, gray, and white to fill in the darkest area of the wave. Fill in the foam shadows with the sky mix from Step 1 tinted with a bit of Payne's gray. Finally, brush in white to add foam.

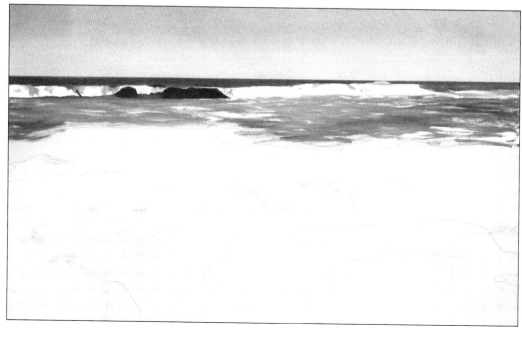

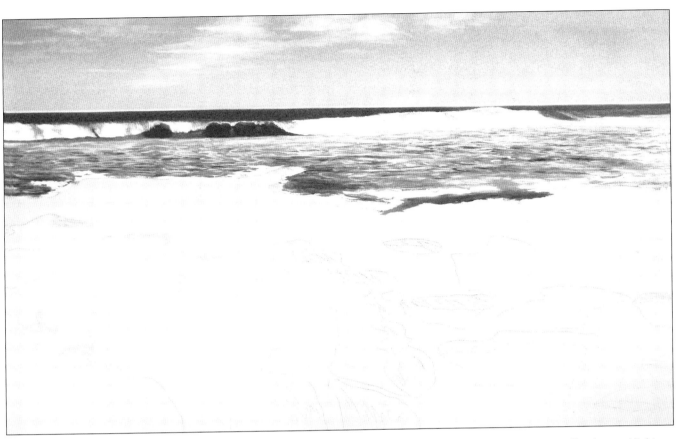

3. Continue painting the sea and sky. First, brush titanium white into the blue hues already laid down in front of the wave. Add clouds to the sky and brush more white into the foam area. Using loose, wavy, small brushstrokes, continue to fill in the sea using various blue hues until it is completely filled.

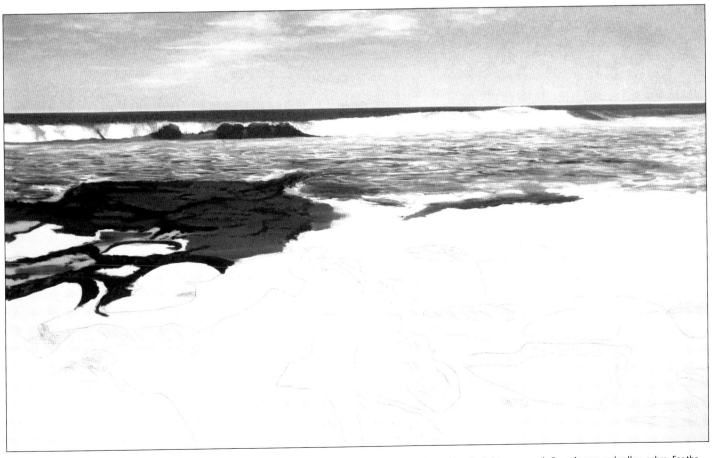

4. Next we'll begin working on the reef. For the darker rocks, mix together raw umber, Payne's gray, and titanium white. For lighter areas, mix Payne's gray and yellow ochre. For the blues in the rocks, use ultramarine blue, Payne's gray, and titanium white. Paint in the brown areas of the rocks first, followed by the blue hues. Fill in the rock pools using a mix of phthalo blue, turquoise, Payne's gray, and titanium white. For the greener areas, add yellow ochre, chromium green oxide, Payne's gray, and titanium white.

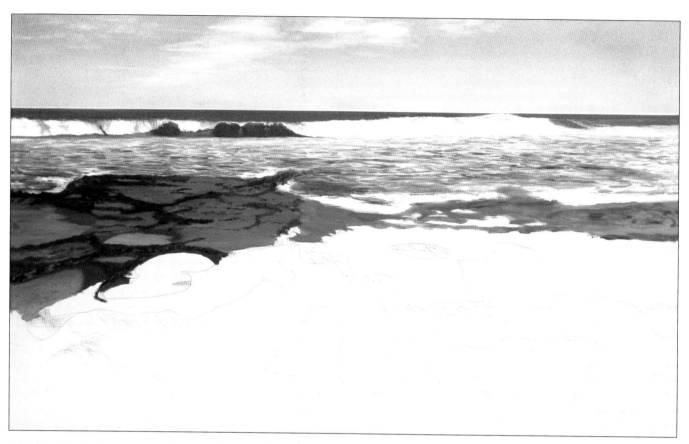

5. For the shadows in the rock pools, use the sea mix darkened with gray. The shadows in the background are lighter than the foreground shadows; therefore, you will need to adjust the values accordingly. Paint in the darkest areas first, followed by the mid and lighter values.

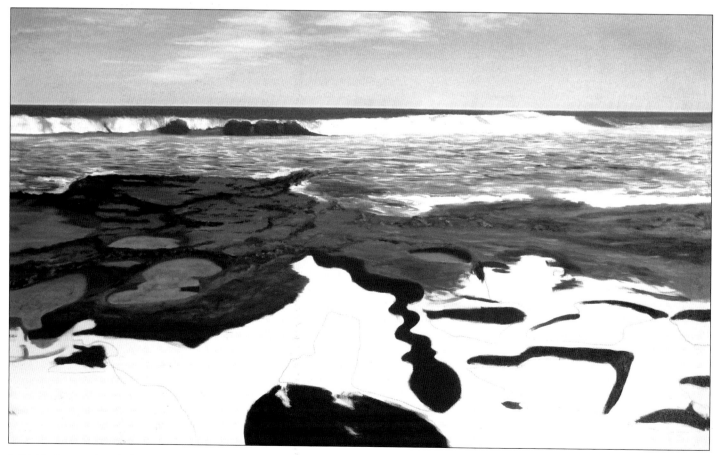

6. Paint the largest rock pool using the blue rock pool hue from Step 4 with some chromium green oxide and Payne's gray added. Continue filling in the darker rock areas. With most of the canvas filled, assess the value relationships between the colors you've applied. For more detail in the rock pools, randomly dab the blue hue, lighter rock pool mix, titanium white, and chromium green oxide on the selected areas.

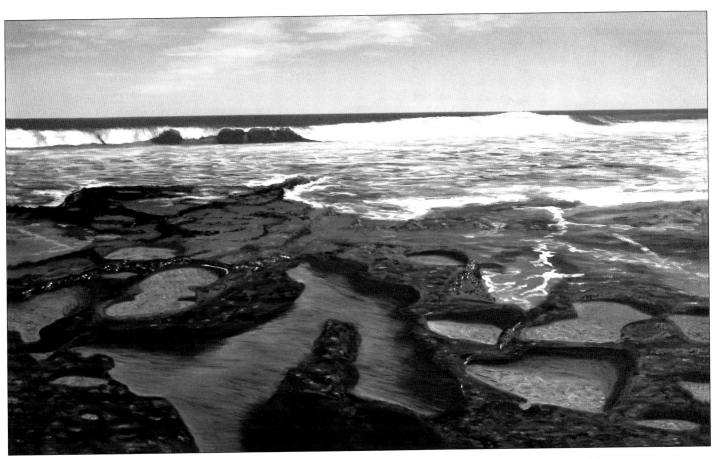

7. Add waves and ripples to the larger rock pool, and soften the edges between light and shadow in all the pools by adding and mixing the shadow and water hues. Apply the darker rock mix over the mid range colors in a patchwork pattern, leaving holes here and there. Using the shadow hue, randomly dab in areas of the rocks to suggest detail. Add titanium white to the rock pools to suggest foam.

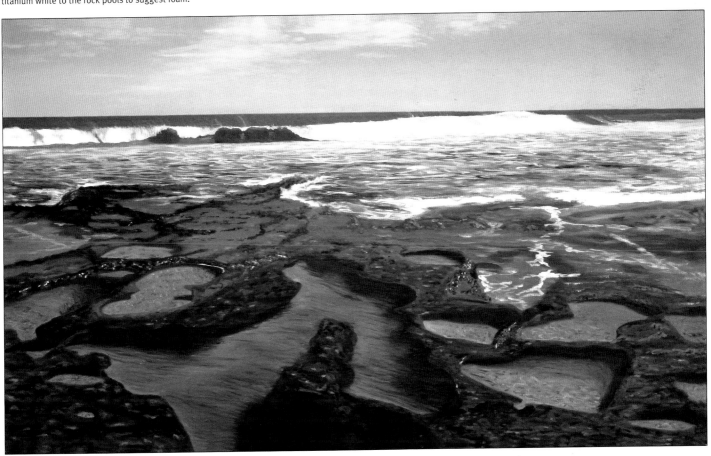

8. For the final step, add a bit of titanium white to the wave for some spray. Stand back, evaluate your work, and make a few minor tweaks, if necessary.

About the Artists

MARTIN CLARKE has been a surfer for 40 years and a painter for 10. He first picked up a brush in 2001 and painted a few horrible pieces. Then one day he painted a subject close to his heart: a wave. Despite the odds, a very good painting resulted. From that moment he was hooked and sought knowledge of painting and art wherever he could find it. Today, Martin is represented by three galleries and has works collected by clients around the world, as well as the State Art Collection of the Government of Western Australia. He has also had a number of solo exhibitions. Martin lives on an island in a coastal city south of Perth with his wife and two of his four daughters, one dog, and three cats. He is within walking distance of his favorite surf break. Visit www.martinclarke-art.com.

ANITA HAMPTON is a signature member of the California Art Club, Laguna Plein Air Painters of America, and Oil Painters of America. Her work is featured in exhibitions across the United States and Europe. Anita prefers to work on site, with little or no photographic help, so she paints quickly and accurately. She currently teaches workshops at the Scottsdale Art School in Arizona.

MICHAEL OBERMEYER has a BFA. in illustration from California State University, Long Beach. Many of his paintings are on display at the Smithsonian Institute, U.S. Air Force Historical Art Collection, and at the Pentagon. Michael enjoys painting outdoors. He believes nature provides the perfect balance of shape, value, and color. Michael keeps a studio in Laguna Beach, California.

KEVIN SHORT studied painting at the University of New Mexico and Pepperdine University at Malibu. He graduated with honors from the Art Center College of Design in Pasadena, California. Since 1989, Kevin has focused his full attention on painting impressionist-style landscapes. He is currently living in Capistrano Beach, California.

ALAN SONNEMAN attended The Art Institute of San Francisco and spent several years working for galleries and museums on the East Coast before moving back to California to divide his time between fine art and the film industry. Alan's murals are featured at the Riverside Hall of Justice in Riverside, California, and the Biltmore Hotel in Los Angeles, California. His paintings have been exhibited in galleries and museums across the United States, including the Corcoran Gallery of Art and the Katzen Center at American University in Washington, DC; The Southwest Center for Contemporary Art in Winston-Salem, North Carolina; and The Chrysler Museum in Norfolk, Virginia. He has received grants and fellowships from the Neddie Marie Jones Foundation and the National Endowment for the Arts. From 1997 to 2001, Alan was an artist for DreamWorks and has contributed to several films, including *Cliffhanger, Titanic, The Matrix Revolutions,* and others.

TOM SWIMM was born and raised on the East Coast and had a successful career as a commercial advertising artist in New York before moving to Southern California in 1982. Inspired by the West Coast landscape, Tom renewed his passion for painting and was accepted at his first exhibition in the Laguna Beach Festival of Arts in 1988. His paintings soon became known for their exceptional use of light and color—a style that Tom continues to develop with each new work. With numerous exhibitions and awards to his credit, Tom's work is internationally collected and is included in many important private and corporate collections.